M000100120

Performing Image

Performing Image

Isobel Harbison

The MIT Press
Cambridge, Massachusetts
London, England

© 2019 Massachusetts Institute of Technology

All rights reserved. No part of this book may be reproduced in any form by any electronic or mechanical means (including photocopying, recording, or information storage and retrieval) without permission in writing from the publisher.

This book was set in ITC Stone Sans Std and ITC Stone Serif Std by Toppan Best-set Premedia Limited. Printed and bound in the United States of America.

Library of Congress Cataloging-in-Publication Data

Names: Harbison, Isobel, author.
Title: Performing Image / Isobel Harbison.
Description: Cambridge, MA : The MIT Press, 2019. | Includes bibliographical
 references and index.
Identifiers: LCCN 2018018402 | ISBN 9780262039215 (hardcover : alk. paper)
Subjects: LCSH: Art, Modern--20th century--Philosophy. | Art, Modern--21st
 century--Philosophy. | Image (Philosophy)
Classification: LCC N6490 .H255 2019 | DDC 709.04--dc23 LC record available at
https://lccn.loc.gov/2018018402

10 9 8 7 6 5 4 3 2 1

Contents

Acknowledgments

I would first like to thank those with whom I have worked at the MIT Press for bringing this theory to paper with such care. I am indebted to this book's commissioning editor Douglas Sery for shepherding it from a pair of draft chapters to this final version, and for bolstering my own critical voice along the way. Noah J. Springer and Marcy Ross were constant sources of professionalism, calm, and kindness throughout production. I benefitted enormously from the peers and readers who volunteered guidance and comments to earlier drafts, which every time provided rich critical pickings and sharp reminders of what is at stake for the task of visual analysis in a new and world-changing economy of images.

This book comes out of a decade of research, during and after a doctoral thesis undertaken predominantly in London, in the Art Department at Goldsmiths, University of London, and supported by the Arts and Humanities Research Council, with subsequent assistance from a writing fellowship from the Arts Foundation. But the instinct to nudge art historical discourse came earlier. I continue to value those pedagogues in the Department of History of Art and Architecture in Trinity College Dublin who rewarded students for concentrated looking and for writing into gaps: I continue to be, at the very least, committed. The staff and students at Goldsmiths where I studied and now lecture provide outstanding interlocutors, but for their influence over this document I would specifically thank Lisa Le Feuvre, Helena Reckitt, Andrew Renton, and Simon Sheikh. Andrea Phillips, to single one person out, has played many vital roles: supervisor, mentor, inspiration, and friend.

I am grateful to the artists, critics, writers, editors, and curators with whom I have worked or learned, and whose conversations around the topics that follow have provided sustenance and stimulation: Erika Balsom,

George Clark, Lucy Clout, Stuart Comer, Mary Cork, Maeve Connolly, Vanessa Desclaux, Ben Eastham, Chris Fite-Wassilak, Orit Gat, Ilaria Gianni, Melissa Gordon, Anthea Hamilton, Leila Hasham, Jennifer Higgie, Ian Hunt, Shama Khanna, Dan Kidner, Andrea Lissoni, Declan Long, Roger Malbert, Simon Martin, Chris McCormack, Darragh McKeon, Massimiliano Mollona, Kathy Noble, Jenifer Papararo, Gail Pickering, Filipa Ramos, Caterina Riva, Ralph Rugoff, Amy Sherlock, Polly Staple, Gilane Tawadros, Isabel Vasseur, Ian White, Catherine Wood, and Rehana Zaman.

To the artists who have fielded my questions and requests, this part of the research is complete but I remain compelled by your work. Thank you Alexandra Bachzetsis, Ericka Beckman, Shu Lea Cheang, Cécile B. Evans, Lynn Hershman Leeson, Mark Leckey, Ligia Lewis, Lorraine O'Grady, Yvonne Rainer, Emily Roysdon, Martine Syms, Leslie Thornton, and Wu Tsang. I am appreciative of those who assisted me at Galerie Isabella Bortolozzi, Freddie Checketts and Andrew Wheatley at Cabinet Gallery, Laura Lord at Sadie Coles HQ, Carly Fischer and Alejandro Jassan at Alexander Gray Associates, Edwige Cochois at Greengrassi Gallery, Rhian Smith at Raven Row, and the Robert Rauschenberg Foundation. Mary Hottelet Giese, The Jerome Robbins Dance Division at the New York Public Library for the Performing Arts, the Fales Library and Special Collections at NYU, the Cy Twombly Foundation, the Merce Cunningham Trust, Sarah Gnirs at the Hammer Museum, Rebecca Goldman at the Archives of Wellesley College and LUX, London, have also generously allowed me access to their archives.

Thanks finally to my parents and brother for a lifetime of unflinching loyalty and inappropriate laughter. The writing would not have been possible without Conor, delighting and steadying me, and our two young children, daily. This book is dedicated to him, and also to my mother Kathleen whose priority has always been my right to education and progression, opportunities she herself did not have. For you, with love.

Introduction

This book comes of two parallel cultural interests and is the result of considering how they interrelate. The first subject is how artists have been combining performance and moving image for decades to explore, from individuated, nuanced subject positions, what their relationship is toward images, how images across formats have the capacity to produce a range of emotions, a sense of proximity, of perpetuity, a heightened or intensified sense of presence, or, conversely (and sometimes coexistent with this heightening), a sense of total isolation or alienation. We clearly produce images, many of us daily, but images also produce us: those that we take and share among ourselves; those that we see and assimilate through mass and social media; and those that we, or certainly I, encounter in various spaces that host art. I was interested in how, in rendering these moments or points of contact, artists were capable of expressing not only singular subjective responses and the relations that they produce, but also how various works were able to punctuate or pause a circuit of image consumption and production, particularly evident in contemporary digital culture. And while each artist I include here asserts their own image relations in unique ways, each provides an alternate and valuable vantage point on these consumptive-productive-consumptive circuits in which I find myself, among billions of others, caught daily.

Simultaneous with this curiosity was an inquiry about whether, particularly over the last decade, and certainly in a Western context, people's relations to images have changed due to the simultaneous and mutually informative development of smartphones, broadband, Internet service providers, and the software, applications, and editing tools of social media platforms, all couched within (and contributing toward) wider changes to the economy, where people are increasingly nomadic and precariously

working. These coinciding developments create an odd marriage, an intensifying need for closeness to one another mediated through images, as social and economic circumstances pull friends and families apart—of being, as Ryan Trecartin describes it, "post-family and pre-hotel."[1] I am one such nomad. I enjoy brief and sometimes long *dérives* online: a process of passing through various news portals and commercial outlets, between social media platforms like Instagram and Twitter and Facebook in breaks from work, as my attention roams. And, back in the round, it is obvious that others' image production habits are co-evolving with social media habits. I am regularly captured off guard in other people's photographs, slipping through restaurants and bars, restrooms and public transport, in shopping malls, cinemas and theaters, in museums and galleries, near monuments, and attending demonstrations. There's a fierce intensity to the widespread witnessing, capturing, and circulating of various moments through images, preoccupations that would appear to be altering individual spatial perceptions, trajectories through public space, and forms of public assembly, as well as (and less easy to articulate) projections and perceptions of self. I am interested in all this "netting" of images, the impetus for constant capture and in the forms of, and platforms for, exhibition created as mechanism and outlet. Social media platforms offer very specific exhibition architectures to their users, marketed as sites for creativity, communication, and collectivization modeled, it would seem, quite closely on the public museum, while mining and licensing the spoils. The exponential rise of Facebook over the past decade has been so obvious and widely reported in print and broadcast media that the questions linger: What possibilities does this activity offer, even when those who are, in effect, building this vast corporation—the users—are by now very consciously working for free? And what might be art's role in better understanding this phenomenon?

Our access to digital imagery has changed, as has our need for these images. In 1936, Walter Benjamin wrote about photography that, "everyday the urge grows stronger to get hold of an object at very close range by way of its likeness."[2] Over the past ninety years, that urge seems to have grown stronger almost daily; and, especially as people travel, migrate, commute, double job, triple job, and live remotely, images present a distinct and complex form of contact. Olivia Laing, in her recent writing on solitary time in New York, observed "how the network might appeal to someone in the throes of chronic loneliness, with its pledge of connection, its beautiful,

slippery promises of autonomy and control."[3] Images have long been produced not solely for pictorial representation, but from a more abstract, gnawing human need. In 1956, Edgar Morin wrote:

The more powerful the subjective need, the more the image upon which it fixes itself tends to be projected, alienated, objectivized, hallucinated, fetishized (as many verbs as can punctuate the process), the more this image, in spite of and because of its apparent objectivity, is rich in this need to the point of acquiring a surreal character.[4]

Morin's writing on the cinematic imaginary, his punctuation of this process, describes in nascent terms a similar charm (or hoax) of images that J. L. Austin ascribes to some forms of language in *How to Do Things With Words* in 1962—and which Judith Butler ascribes to all language in *Gender Trouble* in 1990—as having an inherent performative quality, which both precedes and produces in those who utter it the regulatory regimes of power. I am interested here, as an art critic, art historian, and a self-conscious prosumer, in how, in a new landscape of the imaginary, undergirded by technology capitalism (of which Facebook is one great, or catastrophic, example), the language of images is changing. Images are performative—they both proceed and produce us—and this performance of images, repeated, congeals over time into the fatty perimeter of dominant ideology, now neoliberalism. I am concerned by how, now, with the rise of "DIY" image platforms and technologically developed means of image capture and circulation, this unregulated, all-encompassing image performativity exerts itself relentlessly, spiraling Benjaminian urges into real image addictions, and putting us to work for free in the service of global corporate expansion in an unprecedented colonization of personal information and visual material, the consequences of which we are yet to fully know but must now begin to imagine. Now then, in this loop or cycle of images, which coincides with an odd situation of invisibility, these curious, perplexing, and valuable artworks, which I include in this writing, combine performance and moving image in order to draw out our strange relationship with images, our instincts to perform and to capture, and in so doing present an invaluable navigation point, some critical perspective and spatial relief, from the flatness and nearness of the smartphone screen.

Finding the language for how images are experienced, for how images shape experience, is difficult. The experience of images—this need—is never uniform, it is influenced by a wealth (or dearth) of factors, so this new proximity is varied, individuated, and mixed, and often not purely reducible

to spoken or written language. Finding satisfactory terms in this form of analysis (written accounts of the *visualization* of the prosumer's subjectivity formation) is not straightforward. Eve Kosofsky Sedgwick approached an analysis of affect by "attending to the textures and effects of particular bits of language,"[5] and I apply this approach to works here. But insofar as the textures and effects are those informed by my perspective, education, and white embodied experience, they may exert their own distinct limitations. To complicate this, each artist's unique rendering might defy logical or empirical evaluation and at times veer into the irrational or unknown, or else reflect structural and systemic biases so deeply and violently embedded they have remained to many as unseen, or rather been made to remain unseen by forces of patriarchy, capitalism, and white supremacy. Much of the work to which I will attempt to do justice creates a different mode of visibility for the behaviors and attitudes borne of inscribed and often reductive viewing experiences. These works, like my writing that tries to trace them, often express themselves in abstract terms, abstract as a conceptual decision or else as a side effect of the fact that the encounters that online image activity—grounded and harnessed by social media—sets up, this proximity of images seemingly unfettered by spatial or temporal constraints, is relatively new. The, *my,* critical endeavor of capturing this visual endeavor is itself complicated, convoluted, and rooted, always based on my subjective responses to works. My own proximity to and distance from these works vary, some from documentation, others live and in exhibition, others benefitting (and blinkered) from years of correspondence with an artist, or, in other cases, none.

The theory presents something of a speculative genealogy: some of the artists worked together, others have discussed their elder counterpart's influence. In some instances, I draw correlations between works based on artists' statements of intent, of compatible content or critical responses, or upon how I interpret their operations. As I hope to evince through writing, links between generations of works are tangible through their formal and conceptual approaches, and yet I also place emphasis on a particular heterogeneity of perspectives, necessary, to my mind, to understand the widely differing motives that people have to perform and produce on social media. Attending to this shifting ground, in a final chapter, I disrupt the genealogical arrangement with an alternative interpretative model, which takes the works out of chronological order and conceives of them in terms

of dynamics, or phrasings. These are works that operate beneath images and beyond objective account, and this switch is an attempt to accommodate their sophisticated footwork before and beyond the linearity of any written history.

The book is also a product of my own unresolved relationship with social media, inspired, captivated, and educated by much of the prosumer material I encounter online, but equally fretful, anxious, and self-conscious about the short- and long-term consequences of any contributions of my own. This uncertainty has been further compounded by political events that have taken place during the course of the writing: 2016 saw the election of Donald Trump in the US and the referendum in which the British public voted to leave the EU, a post-war project of unification that from the outset set up to maintain peace in Europe. In its place, British politicians extolled the virtues of reestablishing "sovereign power," a force of and within language that resonated with the US President's ambition to "make American great again," both phrasings implying intended political retroactivities that will completely undermine the project of intellectual and legislative decolonization. While I recognize the material conditions—dwindling resources and opportunities, as well as pressure on education, health, and welfare systems—that led a democratic electorate across these territories to vote this way, as a white, Irish migrant who has worked and lived in both of these domains, I understand this on a variety of levels as the greatest assault upon representational politics of my lifetime. And, far outweighing any symbolic violence, it is clear how this politics of separation and segregation is affecting and often brutalizing its subjects. In such a crisis, finding new modes of communication, collectivization, and self-representation, or rectifying those from neoliberal control, has never seemed so vital.

The point of this being that the research for this book began as a doctoral dissertation, which, completed in early 2015, resolved the online activity of prosumerism to be largely exploitative. Yet now, while I still hold the position that what financial controls underpin this activity are in significant need of regulation and remodeling, I also believe that platforms for communication and personal expression, as well as sites of multiple witnesses, are worth maintaining. Much of the book deals which the complexities of prosumerism's Janus face, resolving it as a technological, cultural, and economic phenomenon that is, in principle, neither good nor bad. This is

not to assert a position of ambivalence, but rather to assert that there is no singular or privileged position from which to draw critical judgment now that representational institutions, on all levels, are in turmoil.

In order to establish such a genealogy of artists that both anticipates and illuminates the new mode of image production that is prosumerism, chapters are organized chronologically and oscillate between scholarly fields, between details and analyses of specific works of art and their cultural and technological contexts, and the rise, contexts, and current modus operandi of online prosumerism. I navigate between histories, theories, and critiques of modern and contemporary art, performance, film, video, and moving image, through feminist, queer, and critical race theories, as fields of study that I see as useful in developing more nuanced understandings of digital labor and digital economics, the attention economy, and prosumerism. It is worth underlining at this juncture that completing a monograph of this breadth and concision has meant forgoing consolidated analyses of the various complexities, contradictions, and points of tension within contemporary feminisms, queer and trans theories, critical race studies, and within the economies and histories of moving image and performance works, set against or within the markets of art; aspects of all of the above, however, are raised and discussed at various points.

I begin in the first chapter with some description of the title "Performing Image," setting out the research and aesthetic fields from which it draws. I discuss in greater detail the operation of Performing Image, which, at the core, is a set of artistic responses to the performativity of images, a set in which performance and moving image are combined or cross-contaminant in ways that are imaginative and daring, and that spotlight how images are encountered, how they are produced and consumed. I also discuss in this chapter the various problematics of medium specificity and its analysis, and previous examples of media convergences and their theorizations, many of which resonate and reappear in the subsequent chapters.

The second chapter begins with works that precede those in the 1970s, with the early Combines of Robert Rauschenberg. I consider Rauschenberg's placement and movement of the body (his own, and others) in relation to and around images within his work, as precursor to many of the choreographies of circulation that I will look at in the course of the writing. Rauschenberg ushers us toward Vito Acconci, who he early on encouraged to work in performance, and Yvonne Rainer, with whom he performed and

collaborated throughout the 1960s, and who was greatly influential on his own practice and pared-down aesthetic. Acconci and Rainer are both artists who use performance and moving image to challenge the imprint of images on perception, identification, and individual and group behavior, seeded by propagandist television and print media. I move to a discussion of Adrian Piper, whose experimental writing had been published by Acconci, and Lorraine O'Grady, to see how these artists used performance and photography, both within art institutions and in self-organized, documented street performances, as a means of exploring the particular visibility or invisibility to which the black subject was delimited by various bodies within repressive white institutional hierarchies. O'Grady also worked between street performance and mediated image, but so too was she an early innovator of the lecture-performance format now so regularly called upon by a much younger generation of artists to explore their own mixed response and/or interstitial positions between responsive and productive imagery.

In the third chapter, I take the analysis to works in the 1980s and 1990s that explored and dramatized various dimensions of cyberspace as a social frontier that could be designed anew, and that could succeed in providing an alternative space and site for self-representation and liberation where other representational platforms were failing. I look at works that pool from moving image and performance by Leslie Thornton, Lynn Hershman Leeson, Shu Lea Cheang, and Ericka Beckman to reflect the viewer-turned-subject, from reality television toward new DIY imaging and circulation technologies, from VR and the Internet, to console gaming and multiuser platforms. These works, crucially, also ask how particular usages of console gaming and multiuser platforms could create meaningful differences or whether the transition from viewer to actor merely propagated and in some instances aggravated image performativity, where reductions or stereotypes from previous media, literature, and film were brought online to be enacted and perpetuated in this not so virtual reality.

The fourth chapter charts how the term "prosumer" was rerouted from its original coinage by Alvin Toffler in 1980 as a "productive consumer" to the later description by Don Tapscott in 2006 (in a work co-written with Anthony D. Williams) of a "pro-active consumer" as prosumerism was brought online, and how neoliberal ideology imposed its weight within this transition. In this chapter, I look at the various formats, and the social

and aesthetic appeals of online prosumerism's current model, and at some of the ways that it derives surplus value from those who are active there. I consider it in these terms, as well as in being a source of data, a vast image repository, and discuss some of the implications of its accumulation strategies.

That fourth chapter brings me to prosumerism as we now know it, as it was articulated in 2006, and in the fifth chapter I look at works from around this period by artists Frances Stark and Mark Leckey, both of whom were actively exploring their own relationship with consumer images as artists, and the political circumstances and consequences of this, prior to the boom years of Internet prosumerism. Stark's and Leckey's works in these terrains provide a valuable, esoteric, and often enjoyable outlook on what it is to inhabit this great indeterminacy between image work and image play (historically, at least broadly understood, as the occupation of the artist).

In the sixth chapter, I chart various scholarly fields in which prosumerism has been subject to scrutiny and critique. I also discuss how a more particularized understanding of art that not only renders aspects of prosumerism, at the sites where this production-consumption is mediated, but that actively plumbs from the instincts to consume and produce images, can bring a heterogeneity of perspectives to critical discourses around affective and precarious online labor, and the tools for reimagining a more equitable redeployment of prosumerism, which scholars, activists, entrepreneurs, and politicians so uniformly and purposely demand.

In the penultimate chapter, I look at a range of practices that address image performativity post-2010. In this decade of ecological and political violence and uncertainly, these are works that explore the fact that, despite new DIY image technologies and circulation software leading to by now innumerable digital images, diverse subjects remain either unseen or seen differently. While each work included acknowledges the emotional spectrum—this "affect"—that images might be said to yoke, each work situates affect's congealment within various situations of precarity. Here prosumerism is not always explicitly rendered, but the forces, subjective and social, that underpin it are omnipresent and often oppressive. Despite this, the collective prognosis is not that prosumerism be damned, but rather that, if strategically redeployed, it has great power to highlight and trouble representational bodies, hierarchies, and institutions in crisis.

In the final chapter, I suggest three choreographies that might exist or coexist within works of performing image, on the basis that they suggest a subject's proximity to or distance from an image, or that they suggest a subject's negotiation of proximity to or distance from an image, given his, her, or their structural relation to or against, within, or outside ideology. This three-part interpretative framework takes its lead from theories of distantiation, overidentification, and disidentifcation as they have appeared in critical theory and literature over the past century. The framework also allows me to think of works not in generational terms, but to return to Sedgwick's "textures and effects," to internal dynamics, and to group artists on the basis of the particularities of these dynamics as I read them within their work. Like the chronological read, this choreography will be as restricted as it is illuminated by my own lines of vision, so I would ask the reader to treat these categories as modular, as moveable and mutable. This theory is meant as a detailed outline of a set of connected practices that might be tested, overturned, or expanded over time. And it is a declaration of their immeasurable value in an economy of attention and a crisis of representation.

1 A "Kind of" Prosumer

Standing at the rostrum of a museum auditorium in 2007, British artist Mark Leckey announces:

This presentation is an attempt, by me, to try and grasp a particular experience that I have with certain things in the world, things that I mistake for images or pictures but that somehow impose on me their actual weight, density and volume—their being in the world [...] How does an image find that presence? And—in turn—channel its effects through my body?[1]

And so he commenced *Cinema-in-the-Round*, a presentation about his responses to various imagery projected on the screen next to him, setting out his visceral physiological impressions of various obscure and seemingly incongruent material culled from the Internet: images from advertising, music videos, art history, and YouTube. His tone was inscrutable, intense, and serious, offering imaginative contemplations about the clumpy dimensionality of flat images, Phillip Guston's lumpen boots, Tex Avery boulders hurtling down a mountain, CGI animations of the Titanic's final nod before turning its nose down and sinking. It was an engrossing performance, as much for the constituent visual material as for the manner and pitch of how it was delivered, the gravity with which he was treating this perceptual inability to decipher things from their image to their object versions. He was wearing a tuxedo. It could have been farcical, except that it was not.

To complicate interpretation, throughout the performance, a camera circled the audience, capturing our reactions to this presentation, itself a meditation on perception. This aspect was incidental, or at least it was not common for all the audiences that would have seen the work during its performance run; it was one of several recordings the artist made, which he then edited into a corresponding video work.[2] But what it sparked was my alertness to intersecting processes, of a pattern of image consumption,

of which—as a contemporary Western consumer I was inevitably part—but also one of production: as I was imbibing his images I too was being reduced to pixelated particulars. In 2008, several months after completing his performance series, and prior to the completion of his next one, Leckey said in an interview:

> I think of myself as a kind of "prosumer," where you produce and consume at the same time, and [digital technology provides] the tools that prosumers use. It's not professionalism, it's something else, something in-between, something less and more than that. [As a prosumer] you're consuming it, looking at stuff, making it, sending it out and it's coming back to you: this is a kind of loop or cycle that you're in.[3]

This identification as prosumer in 2008, sets out the basis for this book, which is to consider the open, esoteric, and often unresolved inquiries of artists on the physiological impact of images on the body, alongside and related to how instincts for images power a new industry of visible, highly networked, and largely unpaid digital labor. This is not to claim a joined-up movement in art that snuffs out prosumerism's exploitative aspects, but rather to establish a set of practices that anticipate and illuminate some of the heterogeneous motives that people have to play with images, and that render or cleave open these "loops or cycles that you're in" in alternative channels of circulation or distinct exhibition architectures, spotlighting some of what might be normally at stake within the exchange.

* * * *

The prosumer is a portmanteau of consumer and producer, evolving from a coinage by Alvin Toffler in 1980 of a "productive consumer" to the later description by Don Tapscott and Anthony D. Williams (published in 2006 in the US and 2008 in the UK) of a "pro-active consumer" as "prosumption" was brought online. Prosumerism, as it is more commonly referred to as now, describes online activity where people produce and consume information on easily modifiable platforms such as Facebook, Twitter, and Instagram.[4] Prosumers regularly adapt their profiles and fill newsfeeds with personal information, bylines, comments, and observations, uploading images, gifs, and videos, as well as adding links to other websites, while linking these information streams to other users' pages, either formally (by following or requesting access) or informally (by commenting or clicking on other content they encounter across networked contributions). It does

not cost money to be an online prosumer, if the calculation excludes the costs of technological devices, electricity, Internet access, and, significantly, a prosumer's time. Online platforms create revenue by mining data and licensing content from prosumer profiles using various web crawlers, personalized algorithms that can track many of the things prosumers click on—information that is then aggregated and sold on to advertisers. When we sign up for social media, we license our uploads and release our data, subject to tracking algorithms that aggregate data for sales. Human data generates hundreds of billions of dollars of revenue every year for corporations that employ relatively few staff while trading on the leisure hours of billions of users.

By the time that Leckey identified himself as a prosumer he had already worked as a DJ, and made both video and in performance, often sampling moving images, sounds, and other visual material within his work. He was already highly regarded by curators and critics alike, having just won Britain's Turner Prize, and shown his work in numerous high profile international gallery and museum contexts in the US and Europe. He was represented by commercial galleries in London, New York, and Cologne, and had just begun uploading works on YouTube, under the username "Mr Leckey." He identified as a prosumer just after making *Cinema in the Round,* a significant work within Leckey's career-long inquiry into the passage of technologically mediated information through the body and what effects it takes—but this was the first of his works that marked how that relationship was impacted by the Internet. *Cinema* uses images sampled from prosumer websites and positions Leckey at the rostrum consciously performing as the self-indulgent consumer and producer. His subsequent *In the Long Tail* (2009) closely examines the online productive mechanisms monetizing these subjective responses, using various feline iconographies to draw out the "long tail" of online consumerism.

Leckey's self-identification as prosumer in 2008 is significant for a variety of reasons. Expanding the subject matter of Leckey's own work and splintering the economies in which he circulates it, it also symbolizes a digital turn in contemporary art, where computation plays a very regular part in execution, circulation, or distribution of works for a broad range of artists far more diffused than previous, more specialized proponents of Cyber and Net artists. Considering art to be a form of information, a mode of presentation or a modifiable object, this moment signals the circulation of

information, the dispersal of presentational modes, and the distribution of goods to be not only integrated with, but dependent upon, digital culture. It offers a navigation point in the development of prosumerism itself, representing a milestone in the Western user's consciousness of their activity producing and consuming online, while the real value of a latent and free online workforce was becoming apparent to many enterprises across industries. And it is no coincidence that Leckey identifies as a prosumer either, or that many artists now do, given how closely artists have questioned their own roles within circuits of consumption and production, since Duchamp co-oped the urinal as the readymade *Fountain* in 1917, changing the object's status by rerouting its channels of circulation. Prosumerism piques Leckey's interest as it occupies and trades on the long-standing ambiguity of the artists' position between distinct circuits, turning consumer object into an intellectual proposition and, sometimes incongruently, a luxury good. Prosumerism markets itself as providing this transformative quality, with a capacity to support creative pursuits, to provide platforms for innovation and exhibitions, to turn consumers into artists.

Leckey's identification as a "kind of prosumer" coincides with several notable moments in the stages of prosumerism: a revised edition of Tapscott and Williams' book *Wikinomics*, which redefined the term *prosumer*, was published in the UK after significant international impact the previous year; the increasing monopolization of social media corporations through merger and acquisition (after investment from Microsoft, Facebook became cash-flow positive in 2009, and a year later was the third largest Web company after Amazon and Google; in 2012 it acquired the photo-sharing application Instagram); the changing and increasingly insidious techniques of data-mining and image licensing employed legally by those social media corporations (in 2009, Flickr was bought by Getty Images as a cheap source of stock images, changing this industry irreparably); the turn of mass media toward social media as a legitimate research source and tool; and the emergence of social media's impact on mass media as the biggest driver of traffic in the world (people more regularly travel from social media to news media rather than the reverse). Leckey's identification of himself as prosumer also anticipates a critical turn, in an emergent school of anthropologists, economists, philosophers, and sociologists, interested and concerned by the adverse effects of prosumerism and its capitalization of indeterminacies between image work and image play, marked by a series of conferences

convened by Trebor Scholz in New York in 2009, which stimulated a new scholarly field of prosumer critique.

Prosumerism is the neoliberal model of twenty-first century labor *par excellence* where one's online viewing habits and information appetites are put to work. Increasingly driven by gifs, selfies, velfies, and videos, prosumerism fashions an image-productivity and image-literacy that is harnessed and capitalized by some of the fastest growing global corporations the world has ever known. People's responses to and desire for mediated images increases daily, and social media platforms adapt to trends in order to best harness them. Instagram is, at the time of writing, the fastest growing social media platform for a number of reasons—still and moving images, when coupled with captions or subtitles, or when looped in gifs, provide a fast and playful means of information dissemination, swiftly uploaded and shared. Its currency is rapidity, because, as John Berger noted in 1972, in the image, communicating at speed, "seeing comes before words."[5] Images flash, fast and competitive, peculiar and funny, in an information economy where innumerable bits vie for our attention.

Social media use—which is synonymous with prosumerism, since they both depend on social media's easily modifiable platforms—has radically altered the ways that we identify, appear, behave, and congregate socially. Encounters and conversations that we have online are constituted, supplemented, or complimented with images: it becomes difficult to discern whether we are conversing with people through images or whether we are having encounters as images, differently dimensioned versions of ourselves interacting with others' different dimensions. Now far beyond disciplines of theater, dance, cinema, or visual art, we are a Western society performing images.

Definition

"Performing Image" is a theory about the uses of performance and moving image, as convergent or cross-referential media employed by artists in response to a new generalized social condition of living and performing, "under the image." Extending Hardt and Negri's concern about the social pressures of living under capitalism produced by new communications systems,[6] we are now trading what Jonathan Beller calls the image-commodity, as "the media, as a de-territorialized factory, has become a worksite for

global production."[7] We live in a new state of precariousness, nomadism, and drift that come from the conditions of late capitalism, the preconditions of which also coincided with, as Fredric Jameson has proposed, the onset of postmodernism, a style that reflected the "enormous social and psychological transformations of the 1960s."[8]

Performing Image works are visible from at least as early as the 1960s, and, in this reading, surface first in North America (during the postwar "American Century") before proceeding outwards, as artists traced the various perceptual and political ramifications for audiences after new social transformations were made proximate through the domestication of television, the advent of video and its facility for same-day and live news broadcasting, the marketization of video cameras to householders, and the "new frontiers" of cyberspace and early online multiuser platforms, which spread from arcades to home consoles. But Performing Image reaches its zenith in the age of social media, when vast majority of Western subjects have the resources and capacities to take, upload, and circulate images to one another among wider networks, anytime and almost anywhere.

Works of Performing Image scrutinize a certain circuitry between the subject, the photographic apparatus, and the screen (or the coinciding of apparatus and screen that smartphones present) and the reciprocity of images and bodies during regular, multiple, and multisited encounters. Many generations of artists have attempted to render the physiological and sometimes beyond-rational sensation of the image encounter, of the desire to approach an image and how it feels when an image *passes through the body*. This potential proximity to an image, of an image, the process of assimilating it, this momentum through which picture becomes posture, embodied, performed, and captured is, as Leckey articulates, a cycle we're all in. Performing Image works represent a cycle of image acquisition and performance, of consumption and production; they are works that *step in* to these cycles in order to co-exist outside of them, that decenter the performing subject through various methods of representation, a subject who may be, at different points, made satisfied or anxious by this ongoing and widely diffused process.

The body itself is a technology adaptive to triggers and objects, to stresses and prostheses, to unforeseeable forces over time. But its skeleton and tissue, its neurons and nerves, are also shaped by technology proper: wrists ache beneath smartphones, spines curve around laptops, minds hum

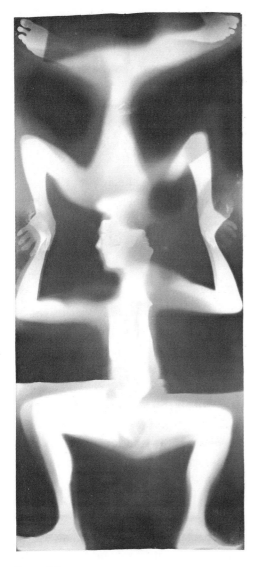

Figure 1.1
Robert Rauschenberg and Susan Weil, *Untitled (Double Rauschenberg)* c. 1950. Exposed
blueprint paper, 6 ft., 10 1/2 in. × 36 1/4 in. (209.6 × 92.1 cm.). Cy Twombly Founda-
tion. Copyright Robert Rauschenbert Foundation.

from the screen's blue light long after the sun falls. Technology touches us; we react and respond to it over time, and that which we assimilate impacts every inch of our being. In a sense, Performing Image is a theory that understands the body as porous, drawing on Spinoza's concept that "nobody as yet has determined the limits of the body's capabilities: that is, nobody has yet has learned from experience what the body can and cannot do."[9] The body affects and is affected by images, it is determined by and in turn determines them, and its relationship with the digital image is now undergoing radical transformation.

The body is mutable, and yet outwardly it maintains expressions of gender, race, ethnicity, class, ability, and so on; thus, it is an unreliable, unstable, and often dumb referent. In Amelia Jones's formulation, "we cannot rely on this referent to be coincident with a 'real' or 'live' body that secures a stable, coherent, or recognizable self."[10] And the body's problem, to a degree, is the image to which it is drawn, which encases and reduces it, resulting in a complex double bind where "representation points to the impossibility of the 'real' ever being known except as the specific experience (resolutely embodied) of spaces, languages, images, sounds, smells, textures, etc.—all of which are on a continuum."[11]

And the digital image is as porous as the hands that guide it. It is materially indeterminate, existing, often simultaneously, as a psychic abstraction and physical entity. It has long resisted internment to language because of its mutability of form. The digital image appeared first around 1957 as a tool for medical scanning and body measurement, for tracing the body inside and out, before overtaking its analogue photograph, which often coexisted in negative and in print, in the Western mass market at the beginning of the twentieth century. The digital image is coding, made up of clusters of light and dark pixels. Photographs and videos are both compressible, how easily compressed dictated by their pictorial (and therefore statistical) regularity or irregularity.[12] The image exists as code or format, as well as printed form. An image can represent an external object obtained by a camera or other ocular device, existing simultaneously in the round while presented in two dimensions on a screen or console. The term "image" can refer to an impression presented by a person or brand, one thing resembling another, or a picture in one's mind that remains after the forerunner is gone. The image is mutable and mobile, retrospective and projected: it has range.

As this theory will try to show, through works, the image is porous, but the bodies it captures are penetrable, permeable, and absorbent too: they are mutually contingent. Absorbed in conversation, with and as images, human contact changes. The prosumer, who once was the spectator, is now capital's most valuable agent, and is with body, however differently signified or abled, and this is a theory anchored by a group of works that each articulate a distinct, subjective embodied experience of the affective image. And the narrative and trajectory through works is influenced by how distinct the subjective, embodied experience of online prosumerism seems from the experience of encountering these works, elsewhere, in galleries and in viewing spaces online, the experience of conceptualizing oneself as productive viewer within specific art encounters. The theory follows the lead of the vital sense of perspective these works of art give to the angled vision of online prosumerism.

These studies of the loops or cycles between image and the body evolve from earlier inquiries into the transitions between image and object, of how objects *register as images* and images register as objects, initially from the mid-1950s by artists like Robert Rauschenberg and Jasper Johns. From the 1960s, a number of artists used performance and moving image to regard how the gendered and racialized body is translated or transformed, is delimited or objectified, through the image. Many works from this period turn the focus from the spectacle to its viewer, scrutinizing new modes of audience participation as invariably complicit within this transformative circuit. These works begin to foresee, and now help contextualize the complex of prosumerism, as a form of productivity and which produces a new social behavior, where one projects and ultimately perceives oneself as among a group of multiply located, perpetually active, coexisting subjects.

This phenomenon coincides with the production of numerous works of art that investigate the nuances of the will to capture, works alert to image performances as presenting different physical sensations and politi cal possibilities at various points in their production. Consuming and producing images online can bring an individual satisfaction and pleasure alongside an intensified sense of isolation or anxiety. As such, the works I gravitate toward are not monodirectional critiques of this activity nor do they, by my reading, present as politically ambivalent: neither the works nor this theory would commend or denounce the activity of prosumerism

as either good or bad. Rather, the works and theory better situate prosumerism as complex, opaque, and value-producing; as the manifestation of the particular economic philosophies residing over it; but also as an activity that might be exploitative and liberating at different parts of its process, depending on treatment, form, and on the prosumer's sense of or relation to power.

Prosumerism, as a new model of production trading on human attention, has created a rich field for social, economic, and political analysis. However, for this art historian and critic, the nuances and appeals of continuous image consumption-production-consumption can be contextualized through at least fifty years of artists' works. Artists have long scrutinized media's appeals to and manipulation of the viewer through a variety of media, creating for the viewer immersive, distracting, or awareness-raising works, or rendering an individual's subjective responses to images from an alternative perspective point. Something that I will return to look at, later in this analysis, is how contemporary art can throw into relief the immersed viewer, choreographing a proximity to images that social media users regularly seek, and ruminating on a more commonly perceived sense of distance that often results from this form of encounter.

Nomenclature

Performing Image refers to how intensifying pressures to take and circulate images, to perform online as in the round as one's imaged or imagined self, activity mediated and monetized by social media, have been anticipated by, and coincide with, a number of art works where performance and moving images are convergent or contingent upon one another. Like the "prosumer," Performing Image is a portmanteau of two visual art mediums: performance and moving image. Both of these terms, not coincidentally, arrived in contemporary art's critical lexicon during the last century, although exact dates are disputed.

Performance has been staged or rendered within the context of visual art for the most part of the twentieth century, marked in the first and second decades in paintings of performances of the touring *Ballet Russes*, followed by *tableaux vivants* staged by Surrealist, Dada, and Bauhaus artists in a European tradition, surreal critical encounters influencing early Fluxus works, and the New York Happenings of the mid-1950s. According to

Claire Bishop, early performance "took place in the actual space-time of the viewer, and these contingencies of location and audience were often factored into the work."[13] There was a conscious breaking down of the theatrical forth wall, "either to dissolve the space between viewer and performer, or, conversely, to expose this division as essential to theater's ontology." During this period, artists like choreographer Merce Cunningham and composer John Cage established performance as an autonomous, albeit heterogeneous, medium that might include elements of sound, dance, found object, text, and task-based activity. Performance was not only defined by its presence before the audience, but also by nuanced absence. Rauschenberg's *Erased De Kooning Drawing* (1953), rendered and donated by the elder, renowned artist as requested by the ambitious youngster only to be rubbed out and labeled accordingly, is arguably a seminal performance, which rests largely in the imagination of the viewer, and the question: "Where is the work?"

Performance, as it equates to any worker's productivity or efficiency, became the subject for artistic critique from the late 1950s, culminating in the influential "Situationist Manifesto" (1960) on the necessary change to labor conditions in the context of the French proletariat, succeeded by self-analysis of the artists' own conditions of production in what became known as "post-studio" practice from the 1960s in both the US and Europe. Coinciding with Althussers's "Ideology and Ideological State Apparatuses," (1969–1970) artists questioned their own role under the ideological apparatus of the state, and performance became a mode of confronting that. Among other objectives, artists working in performance have forged space to present a critique of the Spectacle, or capitalism, by establishing alternative spectacles and viewing conditions to broadcast media and, in various ways, alerting viewers to their own inherent role in the production and reproduction of political ideologies.

The "performative" is an adjective commonly used to describe art, an artist or an aspect of art that is theatrical, dramatic, or otherwise engaged in performance; however, in this theory the term "performativity" will be used as it was in the linguistic theory by J. L. Austin in 1962, where some aspects of language had a performative outcome. This term was adapted by Judith Butler in 1990 into a Foucauldian, anti-essentialist critique of fixed identity categories that sustain "masculine hegemony and heterosexist power."[14] In this way, gender, in Butler's example, "is the repeated

stylization of the body, a set of repeated acts within a highly rigid regulatory frame that congeal over time to produce the appearance of a substance, of a natural sort of being."[15] Performativity, in theories by Derrida and Butler, was a product that "showed itself to be a property of language or discourse much more broadly."[16] Performativity is the way in which human practices are recognized as performed or enacted *a priori*, where individual bodies assimilate and produce socially inscribed norms. Thus, performance, as any loosely framed event in the context or environs of visual art, has been sought as a critical space to trouble the ideological systems that inscribe social behaviors.

Performativity has long been held as a language, where linguistic elements such as actions, behaviors, gestures, or assemblies are not only the output of an individual, but the ideologically constructed repertoire or vernacular through which that individual's identity is produced and reproduced by dominant ideology. Normative imagery generated by conventional Western mass media, the imagery that is supposedly produced for us, of us, imagery that is gendered and gendering, racialized and racializing, sexualized and sexualizing, is such a language. It is fixed and reductive but is also constitutive of us, and this aspect—performativity's productive retroactivity—will often contribute to the sensation of how well we, as embodied subjects, feel represented. Performing Image is to the performativity of normative imagery (or image performativity), what performance (as a loosely framed event) has historically presented to the productive continuity of performativity. Performing Image proposes a critical set of practices where the socially and politically inscribed desire to perform images is rendered, performed, or projected in order to question, trouble, or highlight those same ideological systems that govern and produce them. For it to be effective, performance needs to reproduce with another critical, lens-based, media-responsive medium: moving image.

Moving image, the second half of this compound nomenclature, is another expansive medium that creeps across several creative fields and recent periods. The term "moving image" encompasses works across film, video, photography, installation, and digital environments. But it is more widely used in Europe than the US, having been promoted from the early 2000s by the British artists' film distribution agency LUX, to denote the broad scope of artists' film and video beyond specific references to their material support or distribution networks. (LUX is an organization

established in 2002, to merge the efforts and archives of the London Film-
makers Co-operative, London Video Arts, and Lux Centre.) Moving image
has come to prominence since the widespread digitization of artists' films
and videos, where neither apparatus nor reel were solely necessary for pro-
duction, distribution, or circulation. With a clear distinction between the
terms "circulation" and "distribution" Erika Balsom, writes: "distribution
designates the infrastructures (whether formal or informal) that make work
available to be seen, and circulation designates the trajectory particular
works can take through one or more distribution models."[17] Circulation
is the way of the image, rather than the infrastructure through which it
passes. Her understanding of the distinction between the terms distribu-
tion and circulation departs from that of Henry Jenkins, Sam Ford, and
Joshua Green, who propose: "*distribution* should be preserved for top-down
dissemination, leaving *circulation* to designate the peer-to-peer sharing of
media by consumers."[18]

In terms of art history, the moving image is a term that succeeds
"Expanded Cinema," as associated with artist Stan VanDerBeek in the US
in the mid-1960s and the corresponding, overlapping "Filmaktion" in the
UK, which both encompassed more expansive multi-screened, peopled
installations than traditional screening spaces and film distribution chan-
nels allowed, and which have largely attempted to to striate spectators'
perceptions within immersive viewing architectures. Unlike Expanded Cin-
ema, Performing Image is chiefly concerned with how artists articulate the
performativity of images, how image performances are inscribed by mass
media (as a conduit for state ideology), and how that facet is put to work
within a digital economy (under neoliberal ideology).

The term moving image is not uniformly used by Western art and film
historians. Balsom has recently summarized that while: "*experimental film*
has remained strong in some cases (particularly in the United States), much
of the work encompassed by this heading is now made on video. Mean-
while, the adoption of large-scale projection from circa 1990 onward led
to the waning of the category of video art and its merging with artists'
film, giving rise to now-common labels such as 'artists' moving image', 'art-
ists' cinema' and 'moving image art', all of which avoid specific reference
to a particular material support." Artists' moving image, Balsom writes,
"show[s] signs of breaking ground in North America: in 2015 the Walker Art
Center in Minneapolis changed the name of its film and video department

to Moving Image, noting 'a commitment to contemporary artists' moving image practice.'"[19]

While the usage of moving image is not universal, it has been applied historically across discipline. One French translation of the term, *images mouvantes*, appears in early film theories of the cinematic imaginary.[20] During the period of French Impressionist cinema there was a multidisciplinary investigation by critics and directors into the perceptual phenomenon of *photogénie*, an illusive and extra-linguistic quality of a cinematic image's allure. "It seems," wrote film critic and director Jean Tedesco, "that moving images have been specially invented to allow us to visualize our dreams."[21] Tedesco was managing director of the Théâtre du Vieux-Colombier in Paris between 1925 and 1935, where he had regularly curated screenings that included excerpts from mainstream Hollywood films, alongside examples of avant-garde and independent films cut, ordered, and projected for audiences under specific topics, with the primary aim (aligning with the Russian avant-garde cinema and theater) of creating for the audience particular affective and consciousness-raising experiences. His editing often disregarded his excerpts' original narrative context, montaged together in self-serving, gonzo style. A century on, moving image still functions on a technical level (as images in motion), but also at the level of perception (affective images cut to move audiences). And, just as Tedesco gathered and cut as he saw fit, this is a term that accommodates all sorts of "movies," irrespective of their chosen formats, lengths, screening architectures, and pivotal economies.

The indiscriminateness of this term is not unproblematic. Balsom objects to the term moving image in her project historicizing the methods, infrastructures, and nuances of film distribution, as precedents for how works now circulate online. To project this "catchall" term, anachronistically through many decades of artists film and video, risks the "violent leveling of heterogeneous institutional contexts that must be understood historically to be understood at all."[22] While some attention to the economies of particular works features within this critical undertaking, the primary goal of this work is to create a speculative category for analysis across a range of diverse and singular works that render, dramatize, or antagonize the proactive viewer assimilating images through various generations of media, each from different subject positions. There is a complex heterogeneity of institutional support systems buttressing these works that have been diversely

received, supported, and exposed over the last fifty years; and while I allude to these differences within the work from my own specific vantage point, there's a necessary, if self-conscious, abandonment of art historical method-ologies in order to consider their efforts in concert, and pitch them within a broader cultural context.

Moving image is useful here as a classification for works that include and extend beyond artists' cinema, film, or video to incorporate various uses of digital technology and the Internet to acquire found footage, as well as software for filmmaking, sound recording, editing, and screening. It equally includes works that very loosely or tentatively use still, projected, or multiple images in tandem with other media, installation armatures, and performance practices. Moving image is a laterally expansive and broad term that suits this project, straying into performance during many periods of intense cross-disciplinary experimentation.

Performance and moving image have long used their frame to stage the pressures that social norms (and normative media images) exert upon indi-viduals. Intense periods of experimentation in performance and moving image often coincide with periods where mass media becomes a discern-able monopoly and exerts tangible and untenable stresses on those who encounter it. Thus, new waves of experimental filmmaking and perfor-mance scrutinized the effects of live television broadcast during the late 1960s and early 1970s; in the 1980s, a number of artists used DIY technolo-gies to see how the image was invading the body through the outsourcing of TV stars in home video and reality television; from the late 1980s and early 1990s, several artists looked at how the Internet, virtual reality, and arcade gaming were influencing the performance and politics of identity; and since 2000, works in moving image and performance have alighted on the bright and dark sides of social media and prosumerism. This compound term, Performing Image, highlights the junction of performance and mov-ing image as a critical fissure where artists respond to the pressures of living under the image, as a form of critical redress in an economy driven by those motivated by affective, moving images. Performing Image articulates—names—a significant critical space or event where art may seek to render, approximate, or redress a more generalized social condition emerging from technology capitalism, as evident within Western prosumer culture, of per-forming images, and trouble the singularity, fixity, and recursiveness of the performative imagery that underlies it.

Medium Specificity and Histories of Intermedia

Performing Image follows multiple efforts in theorizing a critical inter-
section of media, disturbing Clement Greenberg's insistence on the sin-
gularity of Modernist masters' focus on "the limitations that constitute
the medium of painting."[23] Specific to painting, Greenberg wrote, "flat-
ness was the only condition painting shared with no other art, Modernist
painting oriented itself to flatness as it did to nothing else." This singu-
larity was complicated significantly by film and video, and performance,
which defied Greenbergian analysis by inhabiting multiple simultaneous
planes, the celluloid reel, the filmic apparatus, the performing subject
or live event toward which it points, the projected image, the light that
throws it, the screening plane, the proscenium stage, and the audience
before it. Its material supports are multipart, a splintering that also created
an unassailable split in art criticism.

As I will go on to look at in greater detail, the early "intermedia rela-
tions" of Robert Rauschenberg's Combines provide an interesting starting
point, concerned as they were, as I see it, about image traffic, how images
pass from one's natural and mediated environs to bear their weight, density,
and volume upon one's person. In creating armatures to host objects and
images of objects, armatures performers could actually *get inside*, Raush-
enberg was both anticipating the infrastructures and the allures—that is,
the complex—of online prosumerism, decades before it came into being.
Importantly, his combinations externalized the internal or psychic contact
between people and images.

After Greenberg's essentialism, artist and critic Dick Higgins proposed
"intermedia." It was, "no accident" he wrote in 1966, that the best work
of the day "seems to fall between media" given the politically chaotic situ-
ation of New York on the brink of economic collapse. Found objects like
Duchamps's *Fountain*, in contrast to the collectors' playthings of modern-
ist painting, retained potency by being locatable between "art media and
life media," a trope that evolved into combines, environments, and sub-
sequently happenings.[24] Higgins coined his own theatrical happenings
as intermedia, "an uncharted land that lies between collage, music and
the theater." And this typified the arts in the late 1960s "since continu-
ity rather than categorization is the new mentality."[25] Intermedia departed
from Greenbergian medium singularly and segued into what Peter Osborne

has recently called generic modernism, "an *affirmation* of the enunciative logic of individual claims in the name of 'art.'"[26] Jonah Westerman recently updated Higgins's term with his "inframedium," where distinction between art and life is perceptible through an infra-thin layer, encouraging us "to imagine performance less as a thing in itself (whether located in an action or its traces) and more as a spatial situation, as a mobile and profoundly indistinct dividing line that joins form to experience and, by virtue of its specific siting in a given work, describes the location and composition of each."[27]

A distinct critical response to multiplane, or "aggregated," media was Rosalind Krauss's proposition of the real medium of film and video as "a psychological situation."[28] Krauss attempted to maintain a Greenbergian framework that rewarded reflexivity between form and content, or a movement of *dédoublement*.[29] Krauss applied this framework to a specific selection of video work from the early 1970s where the artist's body was a central focal point, either prerecorded or else performed and projected live, the body seen on stage and shown on monitors within a feedback loop, trifurcating the cinematic binaries between subject and object, director and actor, self and projected self.

In works by Vito Acconci and Lynda Benglis, among others, Krauss saw the inhabiting of an "image of self-regard,"[30] representing a form of clinical narcissism. Narcissistic works, she proposed, presented no "capacity for transference" [Freud] and in the constant projection of self-image, an "unchanging condition of perpetual frustration."[31] In order to overcome narcissism, a patient, like Krauss's artist, must distinguish "between his lived subjectivity and the fantasy projections of himself as object."[32] As I endeavour to show through works, Krauss's grounds for analysis is fundamentally destabilized when revised in the present, because any artist rendering a constant play of self-projection, a "psychological condition of the self split and doubled by the mirror-reflection of synchronous feedback"[33] shows the key condition of participation within a digital economy, which is, arguably, difficult, near impossible, to overcome. Krauss's subject is no longer bracketed between camera and monitor: she advances equally in both the physical and online present.

Krauss's narcissist is not the incurable subject who casts out and is toed along by her projected self, but any subject living and working under the image, acting against the threat of social erasure. But Krauss's "psychological

condition" is a term to preserve. Krauss's original fixed position, from which *dédoublement* was judged, becomes untenable in a social sphere where one's online identity is a constant mode of performance, when an online persona is the *necessary* extension of an unfixed self.[34] Now that film and video might be seen as synonymous with (and certainly tools for) the widespread occupation of projecting self, their real medium understood as a (collective) psychological situation presents less the basis for critical castigation, than critical value.

Works evaluated in the coming chapters span several art historical generations and expose, from different subject positions, how various constituencies use and are used, produce and are produced by the technologies that promise to enable them. Artists' various protagonists, either performed themselves or by casts, ensembles, dancers, or collaborators, are not vacant intermediaries, but affected subjects, speaking from that bodily matter through which images pass. This writing is similarly produced from a body that has experienced a proximity to people through images by way of prosumerism, which has encountered works in contemporary art that mediate upon these exchanges, and which has subsequently encountered documentation or response to these works contributed by prosumers.

Works of Performing Image are reflexive, not toward a singularity or limitation of medium (as per Greenberg), but toward and against the interdependence or mutual contingency of moving image and performance in a digitally networked society. They regard how the construction of a subject is closely coupled with online productivity, and how this productivity is performative. Thus, reflexivity reaches beyond the singularities and specificities of these two interrelated mediums (if they could ever be said to exist as singularities), extending their aim toward media-activated Western prosumers.

When considering art in relation to capital, critical discourse is regularly drawn to its market, and the museums it furnishes (or vice versa). And while assessing that the art market as a financial index is not only symptomatic of a rapidly developing, precarious field of production, but also a by-product of deregulated capital's constant search for more capital, is a vital critical task, it is not ultimately the primary goal here. This is a study of image as capital in more diffused territory than the art market, where included works might reflect on the activity whereby prosumers create surplus value, rather

than critique art as a particular asset class.[35] This is a very conscious effort to think and situate the research, as well as the theortical wager, beyond immediate considerations of the art market, museum studies, and the art of digital culture, although inevitably works included in this writing have great symbolic relevance to these research fields.

The "kind of prosumerism" evidenced by Mark Leckey, and the artists who precede and succeed him, are often considered among the category of Post-Internet art, that is, art produced within or responsive to what is broadly referred to as digital culture. According to artist Artie Vierkant, "Post-Internet Art" was coined by artist Marisa Olson and developed by writer Gene McHugh in the critical blog "Post Internet" during its activity between December 2009 and September 2010. Under McHugh's definition it concerns "art responding to [a condition] described as 'Post Internet'— when the Internet is less a novelty and more a banality. Perhaps ... closer to what Guthrie Lonergan described as 'Internet Aware'—or when the photo of the art object is more widely dispersed [and] viewed than the object itself."[36]

Post-Internet follows many intersections of art and technology, from Cybernetic art from the 1960s with artists interested in playing with visual and sonic feedback loops, shared circuits, and concepts of cyborgs; to the Generative Systems art of the 1970s which adopted computational or algorithmic logic to structure compositions; and Net art (or net.art), which was established by a group of artists from the early 1990s, considering the Internet as an autonomous medium, locus, and system that could challenge mass media and associated cultural and political institutions. One artist associated with net.art Mark Amerika, wrote an *Avant-Pop Manifesto* in 1993 that "acknowledge[s] the need to develop more open-minded strategies that will allow [artists] to attract attention within the popularized forms of representation that fill up the contemporary Mediascape."[37] Amerika wrote for and to "Mutant Fictioneers," artist-writer-programmers, creating and expanding niche communities online, aiming to make works while eliminating managerial middlemen and blasting the art establishment. Net.art marked itself out as concertedly anti-art establishment, a divide that has since been maintained by a number of critics and scholars, including Edward Shanken, who more recently diagnosed that while New Media Art (NMA) lacks art historical knowledge, Mainstream Contemporary

Art (MCA) lacks a deep understanding of "the scientific and technological mechanisms of new media, the critical discourses that theorize their implications, and the interdisciplinary artistic practices that are co-extensive with them."[38]

The effort here is to create an alternative framework for the analysis of artists' works responding to cultural changes brought about by new mass (social) media and to encourage a consideration of contemporary art and its precedents within a broader field of attention, at the intersection of identity politics and digital economics. As distinct from these NMA and Post-Internet lineages, the works that populate this theory do not necessarily share visual or technical qualities associated with the Internet, coding or digital technologies, nor do they maintain a uniformly oppositional stance toward the "art establishment" (Amerika), or the "art world" (Danto/Shanken). Instead they retain an ambiguous relation to both, either benefitting from the art world/establishment openly, or neglected by it entirely. Some are works that contain within them open and willing contradiction in perhaps the same way a prosumer does, aware of the system of exploitation on which its neoliberal model is built while also seeking to participate in this form of communication, participation, profit and pleasure-seeking.

This theory would depart from those that stress the Internet as a medium or locus distinct from any three-dimensional lived space, whether architectural, social, or political. I am wary of hasty distinctions between "real" and "virtual" spaces within the analysis given how, so clearly, social forums online and off are coexistent and coproductive. Equally, the "eyeballs" to which Internet marketers so stridently appeal veer between domains, and are often dually targeted by artists who want to show their work on prosumer and personalized websites and on specialist online curatorial platforms, as well as in privately and publicly funded galleries, often in tandem. Western exhibition spaces (indeed Western institutions of all kinds) are often the product of ideological conflict, extolling left-wing egalitarianism on platforms built from the loot of neoliberalism, colonialism, and other forms of social segregation. While tending to the particularities, toxicities, and contradictions of specific public spaces and institutions when and where possible, this book carries the tacit hypothesis that, despite their flaws, many museums and galleries offer temporary spaces in which to rehearse and perform new modes of being, unique

spaces for visual thinking, amidst otherwise pervasive economies of attention.

There are many practical, as well as conceptual, reasons why contemporary artists are working across media, including, significantly: lack of studio space and storage in Western metropolitan centers due to exorbitant rents; pressures to exhibit internationally exerted by a still-sprouting international biennial circuit and corresponding circuits of international fairs; and international-residency-nomadism not disconnected to these circuits and depleting institutional and public support. Artists need to be able to compress their work into performances, events, and digital files because objects-as-work cost money to show, ship, and store, and because there is a demand for compressible or transportable work: institutions program performance, screening events, and festivals as a way of attracting visitor numbers. Working across disciplines is a conceptual methodology, but it is also a professional strategy in flexible, precarious post-Fordist work conditions. In Performing Image, these aspects often come together, sometimes explicitly and sometimes within the "psychological situation" of prosumerism, tied as it is to the financial situation of precarious work.

Meta-Media and Information Behaviors

Performing Image does not propose a singular new medium. Beyond modernity's media-specificity and its analysis, the digitization and digital postproduction, storage, and circulation significantly affect classifications of medium. When film and video, digital images, or other forms of documentation pass through various recording software to be edited, shown, or circulated online, medium-specificity becomes impossible: smart technology, as host to software and platform applications, encodes and envelops others as a ubiquitous medium of personal expression. Alan Kay and Adele Goldberg anticipated this blanketing of different media through computation with their concept of a "meta-medium" in 1977. They conceived the Dynabook, a prototype for a computational tablet as a "dynamic medium for creative thought."[39] They set out his ambition for the tablet as a place where any creative output could find form, signaling (at least in ambition) a new proximity between computational power and the human imaginary. Now, we might consider not simply the tablet or smartphone alone as a "meta-medium," but one installed and connected by a platform like

Facebook, which acts, in their terms, like "a medium itself, [that] can be *all other media* if the embedding and viewing methods are sufficiently well provided." Like the Dynabook, it has the capacity for simulation but also expression.

Lev Manovich recently proposed software as a paradigm to understand the "active role that technology plays in cultural communication."[40] He outlines the specificities and impact of software design in culture and identifies "information behavior" as "particular tactics adopted by an individual or a group to survive in information society." The project imagines how a combination of performance and moving image can reflect the experience of communicating, consuming, and producing information on social media, indicating how the physiological impact of images has evolved into an industry, and how in turn that industry capitalizes and exacerbates that sense impression. As such, the combinations within Performing Image have the capacity to double back upon meta-software, dramatizing the embodied experience and "psychological situation" of it with a certain historical, material, and perspectival remove.

The works I will look at are conscious of the platforms that host and structure visual information, but are also concerned with affect, a desire for images that draws us there. Beyond reproducing the aesthetic of various host platforms and reenacting the forms of work and play that take place there, through a variety of means works included probe prosumerism as a mode of viewing, exchange, and production with a greater flexibility than scholarly analysis alone. In this sense, I hope this analysis can escape what Manovich sees as a danger of privileging "cognitive dimensions of culture without providing any obvious way to think about affect. ..."[41]

Images affect us differently; in thinking about the effect of computation on culture and behavior, as well as the particularities of affect, we also need to better understand the politics of representational systems that moderate, preempt, and abut them. Through the course of the writing, I will look at various artists' appropriation of DIY technologies in the face of representational bodies, including elected offices, mass media, and cultural institutions. Social media affects and appeals to individuals, communities, and constituencies differently: it also risks being as exploitative and exclusive as its previous version. It is important to underline that the works selected don't necessarily share clear art historical, established lineages—some have rarely been associated before. Some works may seem antagonistic when gathered in the present. Mediated images have acted as

a conduit first for state ideology, and subsequently for neoliberal ideology, languages that have reduced, neglected, and divided political subjects. This theory includes works by artists operating from different subject positions to mediated images, which is toward power; and the hope for this account is to set forth, in Miwon Kwon's words, a "disjunctive yet continuous intellectual horizon" on the value-producing agents and mechanisms of new, visual economies.[42]

2 Registering as Image

From Pictures to Images

Performing Image begins to gather muster in the closing third of the twentieth century. In 1967, Debord claims, "the social relationship between people ... is mediated by images," a situation where the spectator is the agent of production, where image-mediated social relationships are produced by and productive of advanced capitalism, and where all that was once lived has "become mere representation." The spectacle communicates *visually* but is also blinding; Debord wrote, it must "elevate the human sense of sight to the special place once occupied by touch; the most abstract of the senses, and the most easily deceived, sight is naturally the most readily adaptable to present day society's generalized abstraction."[1] By mobilizing the visual field, post-industrial capitalism expanded to a dominant state of alertness. It began to value attention, that is, to make looking pay.

Debord's theory, which followed on from the Situationist manifesto of the previous decades, preempts student and worker demonstrations in Paris in 1968, coinciding with some of the most significant examples of mass protest in modern history, from Paris, Madrid, London, Prague, Chicago, and Mexico City, among others. "There has never been a year like 1968, and it is unlikely there will ever be again," writes Mark Kurlansky.[2] However global the civic uprisings, they were not part of a universal resistance movement; the riots in Chicago in April, for example, followed the shooting of Martin Luther King, whereas the student and civilian uprising in Mexico City of October was part of distinct, long-term civic dissatisfaction with the PRI.

While the causes of mass protest were different, one catalyst or link between them was technical changes within the media, which had

transformed the reach and capacity of global nightly news reports. From the late 1960s, videotape replaced film as cheap and reusable, facilitating same-day broadcast. According to Sean O'Hagan: "Student protesters in Berkeley and Columbia cheered their TV sets as footage from the Paris barricades made the American news in May, while French students took heart from images of the huge anti-war demonstrations now occurring across Europe and America."[3] The Vietnam War (1955–1975) was the first war beamed into the living rooms of America. Dominic Sandbrook writes: "In the Sixties, television turned up the intensity of what was going on in the world. … We had all seen war footage but this was the first time we had seen it almost as it happened. People had a sense of the sheer disproportionate force involved. The carpet-bombing, the Napalm, the scale of the American operation shocked viewers and then angered them. Vietnam was the first TV war, and, as a direct result of that, it spawned the first global anti-war movement."[4]

In a US context, demonstrations in Paris loosely coincided with what Harvey terms the "open crisis" of Fordism-Keynesianism,[5] the assassination of multiple public figures, the war in Vietnam, protesters at Kent State University, and Nixon's invasion of Cambodia. This crisis witnessed the beginning of international finance's deregulation as the US currency abandoned the international gold standard in 1971, with the OPEC oil crisis emerging the following year. It saw Watergate and Nixon's resignation in 1974, and the US's withdrawal from Vietnam in 1975. Economic turmoil of this period saw the beginnings of North America's submission to neoliberalism.[6] Same day and (subsequently) live broadcast brought pictures of atrocities and deception, as well as civic uprising, into people's homes. Turbulent times were not new to the US, but what was new was the fact that they were newly proximate, as domestic living rooms became a formative screening space, instilling fear, doubt, and uncertainty among viewers and brokering new relationships between the subject and state.

Performing Image configures itself during this period of turbulent connectivity, as recording technologies facilitated same-day broadcast, while versions of those same technologies were being released onto the Western domestic market. Sony's Portapak, for example, was made widely available from 1967. This gave a new politically conscious television-viewing public access to similar recording equipment that was connecting them to the

world. Television audiences were now image-makers too, capable of a form of feeding back, if not through established media channels, then through alternative modes of showing and peer-to-peer sharing. It marks a new period of experimentation by those of relatively modest means, to explore the technical and visual methods of image production, manipulation, and presentation on mainstream media. Video's instant playback could test out how aspects of identity are not just consumed but also produced. Both the media's capacity to feed live images to us, and the individual's newly acquired capacity to subvert or take back this power through video, had a wide impact on the kind of artists working across media concerned by what aspects of the self was seen, or inversely, what wasn't.

* * * * *

This is also a period that marks a transition from a pictures generation to an images generation. In the 1970s, "Pictures" became the moniker for a generation of artists making work about the importance of media pictures that represented and increasingly constituted reality. "Pictures" was the title of an exhibition of works in New York's Artists Space in 1977, by artists Troy Brauntuch, Jack Goldstein, Sherrie Levine, Robert Longo, and Philip Smith, curated by Douglas Crimp, who set out to explore how new editing, rotoscoping, and picture-boarding techniques used in television and cinema were impacting the viewer. Crimp wrote: "While it once seem[ed] that pictures had the function of interpreting reality, it now seems that they have usurped it. It therefore becomes imperative to understand the picture itself, not in order to uncover a lost reality, but to determine how a picture becomes a signifying structure of its own accord."[7] Decades prior to the marketization of digital cameras, the instant playback loops of video allowed artists progress from the Picture generation's explorations of what it was to receive pictures, to probe, penetrate and perform the body or subject's co-productive relationship with the image, and the value-producing, identity-shaping and perception-shifting consequences of each encounter.

During this decade in New York, a recession created a dip in the art market, alleviating pressures for artists to produce objects as commodities, and freeing up or vacating real estate in which formal and informal experiments could take place. A number of influential spaces were established during this period, including 112 Greene Street and the Kitchen (1971), P.S. 1 and

Artists Space (1972), Creative Time (1973), and Franklin Furnace (1976). Artists congregated to experiment, collaborate, and present work across disciplines in informal, ad hoc, nonprofit spaces.

RoseLee Goldberg described the 1970s as a political coming-of-age, where performance moved on from being "an irritant" to a medium widely accepted among academics, curators, and critics. She calls the 1970s: "the Golden Years of performance ... when the medium grew from an array of eccentric gestures—variously called body art or living art or *art aktuell*—aimed at unsettling the art establishment to a fully accepted art form with its own written history, magazines, and critics."[8] Experiments and advances in performance coincide with those in film and video, and run parallel to this great change in broadcast media. Herbert Molderings observed that, just as abstract painting corresponded with the emergence of narrative film—or the movies—around 1910, "similarly performance art and video experiments [during this period] are a response to an even deeper disruption caused by television today."[9]

The image generation that emerged in the 1970s was not only interested in how pictures were presented in and by the media, but in how images were to impose themselves upon the viewer's body, to bear weight, density, and volume, to influence movement, behavior, and comportment, and affect states of mind. As such, the body is regularly presented in works by artists concerned with the continuous consumption of media imagery, whether that body is depicted, framed, staged, projected, mirrored, or inferred, often reflecting back upon the viewer, made self-conscious as otherwise, heretofore, the immersed viewer. Before looking at some key works of this period, I want to consider and contextualize the convergence of performance and moving image neither through early seminal pieces of experimental film, nor through Happenings or action art (often seen as the forerunners to the "Golden Years" of performance) but through the early Combines of Rauschenberg in the 1950s, noting how they began to externalize the dual and intersecting processes of image consumption and production, presenting and reorienting these processes through experimental combinations of media.

Contact: Robert Rauschenberg's Combine Paintings

"What interests me is a *contact*: it is not to express a message," said Robert Rauschenberg in an interview with André Parinuad in 1961.[10] An artist

who had trained with the Black Mountain College from the late 1940s and often made work from scavenging, arranging, and coloring detritus and found ephemera before gumming them to the surface of various armatures, Rauschenberg's pieces presented, if anything, a series of sustained and exuberant pauses within circuits of imagery consumption and production, accelerated at the dawn of a new broadcast era. In the same interview, he said, "I would like to make a painting creating a situation which leaves as much of place for the viewer as for the artist."[11] While "contact," in this sense, would imply Rauschenberg's interest with the viewer's subjective encounter with the work, throughout his oeuvre there's an overt and sustained investigation across media of how visual material makes contact with him, manifesting as affective inquiries into how imagery impacts his senses, comportment, and movement. And while Rauschenberg's works seem little interested in eliciting the identical subjective responses to material in the viewers, neither are these two forms of contact necessarily mutually exclusive.

While Jasper Johns, Rauschenberg's peer, lover, and long-term interlocutor, concentrated on troubling the distinction between image and object in a viewer's perception with his American flag paintings of the 1950s, Rauschenberg's work of the same period traces how an image might proceed or pass through the human body. Early on, reference to the body was to be both figurative, with his *Untitled (Double Rauschenberg)* (made collaboratively with then spouse Susan Weil) of 1950, and more suggestive, as with his *Erased De Kooning Drawing* (1954), where the body (his and De Kooning's) was present primarily in the imagination of the viewer.

Rauschenberg remained interested in the movement and implication of images in circulation. After an exhibition of the artist's work in the Charles Egan Gallery in 1954, as prompted by the dancer Carolyn Brown, Merce Cunningham commissioned Rauschenberg to design a set and costumes for his new dance *Minutiae*, stipulating that the dancers should be able to "move through" the piece, and what resulted was, as Brown describes, "an easily dismantled three-paneled screen that stood on its own legs." Rauschenberg had made for Cunningham a freestanding screen, with highly colored and patterned fabrics layered upon found objects, such as a toothbrush, a J-cloth (i.e., a cloth used for household cleaning), newspapers, and comic book pages, all mounted and supported by assorted legs, and stanchioned to the front by a smaller, similarly furbished second screen. A round mirror was attached to the front screen inserted just below chest height. Helen

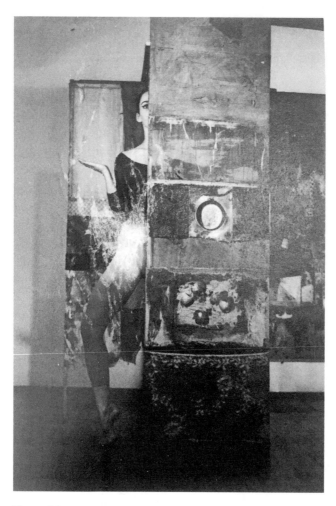

Figure 2.1
Carolyn Brown, dancer in the Merce Cunningham Dance Company, with Rauchenberg's *Minutiae* (1954). Mid-1950s. Gelatin Silver Print, 5×7 in. (12.7×17.8 cm.). Photographer unknown. Jerome Robins Dance Division, New York Public Library, Astor, Lenox, and Tilden Foundations.

Molesworth describes this curio as: "somewhere between a screen and a hallway, it is an object that dancers could either glide through or hide behind." P. W. Manchester described it, referring also to the lens-like mirror, as "a bit like a photograph yourself kiosk,"[12] a structural ellipses within a space through which performers were to pass through. It's significant to the later analysis that what Rauschenberg was presenting was a structure for images into which viewers were encouraged, perceptually and physically, to get inside.

Cunningham's invitation influenced Rauschenberg's later works. Rauschenberg made *Untitled (Man with White Shoes)* the same year, an early Combine with two cases stacked upright and opened at converse sides, their exteriors embossed with press clippings, postcards, family photographs, and other personal mementos, retouched and weighted with paint in his own inimitable style. Inside the bottom unit was a stuffed chicken, with a pair of white shoes in its upper, conversely positioned counterpart, visible from the other side. Like *Minutiae*, and other Combines that come after (like the *Monogram*, 1955), there's no one perspectival point from which to view this work. It's a "moving image" work, not because of its relation to film or video, but rather in how its position denies its viewer's stasis. We must move around it, but as we do, the heterogeneity of images and the process of their assimilation, which we might experience on any given day, are exteriorized upon Rauschenberg's angular image scaffolds. Writing in 1974 about these works, Krauss questioned how two visual "fields," of the picture and the memory, might provocatively coalesce within a work while simultaneously rejecting the transcendental spaces of Rauschenberg's modernist precedents:[13]

... it is exactly the notion of memory, or of any other private experience which paintings might have formerly expressed, that is redefined by these pictures. The field of memory itself is changed from something that is internal to something that is external; from something that is private to something that is collective insofar as it arises from the shared communality of culture. The is not culture with a capital C but rather a profusion of facts, some exalted but most banal, each of which leaves its imprint as it burrows into and forms experience.[14]

Rauschenberg, Krauss asserted, was capable of rendering the field of memory as it brimmed with images. Rauschenberg's work represented "the stuff of experience—the things one bumps into as one moves through the world—that forms experience."[15] Rauschenberg's Combines present an

externalization of the psychic space of images, armatures on which societ-
ies' images are dumped, an interrupted profusion of facts, some exalted,
most banal. "By being absorbed into his world," Krauss wrote, "by being
'delayed' there as an incorporated part of his experience, the objects them-
selves are registered as images."[16] This work exists as a similar perforation
and exposition of the circuit of loop of images that we are in, as Mark Leck-
ey's *Cinema in the Round*. And while the work does not necessarily intend
to yield the same subjective response from its viewers to individual visual
components (he was not concerned by the "message"), what it achieves
is a pause or delay in the incorporation of images—the process by which
images make contact.

The perceptual impact of information circulation appears from his very
early works, long anticipating Experiments in Art and Technology (E.A.T),
which he co-founded in 1967, a collaborative performance and exhibi-
tion platform for artists working with engineers. In *Broadcast* (1959), the
artist concealed three radio transmitters behind a canvas, with only the
frequency and volume knobs visible to the viewer at the composition's
center right. With a more muted palette than his Red Paintings, the can-
vas is adorned with household ephemera (a comb) and layers of fabric,
newspaper (a cropped headline that reads "HELP!"), and photographic
reproductions (images of athletes competing and horses racing) below
steeped wide monochrome brushstrokes. The piece was recomposed several
times so that, in the end, the visual components did not overwhelm the
more abstract sonic element of three simultaneously retuned (and there-
fore inaudible) radios. In this work, image and sound were in cahoots, just
as sound was being synched with image in television broadcast, and this
work seems concerned with the perceptual ramifications of this, reflecting
how aggressively the domestication of television vied for the householder's
attention.[17]

Black Market (1961) abandoned *Broadcast*'s technical elements and
instead implemented the viewer as producer, an early open sourcing of
an elementary composition that somewhat anticipates prosumerism's
consumption-production-consumption mode. The piece has two elements,
a wall-mounted canvas assemblage connecting to a wooden suitcase on
the floor by a piece of rope. The suitcase originally contained a flashlight,
a photograph, a handkerchief, and a barnacle-covered lightbulb, along
with pencils, a rubber stamp, inkpad, and typed instructions in a variety

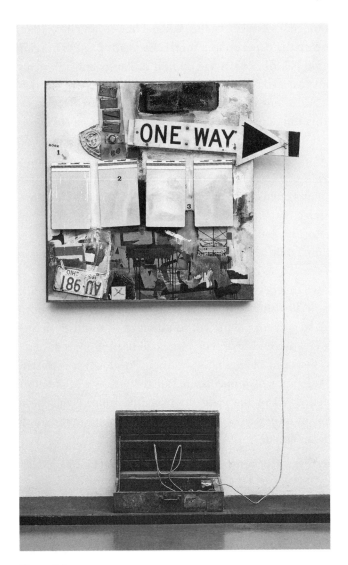

Figure 2.2
Robert Rauschenberg, *Black Market* (1961). Oil, watercolor, pencil, paper, fabric, newspaper, printed paper, printed reproductions, wood, metal, tine, street sign, license plate, and four metal clipboards on canvas, with rope, chain, and wood suitcase containing rubber stamp, ink pad, and typed instructions regarding variable objects given and taken by viewers, 49 × 59 in. (124.5 × 149.9 cm.). Museum Ludwig Cologne. Copyright Robert Rauschenberg Foundation.

of languages, encouraging viewers to trade personal objects and index (and sign) the exchanges on the paper on four metal clipboards fixed to the canvas. The canvas itself is a riot of signage, typical of Rauschenberg's richly colored and roughly textured surfaces, with an upturned license plate on its bottom left corner, and a "one way" street sign to its upper right.[18] This piece imagined an information "super highway" thirteen years before Nam June Paik uttered the term in relation to a nascent information economy, proffering a meeting point for media bits and personal signatures that, contrary to its signage, was not one way. *Black Market* offered a form of participation different than what was offered by happenings or performances at the time, encouraging an interactivity that foresees the basic appeal of a form of public, creative coauthorship, and the allure of a new user-controlled platform for image circulation, while also challenging the reification of painting in the dynamics and economies of consumerism.

However, if Rauschenberg's open source experiment anticipated the best in its coproducers, it also showed them at their worst, preempting open source's failings by staging a public's will to sabotage or profit from any such collaborative creative endeavor. The piece had been produced for an exhibition called "Bewogen Beweging" (or "Art in Motion") for Amsterdam's Stedelijk's Museum, which opened in March 1961, and even before the exhibition opened, all of the elements from the suitcase had been removed, reputedly by other artists included in the group exhibition.[19] Rauschenberg later lamented:

The operating instructions for the permission of the piece had been written, rewritten, simplified and clarified in at least seven most common languages. Communications and directions were not the flaw. Unfortunately the work still remains avant-garde and basically appeals to the darker side of human nature. I am still disappointed that a gift cannot be accepted and exchanged when it preferably can be stolen.[20]

Rauschenberg's work of from the mid-1950s to the early 1960s moves from an exploration of the image's passage through the body to the body's imprint upon the image. He collaged photographic images and aspects of performance (calling upon the dancer's or the viewer's body movements) to render and pull open this passage of consumption and production, this loop or cycle we're in. Contrary to Branden W. Joseph's in-depth reading of *Broadcast*'s retrospective aesthetic, I would see *Black Market* as the work that bridges the early "intermedia relations" of his Combines, not only to his

later involvement and experiments with technology, but to many subsequent generations of artists exploring how a strategic convergence of media could respond to a new situation of images.[21] Rauschenberg's works from this early period render, enjoy, and sometimes trouble image "contact" from a singular, external perspective. His was a post-Greenbergian, multimedia, multidirectional exploration of what it is to exist within a circuit of images.

Krauss recognized the significance of this facility in the Combines some twenty years after they were made, and in a different political and technological moment, as live broadcast television coincided with mounting US economic and political instability. Just as Rauschenberg's stuffed, still, and signifying objects "register as images," the work seemed conscious of how people receive or register images and are, in turn, registered as images. The same year that Krauss's analysis was written, Vito Acconci, one of Rauschenberg's tutees, was preparing to make work exploring the Americanization of the psyche through live television broadcast. In Acconci's work appears a Rauschenbergian delay to the moment a propagandist image is internalized and incorporated.

Filmic Space as Psychic Space: Vito Acconci's *The Red Tapes*

Acconci's first medium was poetry.[22] But, David Bourden notes, "the decisive shift in his work, from poetry to performance, occurred during a marathon group poetry reading at Robert Rauschenberg's loft in the late 1960s, when Acconci was asked to contribute to 'a kind of poetry/event.'"[23] From his poetry days, he became invested in challenging the terms of agreement between consumer and producer, between reader and writer, or viewer and performer, as well as testing the parameters of a performance in any given space.[24]

In *Following Piece* (1969), Acconci followed a series of strangers through the streets of New York over the course of three weeks, jotting down the haphazard trajectories and reporting them to various art world dignitaries, critics, curators, and collectors in typewritten notes. This form of voyeurism tested, on several levels, the relationship between the viewer and the viewed. In *(Untitled) Project for Pier 7* (1971), Acconci stood at the end of New York's Pier 7 between 1:00 a.m. and 2:00 a.m. each night over the course of a month, promising to reveal, to those who met him there, something

they did not anticipate. These piers were at the time a cruising area for New York's gay community, so in this already symbolically designated city outpost, Acconci's piece asked: What are the power relations between viewer and the viewed? How are different forms of control established through co-opting lines of vision, and by whom?[25]

Similar questions arise in *Seedbed* (1972), at New York's Sonnabend Gallery, where for two days a week over the course of the exhibition, Acconci masturbated beneath a specially constructed ramp to obscure himself from view. Accompanying noise below, he voiced his exertions, his fantasies, and the visitors' sounds prompting them, to microphone, in a monologue relayed through speakers. Acconci was ostensibly testing the power dynamics produced within different fields of viewing, between different agents within the Spectacle, hierarchies that would ultimately and quite profoundly—as a successful, white, male artist—favor him. The work also proposed viewing itself, within and despite existing or acknowledged hierarchies, as a search for self-gratification or for objects of desire, and his early works in performance and moving image might be read as repeated attempts to infiltrate or penetrate this Rauschenbergian sense of "contact." In 1972 Acconci proposed, "the performer can work as a producer; the performance pattern can be linear—a series of additions of material and energy. Or he can work as a consumer."[26] Acconci early treated performance as strategy to feed or interrupt audience response, subverting or visualizing information feedback loops at play all around us.

In 1972, *Avalanche* dedicated a whole issue to Acconci, announcing his use of the body as a response to the "present repressive socioeconomic situation" of a failing US administration.[27] His live and itinerant performances drew focus on the body, as an agent capable of defying the constriction of fixed parameters of viewing. This purposeful, physical remove sought to break the contract of the viewing encounter. As Robert Nickas observes: "Acconci's progression from 'movement over a page' to his own movement in space should not be seen as evidencing a replacement of the presence of language by performance but as its extension."[28] And from the 1970s on, this transgression of controlling lines of vision was applied to the techniques and architectures of filmic space.

While Acconci had largely avoided the alternative economies and activist politics of film collectives like the New York Film Cooperative (as evidenced in works of the late 1960s by artists including Stan Brakhage, Carolee

Schneeman, Peter Gessner, and Fred Safran) in favor of more abstract performance works in ad hoc and later commercial gallery spaces (and subsequently by the Castelli-Sonnabend video art collection, 1974–1985), a new North American consciousness of war and violence, activism, and occupation from the late 1960s and early 1970s brought about a change in Acconci's focus and an interest in the Americanization of the psyche through the domestic encounter with broadcast images.

The Red Tapes (1974–1976) is a three-part epic video running almost 142 minutes in total. In *Tape 1: Common Knowledge*, the camera oscillates between Acconci's face recorded close up in recurrent intervals and recorded images, stereotypes of North American landscapes, architectures, streetscapes, and vehicles, accompanied by a disturbed narrative, voiced by Acconci. *Tape 2: Local Color* focuses on the artist's body as seen in the context of the architectural and sculptural space, sometimes shown as models or maquettes, an intermingling of physical space with the psychic or psychological. As if to exaggerate this, his accompanying script often represents oppressive psychological states or conditions. In the most overtly theatrical of these works, *Tape 3: Time Lag*, six actors are recorded acting out a "rehearsal of America," their bodies filmed throat-to-knee pacing around a rehearsal studio, before loosely assembled props, ladders, and stools. Acconci reads through a script, without pause and with occasional dramatic interruptions, issuing a list of directives both for actors and camera:

[A young woman's voice reads:] come on let's be crazy, let's do it, let's be crazy, crazy, crazy, [no pause, Acconci, reads:] then in the corner a straight man, the problems of a mixed straight man, leave the straight man be, problems of a straight man, leave, leave the straight man be, camera moves, moves through the window, camera pans around America, we go around, we go around in circles, and underneath it all the unknown voice, come in again Dragon Lady, you're in it again Miss America, there you are Mother of Pearl, you're the one, you're the one, you're the one, camera moves, calling American, black out, black out, camera fades, black out America, America is born again [another man's voice] places, places Born Again. ... Ok Act five ...[29]

The camera passes from the studio, to a blank image, to the close-up image—accompanied by funereal organ music—of a white, blonde woman's face screaming silently, before she is blindfolded, wrapped in white cloth, and covered by the flag of the United States. A symbolic burial is taking place here, an internalized ceremony, a harbinger of the death of patriotism informed by television and cinema reels. Gunshots ring out

against a blank, darkened image. As each progression, the distance between state and psyche draw closer, its landscapes, domestic spaces, and interiors impose upon the viewer, "working out" these productive actions. To viewers, the work declares, propagandist images exert their power, they conscribe. "You're the one."

Acconci teased out how immersive and generative television viewing was becoming. The work's tone and tempo change dramatically every few minutes, pacing through semi-autonomous vignettes. Acconci's treatment of image and script is disruptive, with representations of America appearing, then spoiled through a series of reveals. His actors' characterizations are flattened by stage directions voiced to interrupt the script. Props lay scattered, bare and unassembled. Faces are shown close up or cropped from the body. Dramatic sound effects like gunshots accompany or kill vacant images. While Rauschenberg was testing the way that broadcast images competed for viewer's attention, here was a livid destruction of those conventions at play. As Monika Szewczyk wrote:

The Red Tapes maps the Americanization of a psyche, proposing political consciousness as absorbed through the broadcast image. Acconci's work was scrutinizing the particular processes of manipulation through immersion. The work proposes that in 1970s America, filmic space (from cinema to television, screening advertising to news reportage) constituted psychic space and as such, that space could be intercepted by artists, its conventions teased or subverted, however privileged (and perhaps contradictory) the conditions of its eventual screening.[30]

Once he completed The Red Tapes, Acconci stipulated that it must always be projected onto a wall rather than screened on a monitor. This was one of the first examples of such instruction for an artist's video: relating it not only to the projection methods of analog film, but also, spatially and in scale, to the physicality of theater or dance. Its projection would provide greater compatibility of scale to the visitors' bodies than if they had encountered it on the diminutive television screen, pacing at a similar height to Acconci's ensemble of actors in Tape 3: Time Lag. This interest in the passage of images through the body evident in Rauschenberg's Combines was to manifest in Acconci's recorded performances. In a very different moment, where live broadcast and political events were coproductive, and the US economy, democracy, and foreign policy were looking considerably less stable, Acconci cast light on how the broadcast image shaped its viewers' perceptions and paranoia.

Registering Like a Photograph: Rainer and *The Man Who Envied Women*

New York's recession of the 1970s drove inhabitants toward the suburbs and New Jersey, which afforded artists vacant spaces to rehearse, workshop, record, and perform work. RoseLee Goldberg noted that: "a genuine lack of interest in producing art objects continued to provide a breeding ground for performance of all sorts ... a generally curious and amenable 'scene' developed around these events. This in turn had a multiplying effect in that it encouraged artists from other disciplines to use the performance setting and existent audience for their own experimental work."[31]

This was a cross-disciplinary instinct that was also influenced by the success and reach of the Judson Dance Theater, a loosely organized collective for avant-garde choreography congregating in Greenwich Village between 1962 and 1964.[32] Its dancers had broken away from the classes of Robert Dunne and choreography of Merce Cunningham to make their own public performances in this Washington Square church hall. Goldberg writes: "there they developed a vocabulary of dance and composition that insisted on the audience examining the matter of dance—the body—and its everyday movements, uncluttered by formalist jetés or classically bowed arms."[33] Yvonne Rainer, Trisha Brown, Simone Forti, Steve Paxton, and Lucinda Childs were interested in new "patterns of movement, complex spatial tactics performed by dancers less concerned with turnout than with conceptual strategies, such ideas formed the basis for the new dance [...] pared down to 'pure ideas', freed of costume, lighting, or decoration of any kind, with even the traditional musical accompaniment being replaced by the sounds of feet stamping or hands clapping, the movement of clothes loosely draped across bodies.[34] Although not typically associated with the media critique of the early postmodernists,[35] Chris Salter notes that dancers of the Judson Dance Theater were acutely aware of "the manipulation, intervention and extension of the (dancing) body through all manner of choreographic systems: simple tasks, rule-based or chance techniques, mathematical procedures, game models, or any other kind of movement resulting from certain decisions, goals, plans, schemes, rules, concepts or problems."[36]

Post-Judson, Rainer innovated a pointedly regulated and temperate form of avant-garde dance. It was alert to the power of the image as a productive force, and much of her choreography played with the theatrical stage

as a pictorial frame to be manipulated or damaged.[37] Rainer veered away from dance that undulated toward crescendo and spectacle to solicit the image, producing works that defied both technical convention and media spectacularization, and the interconnection between the two. And what's significant here is this manipulation and focus, not on the image but on the *performance of the image* by its most frequent object, that antagonized how images objectified the (often white) female body within mainstream media. Rainer looked with caution upon the relationship between the camera lens and the female body, a particularly gendered performance evident all around her in the media, which she had felt to be a particularly pressurized space. And ultimately this pressure to perform becomes the subject of much of her choreography.

Evidence of this wariness presents early on. In *Duet Section* of the evening-length performance *Terrain* (Judson, 1963), danced by Rainer and Trisha Brown, both were dressed in leggings and a black bra. Rainer danced a ballet adagio combination that she had learned in ballet class with Brown next to her performing a combination of ballet postures and those of a more seductive burlesque number. In her analysis of the specter of photography looming within Rainer's work, Carrie Lambert-Beatty notes: "lest the audience miss the point that classical and peep hole dance are equally structured on the viewer's visual pleasure, Rainer and Brown together ran through a series of still stances. Like pinup girls flirting with the camera, the two avant-garde dancers preened and posed."[38]

Rauschenberg had designed the lighting for this piece, marking the first of his collaborations with the Judson group. He had been involved with the staging of Merce Cunningham's pieces since 1952, and this marked something of an influential progression. Although his works in performance were still finding form during this period, Rainer's pieces of this period display markedly similar sensibilities to Rauschenberg's early works, which, as Joseph has noted, challenged, "submission to any a priori model or ideal with which the spectators could identify or perform"[39] through sophisticated strategies of staged and re-sequenced images. While Rauschenberg built his own stages within or upon his paintings or Combines, Rainer uses the proscenium stage, and where Rauschenberg's sequenced images are manually cut and pasted onto his stages, hers, certainly within this piece, were postured and juxtaposed within regular, task-like movements. They were both clawing at the apparatus, ideologies, and industries that made their respective sets of found images function.

Lambert-Beatty observes that, "[w]hat Rainer would later denounce as the 'narcissism, and disguised sexual exhibitionism of most dancing' was expressed in *Duet* by pinup posing; that is, by literally 'registering like a photograph.'"[40] Lambert-Beatty quotes this phrase of Rainer's, a distain for dancers, "registering like a photograph," written in her "Quasi-Survey of Some 'Minimalist' Tendencies ..." (first published in 1974), a phrase that closely resembles Krauss's description of Rauschenberg's object, and how it might be "registered as image." Both reflections on these respective works from the 1950s and 1960s appear in print in 1974.[41] Krauss's phrase describes how objects are channeled as images, while images are perceived as objects within Rauschenberg's Combines, where Rainer's phrase describes a more toxic transference where gendered images are perceived as objects, that is, the process, mediated through images, whereby women are objectified. And Rainer seemed highly attuned to how this cycle put pressure on a subject to posture sexually to a camera, as image, in order to register at all as subject. Here the juxtaposition of classical dance with its more seductive, seedy version brings pan-historic conventions of gendered viewing under the spotlight.[42] In fact, it's still a surprisingly evocative description given its non-specificity, perhaps because "registering" this way, in this solicitous, servile, peephole fashion, remains predominantly tasked to one gender, a specific posturing so prevalent it survives mass media and thrives in its incumbent.

From *Duet Section* on, Rainer choreographed performances that systematically denied dance photography the "focal moments" traditional dance bestowed, purposely leveling out the modulation and emphases, climaxes and stillness of traditional phrasing, replacing them with evenly paced, systematic movement patterns. In 1974, between choreographing a 43-minute dance piece called *Sextets* and appearing oiled up beside Robert Morris in his performance piece, *Waterman Switch*, at the Albright Knox Museum in Buffalo—documentation of which appeared in *Life* magazine and became infamous as her "nude dancing pictures"—Rainer wrote a piece which, when published the following year, became known as her "NO Manifesto."[43] Among other renunciations (including no to spectacle, virtuosity, and "the glamour and transcendence of the star image"), Rainer wrote, "no to trash imagery," by which she was perhaps obliquely referring to the nude images of her body taken to publicize Morris's performance, or the media industry that seized upon them while ignoring her work, muting and undermining her as an artist.

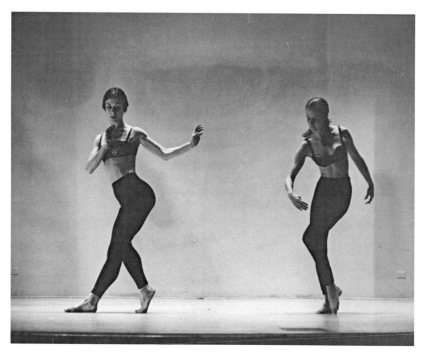

Figure 2.3
Duet from *Terrain* (1963), Judson Memorial Church, New York, April 1963. Yvonne Rainer and Trisha Brown. Photo Copyright Al Giese. Courtesy of Raven Row, London.

From the 1970s, Rainer discontinued making works in performance and concentrated instead on writing and filmmaking. Her feature-length film *The Man Who Envied Women* (1985) subsequently responds to Mulvey's theory of cinema's gendered and gendering gaze,[44] attempting to create an alternative feminist filmmaking methodology:

Play with signifiers of desire. Have two or more actors play the main male character. Remove the physical presence of the female protagonist and reintroduce her as a voice. Create situations that can accommodate both ambiguity and contradiction without eliminating the possibility of taking political stands.[45]

Rainer's protagonist is Trisha, and the work is set during the week she leaves her husband, college professor Jack, played by two male actors. Trisha does not appear before the camera, a pointed absence that is frustrating to watch; Trisha's presence signified by voice alone. In one significant moment, Trisha cuts off Jack's "a man is nothing without a woman" speech,

breaking from her position as passive spectator to narrator as she (seemingly) watches it obliquely, to an assertion of herself as active agent within the filmic space. Writing about this as a spatial, feminist strategy, Peggy Phelan notes: "In displacing Trisha from the visual field, Rainer forces the spectator to concentrate on the way the filmic frame both fills and limits the space of the film. She is attempting to elucidate how the given to be seen requires a strict prohibition on what and who remains unseen."[46] Rainer's piece suggests that to be unseen but unequivocally present is something of a privilege unfamiliar to white, female protagonists, increasingly faced with the inverse: to be shown but without significant presence. Phelan writes, "In leaving Trisha outside the visible content of the frame, Rainer displaces her from the filmic space into the spectator's psychic space."[47]

Various other techniques corrode or striate immersive and generative viewing habits, and there's a similar overlapping of images in this work as appears—albeit in different formats—through the sets of Acconci and staging of Rauschenberg. In an extended sequence, Jack sits in a darkened studio with Super-8 footage projected into his background, all shot onto the smoother surface of the 16 mm film. Behind him run excerpts from Hollywood movies (including *In a Lonely Place,* directed by Nicholas Ray, 1950), sequences of experimental film (Trisha Brown dancing in *Water Motor,* directed by Babette Mangolte, 1978), episodes which were to obliquely represent Jack's inner world. It's a cinematic *mise-en-abyme* that anticipates the kind of image compositing that digital technologies facilitate, a pictorial conceit of image projected within image in which the piece's own construction, conditions, and means of production or authorship are drawn into the frame.[48] In this example, as in Acconci's *The Red Tapes* (with his superimposition of hands over crowd shots) and Rauschenberg's Combines, many of which contained mirrored surfaces, this imposition of one image within or upon another allows artists to articulate how images impose upon subjects, how, as palimpsests, they comprise memory, subjectivity, and subjecthood, and inform behaviors. The *mise-en-abyme*'s central image, that composited within the other, presents a siphon through which others can flow. It's a pictorial conceit that might reveal the performativity of images, producing their subjects, like Jack, captured beside or before them.

It also disturbs our attention in ways that are perhaps useful. Rainer describes her use of the *mise-en-abyme* as an attempt to break down the

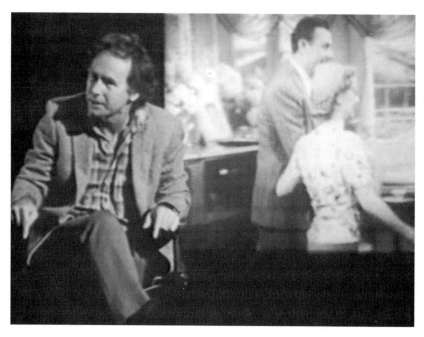

Figure 2.4
Yvonne Rainer, *The Man Who Envied Women* (1985), 16 mm (color, sound), 125 minutes. Courtesy of the artist.

cinematic frame, to render *distance*, as a "disruption of the glossy, unified surface of professional cinematography by means of optically degenerated shots within an otherwise seamlessly edited narrative sequence […] I'm talking about films where in every scene you have to decide anew the priorities of looking and listening."[49] And this accumulative technique tempers the protagonist, conflicted about the marital situation in which she is unhappily and constitutionally bound, like the fixed image in which she has been bound. Rainer frequently samples texts in soundtracks or scores (Jack's script quotes much from Raymond Chandler), and she has commented that, by making her characters quote, she is able to: "foreground not only the production of narrative but its frustration and cancellation as well. Words are uttered but not possessed by performers as they operate within the filmic frame."[50] This strategy of overlapping found scripts in order to destabilize linear narrative is consistent with her treatment of images, undercutting any sense of fixed image or identity.

There is a particular choreography of images articulated in Rainer's work, which is not the choreography typically associated with the artist. It's a *pas de deux* between the camera and the female body, but, where normally that female body is positioned within frame, Rainer moves her around that camera's lens. In wrestling common object from frame, she pulls focus on the woman as presence, multifaceted, non-reducible.

Rainer was not alone in absenting her female characters on film in order to "challenge the nature of filmic presence."[51] Many artists of this period working across media were involved in pointed lens-conscious performances, reorganizing female protagonists to present illusively, partially, or exaggeratedly before the camera. Combining elements of masquerade, alter ego, spoken word, repetitive activities, sophisticated camera rigs, and on-stage projection, artists like Joan Jonas (in her *Organic Honey* performance phase, from 1972–1977), Cindy Sherman in her early film stills (1977–1980), and Julia Heyward in her outlandish vocal and musical performances to camera (1975–1981), adopted the familiar posturing of the nominal or stereotypical Glamorous Woman familiar to us from Hollywood movies or television melodramas, and painted, perverted, or parodied them from within their own image to drive the typically sexualized, cinematic object out of sight.

From the 1970s, performance and moving image were readily called upon by artists in a widespread negation of the pressures of "registering" as an image, artists considering these pressures from different gender and racial perspectives, a rejection that utilized the conventions and characterizations of mainstream media, not as a point of parody, but rather one of identification: artists were to identify as and against character types in order to make space around them, bringing into the frame the larger representational systems that created or sustained them. Goldberg saw a generational shift around 1976: "media artists," who "received it all as so much recycled imagery—the post-Warhol children, the children of distance and dissimulation."[52] Goldberg's television generation was alert to the impact of the broadcast image in the construction of identity, indeed of self, and found themselves newly equipped by video to explore it using the techniques of this construction. Goldberg cites Laurie Anderson, Julia Heyward, Michael Smith, Martha Wilson, Adrian Piper, Michael McClard, and Robert Longo as co-opting features of variety theater, cabaret or stand-up comedy, to create a seemingly familiar format that pointed, "to a different relationship

with the audience, one that actually verged on audience gratification—on entertainment—rather than the intentionally oblique and disturbing actions of an Acconci or an Oppenheim."[53]

Adrian Piper's New York street performances and media appearances of the early to mid-1970s asked how one might construct and inhabit an identity, and through it test and recalibrate public perception. By the time Piper performed *Mythic Being* (1973–1975), she had already created a number of performances in the public realm, and published critical and creative writing (an early conceptual work was published by Vito Acconci and Bernadette Mayer, in their experimental journal *0-9*, in 1968). For this series of performances and publishing endeavors, the artist dressed in drag, with a dark, curly haired wig, a mustache, sunglasses, and dark, flared pants, and walked down a street in New York reciting various mantras taken from her diary, in what she called an ongoing exploration of "internal expectations versus external audience perceptions."[54] Printing these mantras in a thought bubble over photographs of herself in drag, she created individual posters which she published monthly in the gallery pages of *The Village Voice*.[55]

Piper's performed image was a guise that allowed her, in various formats, to embody male presence and explore "feelings of macho masculinity towards my male friends that even the woman's movement hadn't facilitated."[56] Prior to making the work in 1973, Piper has described an experience, dancing in a nightclub where she was "becoming the music," and it was perhaps that physical, perceptual sensation of "becoming" that might resonate with her instinct to transition into this alternative persona.[57] Uri McMillan proposes that "performed objecthood" has historically provided a means for black subjects to become black art objects, "wielding their body as pliable matter," and has evaluated at length Piper's "bold experiments with disorientation, self-estrangement, and becoming a confrontational art object."[58] McMillan observes, particularly of the image components of *Mythic Being*, "methods by which Piper attempted to deconstruct the visual field that racial information, racism and xenophobia depended on and maneuvered within."[59] Hers was a unique test and corrective to image performativity particularly as it carried racial and gender bias, through a performed subject "who had exactly [Piper's] history, only a completely different visual appearance to the rest of society."[60]

Piper, like Rauschenberg, was looking at how an image might make contact, pass through the body to register outwardly and recirculate anew. While for Rauchenberg this traffic of imagery was noteworthy, and perhaps pleasurable, for Piper this transferal was heavily and problematically mediated. Unlike Rauschenberg, who regularly exhibited in commercial galleries and public institutions, Piper rejected the established networks of an "art-world hierarchy" she felt to be exclusive and guarded, and used various modes of public performance to remain purposely outside "a system that I find politically and economically repressive, exploitative, and unethical."[61] The effort here is not to conflate these artists' experiences and thereby disregard the exclusions faced and reparative parameters set by Piper, among other female, non-binary or non-white artists, but rather to consider, through works, an art historical arc where artists using critical convergences in new media did so in order to depict the contact between the body and its image as an encounter that was formative, socially constructed, and ultimately contestable.

Closed Loops: Lorraine O'Grady and *Nefertiti* and *Devonia Evangeline*

Lorraine O'Grady was another New York inhabitant who began, in the late 1970s, to combine performance with still and moving image to explore different instincts to perform image. Like Piper, with whom she worked on several occasions, O'Grady was as concerned about what images mainstream media and other representational institutions were conspicuously excluding on the basis of race as well as gender.[62] Not incidentally, both artists were making work that was staged in art gallery contexts, but which they also produced in public space, in distinctive acts of masquerade, and large-scale street performances. Unlike Piper's work across media, which has long been recognized and theorized within art criticism and the academy, and by Piper herself, O'Grady's career to date might be considered in two halves, the first an active engagement with public interventionist performance; the second, following a significant career break during the 1980s, invested in photo-based installation work. Although there has been steady institutional support of her practice since the 1970s, this has spiked in recent years owing to, among other factors, the extensive photographic documentation of her performance and installation works posted on her website since 2009.

Like Acconci, O'Grady had come to performance from an interest and academic background in experimental poetry and literary strategies of the Dadaists. In 1977, during an extended hospital stay, she began cutting and pasting words from Sunday newspapers to create concise reflections on her own position as a black female artist. These later found voice through her alter ego *Mlle Bourgeois Noire* (1980–1983) or "Miss Black Middle-Class." *Mlle* appeared at openings in various New York galleries including Just Above Midtown (JAM) and the then recently opened New Museum (1977). Dressed as a debutante from Cayenne in a gown made of 180 pairs of debutante's white gloves, and a cat-o'-nine-tails, a whip used on slave ships, O'Grady appeared reciting what Nick Mauss describes as "vituperative poems."[63] This work had different goals than those of white feminists of the 1970s, who according to O'Grady were:

driven by two goals: the right to a career outside the home and the right to sexual freedom … but these goals were not universal. If you asked what those goals might mean to black women who'd never had the right *not* to work, never had the right *not* to be considered sexual objects, you could see the goals might need calibrating. That same calibration was also required for the art that was made or that needed to be made. The attitude to the physical *body* in performance art that's accumulated the largest concentration of scholarship … has seemed defined by the white woman's revolt to take off her excessive clothing … The fact is, in some ways the right to *dress up* was closer to the needs of many black performance artists.[64]

O'Grady's works first took aim at the art world, in a practice that sought "to challenge both the art world's entrenched (and often overlooked) conservatism and its presumptive avant-gardism."[65] Having been moved to make art after several years working as a journalist, O'Grady considered the art world the first place where she felt "cornered" based on her appearance.[66] Her subsequent pursuit, *The Black and White Show* (1983), was part of what she describes as a career-long "invasive strategy" to counteract the exclusions of black artists within a cannon of Western art history and the institutional exhibitions that supported and reinforced it. For the exhibition, O'Grady invited twenty-eight artists, of whom half identified as black and the other half, white, to contribute new works to a gallery at Kenkeleba House, in the East Village in New York. Artists were invited to contribute black and white work, and the gesture highlighted, among the diverse interests and formalist concerns of its participating artists, "the absence of such parity elsewhere in art."[67] O'Grady has previously described her approach to this work as "a conceptual artwork that used curating as a medium,"[68]

(a)

Figure 2.5a
Art Is (Troupe Front).

(b)

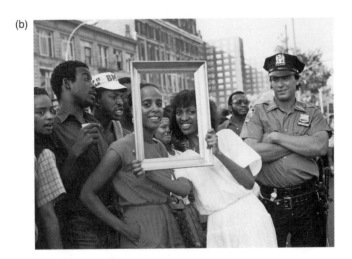

Figure 2.5b
Art Is (Woman With Man and Cop Watching).

(c)

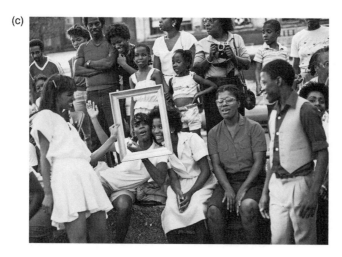

Figure 2.5c

Art Is (Women with Crowd Framed), 1983/2009, Performance and C prints (3 of 40).
Courtesy of Alexander Gray Associates, New York; copyright 2018 Lorraine O'Grady/
Artists Rights Society (ARS), New York.

but more recently has revised this and clarified how she considers these two
pieces, alongside a third, *Art Is* (1983), as "a single work of conceptual art/
institutional critique."[69]

While O'Grady's work first takes aim at art's institutions' close confines
and exclusionary practices, it subsequently regards more widely felt exclu-
sions in broader representational economies. In what she describes as a
"handmade work" (*Art Is* …), O'Grady "curated" a float at the annual Har-
lem African-American Day Parade in 1983.[70] Initially prompted by a friend's
passing remark that avant-garde art had nothing to offer black communi-
ties, O'Grady's instinct for gathering diverse, purposeful material was now
transposed on to the city street. Documentation of forty colored photo-
graphs reveal a float festooned in gold, transporting a large group of young
black male and female actors dispersing among the crowds holding gilded
frames. A camera documented the group, capturing the frames that held
within them the crowd's faces, young and old.

White figures are the minority in these shots, appearing solely as police
officers surveying the crowd. All but one expresses some degree of pleasure
with this street performance, but their inclusion within these shots serves
to reinforce how public policing and surveillance, as a tool for a repressive

state ideology, identifies and divides its subjects. O'Grady has said of the piece: "1983 was a basically one or two years before the crack epidemic hit Harlem, and before a different kind of policing hit Harlem. There's always been surveillance, and policing of minority neighborhood, but I think the methodologies of policing [has] changed substantially. As a result, you could not do that piece now."[71]

The majority of O'Grady's subjects are people picturing other people. "Make Me Art" onlookers shouted, according to O'Grady's account, "Turn Me into Art." She was surprised at how the crowds responded, with over half those participating willingly, albeit "very self-consciously turn[ing] themselves into art objects."[72] Her photographs show people enjoying contact with others through images, enthusiastic about the promise of being caught in time as image. It's a work that renders photography's promise of proximity, to one another, to many others, of being framed in perpetuity, while representing the constant threat to black subjects presented by predominantly white police forces. Performance and photography are pitted together to capture this social tension, picturing people, frame after frame, roving from O'Grady's golden float. "That parade was creating a film," the artist has since recalled, "and it was capturing everything on that route as cinema."[73]

O'Grady regularly mined her own subjective experience, events within her own biography, and considered how they took shape through particular collections of images. The complexity and depth of feelings these evoked were examined in *Nefertiti/Devonia Evangeline* (1980). In that work, O'Grady projected image pairings of the ancient Egyptian queen and the artist's sister Devonia, both of whom had died in their late thirties. The work began when O'Grady visited Cairo first for work in 1963 and later, after her sister's death, where she "found herself surrounded by a population who, 'looked just like me. ... Here on the streets of Cairo, the loss of my only sibling was being confounded with the image of a larger family gained.'"[74] Struck by the complexities of ethnicity and race, of the resemblance between her middle-class African-American sister and this ancient Egyptian queen, O'Grady returned to the States to research Nefertiti's Amarna period. In 1980, following her *Mlle* performances, she was invited to create a live work for a performance festival by JAM's curator and director Linda Goode Bryant, which gave O'Grady the opportunity to reconsider much of this material alongside the documentation and narratives of her own family history.

In the 1980 performance at JAM, images from both periods were pro-
jected as a slideshow of sixty-five pairings from two adjacent Kodak slide
projectors onto the gallery walls, accompanied by an audiotape of the
artist narrating her account of the lives of both Nefertiti and Devonia, in
her description, "speaking in about 11 different voices, sometimes narra-
tively, sometimes descriptively."[75] While image and sound played, O'Grady
dressed in a cape and spotlighted on a delineated stage, performed an Egyp-
tian death ritual intended "to honor the memories of each woman." The
events and accounts around Nefertiti's death vary and are contested, some
alluding to a sudden death after the monarch's fall from power. Like Nefer-
titi, the artist's sister died in her late 30s from complications following an
abortion. O'Grady has since recalled: "this [work] was a personal endeavor,
I was seeking a catharsis ... To the degree that the audience entered my con-
sideration, I hoped to say something about the persistent nature of sibling
relations and the limits of art as a means of reconciliation. There would be
subsidiary points as well: on hybridism, elegance in black art and Egyptol-
ogy's continued racism [which denies Nefertiti's African ancestry]."[76]

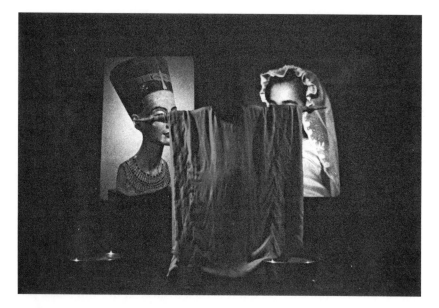

Figure 2.6
Lorraine O'Grady, *Nefertiti/Devonia Evangeline* (1980), Performance. Courtesy of Al-
exander Gray Associates, New York; Copyright 2018 Lorraine O'Grady/Artists Rights
Society (ARS), New York.

Documentation shows O'Grady on stage before two projected images: one black and white photograph of Nefertiti's famous bust mounted on a plinth and seen from its side, lit by the camera's flash; and beside it, again in black and white, a photograph of Devonia as a young woman, at a similar oblique angle, her dark hair covered in a delicate white veil. O'Grady's body stands before the audience, between the projector and images, these images that have passed through her body, weighed upon it. Spotlighted in red, her cape casts its own shadow on the images, before the audience, as she recites a line from an ancient Egyptian "Opening of the Mouth" ceremony, performed at funerals so that the person who had died would be able to eat and drink in the afterlife. "You are protected, and you shall not die," O'Grady's recorded voice pledges, across her diptychs.

O'Grady has discussed how the audience responded to her performance at the time, many of whom either objected to or derided her image juxtapositions as arrogant or misguided. Mauss contends: "their verdict missed the greater provocation of her conceptual linking. In an interview with Linda Montano, O'Grady states, 'Putting a picture of Nefertiti beside my sister was a political action.' *Nefertiti/Devonia Evangeline* enacted legitimate pain in a complicated work of mourning, triangulating between the present and two irretrievable pasts."[77]

Lisa E. Farrington has observed the work as "indicative of the artist's commitment to social change through intellectual and visual dialogue."[78] Nefertiti's ethnic identity is highly contested within the white, Western, Eurocentric field of Egyptology; so O'Grady's presentation of resemblance between her sculpted image and that of Devonia's poses urgent questions about revising methods of historiography, as much as about the role images play in perpetuating systemic exclusions.[79] In her work, O'Grady repeatedly creates a position for herself within and beyond the pictorial frame, visualizing the process of image making and implying what is at stake, a process where she presents herself as both subject and object, viewer and viewed, surface and interior. In *Nefertiti* what's presented is the illusive sense of feeling of both one's simultaneous proximity to and distance from images—that for the viewer, or in this case the sister, an image promises the tangibility of its subject, but can also, simultaneously, mark its irreconcilable absence. As such, an image has the capacity to draw the viewer's body toward it as it withdraws.

These artists, making work from different vantage points, and with different levels of institutional support, present the first wave of a much larger surge of artists to render the dynamics of a formative circuitry of images, which is performative, mediated, and often socially and politically unaccommodating. They explore different forms of contact that a subject might have with an image, distinct motivations to "register" as photograph or image. They do this through a variety of methods which will be taken up in many of the subsequent works of this analysis, including the choreography of image sequences and circuits; the projection or composition of *mise-en-abymes*; the de-objectification of female actors through either de-centering or re-centering them in frame, on stage or in the street; or slide-responsive lecture performances, all convergences of performance and moving image that interrupt, pause, invert, or exteriorize circuits of image consumption, production, and consumption.

3 Images Invading the Body

In the 1980s, several major developments in image technology were to have enormous impact on individual behavior and group activity, in a Western and global context. There was a huge rise in video gaming and console production in the 1980s, oscillating between the US and Japan; in 1989, CERN's "distributed computing" system became the medium with which Tim Berners-Lee was to write the World Wide Web; and in the late 1980s virtual reality (VR) was poised to move from an operative, but relatively little known, immersive multimedia system, designed for the military and gaming industries, to a revolutionary computer technology as potentially lucrative as the Internet has worked out to be. During this period in the US, there was a widely held view among technologists, artists, and theorists, as well as various corporations and management consultants, that the Internet and VR would evolve in tandem to create a new spatial frontier with vast potential for its participants or inhabitants, or for those enterprises able to marshal those participants or inhabitants.

In parallel with these changes in technology during the 1980s came an upturn from the previous decade's recession, with new money in New York's Wall Street and a strong Japanese yen, attributable to both the deregulation of financial markets, as well as a global shift in technology capital, which in turn had a knock on effect on the art market. An art boom resulted from a new understanding of art as an asset class for investors, which "constituted the best return on investment for some during the 80s—provided it sold at all."[1] This had the inverse effect on art production as the previous decade's recession, formalizing relations between "profit" and "nonprofit" organizations, driving up real estate prices, which restricted ad hoc improvisation, staging, and screening, and in turn, financially encouraging artists into either object or commodity production, or else a nomadism of

artists veering away from the institutions that ostensibly supported them. The street performances and media interventions by Piper and O'Grady anticipate subsequent intersectional efforts to de-territorialize patriarchal, capitalist, and white institutional spaces within new techno-spatial domains built and defined by peer-to-peer systems.

During this period, Dallas Smythe established the term "audience power" as a commodity generative of capital, and of meaning—a power that has since been articulated from a variety of theoretical and industry perspectives, by technologists, capitalists, scientific management, cultural theorists, ethnographers, queer and feminist theorists, and artists. This chapter details works by several New York based artists, with backgrounds in performance and filmmaking, who migrated toward the early Internet as a new spatial frontier with vast potential for a new, lived politics of representation—and for the free and equal construction and performance of identity therein—combining or retooling the media they were familiar with to reflect this new technology's novel activation of, or radical potential for, its audience. These artists include Leslie Thornton, Lynn Hershman Leeson, Shu Lea Cheang, and Ericka Beckman.

Ericka Beckman has said of her work, since graduating from CalArts in the mid-1970s, that it is about "performing the image," and each of these artists, to different effect, evidence this strain while asserting how new image-technologies inform and produce one's experience in the world.[2] As Douglas Eklund has written of Beckman's work, it "show[s] how the machinery of representation structures all social acculturation and how gender relations are deeply encoded from our earliest days and reinforced with images."[3] Eklund saw Beckman's works among other Pictures peers, self-scrutinizing their responses to television watching as a form of physical consumption, seeding distinct appetites and distastes. In 1992, John Hanhardt wrote about Mike Kelley's video *Kappa*, made collaboratively with Bruce and Norman Yonemoto (1986), where Kelley transforms into the eponymous green water creature of Shintō folklore, in an absurdist cultural juxtaposition of Oedipal and Kappa myths: "the movement of the Kappa between high and low culture, situates Kelley's characterization in close proximity to David Kronenberg's *Videodrome*, where television is depicted as an absorbing technology that literally invades the body and consumes the television viewer (the consumer himself)."[4] This period sees a transition from television's "invasion of the body" to online activity's—arcade gaming,

virtual reality and multiuser platforms, and home consoles—invasion of the body.

And this bodily invasion pervades popular cyberpunk film and literature of the 1980s, viscous imaginings of artificial intelligence, cryonics, and cyborgs, as in Ridley Scott's *Blade Runner* (1981), William Gibson's *Neuromancer* (1984), and Bruce Sterling's *Schismatrix* (1985). It's a consumption of the body that, Hanhardt observes, "describes a crisis of definition and self-representation within contemporary society."[5] Kelley's work is tangibly class and gender-conscious, alert to patriarchal power precipitated through broadcasting, and the social divisions it maintained.[6] Squaring up to this, through performance and moving image, Kelley often played a "pathetic"[7] sad sack character not dissimilar Michael Smith's naïve, underdeveloped "Baby Ikki" performance persona. However, rather than self-rendering as emasculated or juvenilized by media culture, Beckman, with whom Kelley had studied and collaborated and who was highly influential on Kelley's aesthetic sensibilities in both performance and moving image works, saw this invasion as a process that could be addressed, intervened, and redeployed by rendering or recuperating the media strategies that produced it.[8]

One midpoint in the transition from network television into the user-generated content hosted by social media online today, *vis-à-vis* audience participation, is the rise of reality television. This genre followed real-life non-actors through various social encounters and experiences, with early examples in the US and the UK dating back to the 1940s. By now the "reality" format is so omnipresent that it encompasses all manner of programs, from scripted documentaries, chat shows, and live judiciaries to work, dating, and holiday shows. During the 1980s, shows like *Real People* (NBC, 1979–1984) became popular, and created a slew of others, including MTV's *Real World* (1992). The new genre switched focus on the television viewer as newly active content provider.

In 1984, New York based filmmaker Leslie Thornton made *Peggy and Fred In Hell: The Prologue* (1984, 16 mm), the first episode of an ongoing and open-ended serial shot over three decades, with twenty-three episodes to date. From the outset, it followed two children as they're raised, recording them "adrift in the detritus of prior cultures," in what Thornton has described as "post-apocalyptic splendor."[9] Unlike the *Up* series (Granada, 1964–2012), or the other constructed documentaries that have since

charted the developmental journeys of various sets of children, these two children are set in an isolated environment, sealed from the outside world. Over the course of production, Thornton recorded and edited across a range of formats, also including various excerpts of found footage. Thornton has estimated that:

98% of *Peggy & Fred* was shot on 16mm film, and 95% I shot myself. Even the found footage was obtained as a film copy, mostly from the US National Archive, and The Library of Congress (Paper Print Collection). The first episodes were edited partially or fully on film, on a Steenbeck—*The Prologue* through *Duck Factory*. The Prologue is the only episode released as a 16mm film. All subsequent episodes were transferred and/or entirely edited on video or digitally, and exist as videos only, though several early episodes did include a simultaneous film projection—*Dung Smoke* and *The Problem*.[10]

Thornton's use of film stock in this first episode, both shot and found, creates an aged or otherworldly appearance, and an ambiguity to the scene's temporal and spatial coordinates. The soundtrack is similarly composed of improvised script and atmospheric sound, as well as found recordings. In the first episode, the children's dialogue is spliced with an opera by Handel and some industrial noise, as well Peggy's soft, impromptu rendition of Michael Jackson's "Billy Jean" (1982). There's a subtle severance between their world and this, and all elements collude to make a distinctly post-apocalyptic atmosphere. In *Peggy and Fred in Kansas* (1989, video), the camera dwells on a porcelain figurine of a woman, among other shreds of detritus, emphasizing this space as unkempt and free of parental scrutiny. These children are living in what Krauss might have called a "collapsed present," sealed off from daily life, sunshine, and supervised childhood routines.[11]

The minors' awareness of the camera, which appears as a naturalized element of daily life, and their constant appeals to it present the camera as a vital, regulatory presence to them, an Orwellian Big Brother. Thornton has since written of her motivation to work with children: "because children are not quite us and not quite other. They are our others. They are becoming us. Or they are becoming other."[12] There is a sense, certainly as we develop in a society where photographic apparatuses are ubiquitous and digital platforms for viewing always accessible, that images have a latent, transformative quality, that can exert their own presence and can, strategically deployed, create a lateral social mobility. And that capacity to circulate

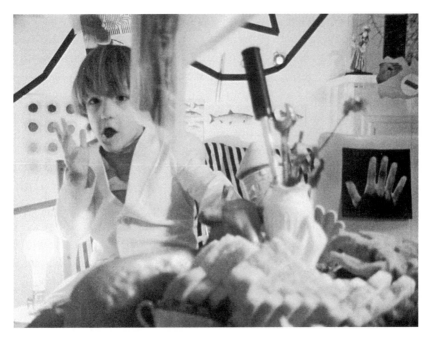

Figure 3.1
Leslie Thornton, *Peggy and Fred in Hell: The Prologue* (1985), film transferred onto video. Image courtesy of the artist.

one's own image in a media that is enterable, presents the possibility of one's own control of the process of "becoming other." As online multiuser platforms were to develop into various identity and world-building games later in the 1980s and 1990s, activities of becoming other allowed users to cross racial, gender, and class boundaries. However, in this early iteration, Thornton's gesture of casting children as "others" was a method of making visible, in abstraction, the complicated matter of one's multiple possible projected versions. As if anticipating how this user-generated media might offer a reversal of representational control, Thornton has said of her work: "I see myself as writing with media and I position the viewer as an active reader, not a consumer. The goal is not a product, but shared thought."[13]

Ed Halter has compared this work to early examples of cyberpunk, where "*Peggy and Fred* jettisons any notion of technological or social progress in favor of a collapsing of the future and past into a dystopian, postindustrial

present; it explores the convergence of human consciousness with electronic systems; and it raids a variety of genres for its formal devices."[14] And what this work shares with others in this chapter, is a distorted sense of reality, when the viewer becomes the subject, when the lens turns upon its viewer. Thornton's enclosed set where children are held and surveyed presents a dystopian vision of the techno-dependencies many of us now harbor and the substantial isolation of that captivity.

So while Thornton's work responds to a television audience's will to self-position or to become other before the camera, it anticipates and coincides with the instinct to position that self as avatar within the expanded dark caverns of cyberspace. Wendy Hui Kyong Chun has described cyberspace "as a virtual nonplace, [which] made the Internet so much more than a network of networks: it became a place in which things happened, in which users' actions separated from their bodies, and in which local standards became impossible to determine. It thus freed users from their locations."[15] And what becomes very clear from art, film, and literature from the mid-1980s onward, is the promise that the early Internet teamed with VR and arcade gaming might represent something of a new spatial, temporal frontier, newer, freer grounds for a performance of identity that might escape, challenge, or bypass the various problems of embodied social experience in Western society, media, and representational politics in the 1980s. There was a shared optimism and curiosity among artists about the various potentials of a cooperative new virtual reality.

During the 1970s, Lynn Hershman Leeson was one of a number of artists who had performed with masquerade and fictional persona as part of a second-wave feminist effort to scrutinize the construction and enactment of gender. From 1979 onwards, Hershman Leeson transferred her interests from an improvised and often serialized performance practice to inhabit various guises online. *Roberta Breitmore* (1973–1978) had been a multipart inhabitation of a fictional Roberta, described by the artist as "a simulated person who interacts with real life in real time."[16] Roberta had her own quotedian tasks and her own visual identity, distinct from the artist's own, and, eventually, had an independent legal identity as well: Roberta opened bank accounts and credit cards, signed a lease, and obtained dental records and even a driver's license. She famously saw a psychiatrist, joined Weight Watchers, and ran classified ads in local papers, all carefully documented by a photographer (the work survives in three archives, each with 200 identical

elements including notes, clothes and objects). Eventually, Hershman Lee-
son turned over responsibility for performing Roberta in the world to others,
training three Roberta "clones," and in a ceremony in 1978, where she was
"exorcised" in the crypt of Lucrezia Borgia in Ferrara, Italy, formally ended
the project. Her subsequent work, *Lorna* (1979–1983), which is considered
the first interactive video installation, cut on LaserDisc, allowed gallery or
exhibition viewers to engage with and direct Lorna on screen through text-
based instructions, with viewers using a remote control navigation system to
move through dozens of different possible arrangements of images, action
sequences, and narrative outcomes.[17] In Hershman Leeson's setting, Lorna
was a forty-year-old agoraphobe whose contact with the outside world was
mediated entirely by the telephone and TV screen. One potential ending
allowed viewer-participants to instruct Lorna to die through suicide.

From *Lorna* on, Hershman Leeson began creating Internet-based projects,
including *CybeRoberta* (1996), a robotic doll version of Roberta Breitmore,
placed in a gallery setting, whose eyes, replaced with webcams, would live-
stream images of gallery goers onto a specially constructed website, and
turn the viewer into the viewed. The work is unsettling in a variety of ways,
but perhaps most significant in this context is how, despite the promise of
cyberspace's new frontiers, *CybeRoberta* evinces ongoing pressures to con-
struct and enact ever more exaggerated versions of femininity in order to
exert even minor degrees of control in her everyday life. Rather than release
the female subject from her veneer in any convincing way, Hershman Les-
son sets its most disturbing version—the robotic doll—into the gallery's
viewing matrix in order to infiltrate established channels of attention, "cat-
fishing" gallery visitors into unexpected situations of hypervisibility and
online surveillance.

Shu Lea Cheang: *Brandon*

An early sense of the kind of pervasive violence that could take place within
provisionally utopian spaces is articulated in a number of works from the
late 1980s and early 1990s. Shu Lea Cheang is an artist and filmmaker drawn
to the radical potential of online space for the construction of identity
from the early 1990s. *Brandon* (1998–1999) was a web project by Cheang,
commissioned by John Hanhardt while at the Whitney (and subsequently
of the Guggenheim), a multi-artist, multi-author, multi-institutional

collaboration that adopts the mainframe of a website to host multiple narratives of and about one protagonist. As a non-linear, partially interactive, web-mediated project it shared some qualities with Hershman Leeson's *Lorna*, but was based upon and within a set of social and political relations arguably more complex.

Cheang's website hosts a number of images, historical reference points, and personal narratives, real and fictional, contributed by a range of writers (fiction and sci-fi writers, art critics, artists, and others), both invited and voluntary, to contextualize the physical, social, and constitutional violence committed against its protagonist, Brandon, among other accounts of abuse toward transgender people. The website hosts a number of interfaces through which the visitor or viewer can plot their own pathway through this narrative space. These interfaces include *Roadtrip*, *Mooplay*, *Bigdoll*, and *Panopticon*. Each interface is "programmed as a mainframe, a structural construct while the contents and the inhabitants can move in and out in flux."[18]

Brandon has had a number of exhibition formats in the twenty years since its inception, first as a website, from 1998 to 1999, when narratives, images, and pop-up windows were gradually being generated, gathered, and contributed (invited collaborations are attributed rather than anonymous). Second, it was projected "live" onto the Guggenheim's video wall as an interactive gallery installation. Third, and simultaneously with these other two iterations, it was constituted by two public events hosted by multiple institutions joined through live feed from New York, including a performance event at Harvard, called "Would the Jurors Please Stand Up? Crime and Punishment as Net Spectacle."[19] In the intervening years, the website was removed from and then subsequently restored onto the Guggenheim host website, where it currently (at the time of writing) is accessible to viewers, possibly due to a renewed public interest in net.art a category to which this work was early associated, an antecedent of Post-Internet art.[20]

Brandon was informed by two violent events in 1993, first, the actual gang rape and murder of Brandon Teena in Nebraska, when several men discovered his birth gender, as reported by Donna Minkowitz in *The Village Voice*, and second, a fictitious event described in Julian Dibbell's article, appearing in the same issue, "A Rape In Cyberspace."[21] The latter is a literary account of the rape of two avatars—legba (who Dibbell describes as "a

Haitian trickster spirit of indeterminate gender, brown-skinned and wear-
ing an expensive pearl gray suit, top hat, and dark glasses") and Starsinger
(who Dibbell depicts as "a rather pointedly nondescript female character,
tall, stout, and brown-haired"). The rape takes place in LambdaMOO, a
"database especially designed to give users the vivid impression of moving
through a physical space that in reality exists only as descriptive data filed
away on a hard drive." This VR violence, Dibbell proposes, is one that has
real-world impact and consequence, not least the PTSD of several of the key
players. Dibbell recounts from his viewpoint as a visiting avatar, an event
that he claims:

> ... asks us to shut our ears momentarily to the techno-utopian ecstasies of West
> Coast cyberhippies and look without illusion upon the present possibilities for build-
> ing, in the on-line spaces of this world, societies more decent and free than those
> mapped onto dirt and concrete and capital. It asks us to behold the new bodies
> awaiting us in virtual space undazzled by their phantom powers, and to get to the
> crucial work of sorting out the socially meaningful differences between those bod-
> ies and our physical ones. And most forthrightly it asks us to wrap our late-modern
> ontologies, epistemologies, sexual ethics, and common sense around the curious
> notion of rape by voodoo doll—and to try not to warp them beyond recognition in
> the process.[22]

Cheang has said that *Brandon* was conceived as a convergence of these
two news stories that each evidenced a threat to the transgender body
in both real and cyberspace. At the same time, the work is constructed
to accommodate its multifaceted subject in such a way as to support the
possibility that cyberspace could provide an alternative social and repre-
sentational space that was open to its participants in "socially meaning-
ful" ways. The works comes of a period slightly earlier in the 1990s, when
Cheang was retreating "from actual space to cyber/virtual, claiming myself
a cyber-nomad," following from an earlier period of optimism when there
"was high hope for a super-highway, for a virtual world where race/gender
does not matter any more."[23] Cheang moved to cyberspace to think social
formations anew, but was also alert to reports of grotesque sexual violence
being committed there.

Prior to making this work, Cheang had been a filmmaker and activ-
ist. She had relocated to New York from Taiwan in the late 1970s to study
filmmaking and had situated herself within the "lower east side/east vil-
lage scenes of indie filmmaking, performance, graffiti and clubbing."[24] By
the early 1980s, many of her peers were affected by AIDS, and from its

establishment in 1987 she regularly campaigned with ACT UP, an advocacy group campaigning for legislation, medical research, and treatment against AIDS. During the early to mid-1980s, she was also involved with Paper Tiger TV, an open, nonprofit, volunteer video collective creating a public access series, and media literacy and video production workshops, as well as instigating community screenings and grassroots advocacy. During this period, Cheang says: "I didn't have the means to conceive a film production myself at the time. Portable, low cost video was more an accessible tool of production for me."[25] From the late 1980s, Cheang started synthesizing her interests in gender and identity construction, narrative filmmaking, and creative modes of activism.

Color Schemes (1989) was a twenty-eight-minute video produced for the Boston-based non-commercial educational television station WGBH on its *New Television Network* program during this period, in which Cheang asked twelve non-white actors and performers to recount their various experiences of racism within the television and entertainment industry. The work uses the glass door of a washing machine to frame actors' faces, while adopting the four cycles of a wash to structure the sequential vignettes, from "soak," to "wash," to "rinse," to "extract." Vignettes show groups of actors recounting the various requests from casting agents to perform racial stereotypes. In a concluding scene, the twelve actors take a seat in a room styled after Leonardo Da Vinci's *Last Supper*, one of many implications here being that Western art history precedes television and cinema as the representational space long denying non-white subjects a place at the table.[26]

This exploration into how politically formative television is as a dominant representational space comes to the surface again in *Fresh Kill* (1994), a feature length film about two class-conscious lesbians as they struggle against a multinational corporation. The narrative follows a strain of toxic tuna as it poisons various dimly lit sushi restaurants across New York. The toxins have been caused by pollutants in Japanese waters from an American hydrogen bomb dropped off the coast of Okinawa twenty-four years previously. The aftereffects of American-Japanese conflict post WW2 are still felt environmentally and its consequences—the poisonous tuna—are sent over to the Western metropolis to consume. It's a noxious situation the two female lesbian leads endeavor to rectify, in a style of queer, indie filmmaking that refers obliquely to Lizzie Borden's *Born in Flames* (1983). There's a similar creep of political paranoia filtering into Cheang's dark caverns, as

there is in Thornton's missile-shielding vacuum, although where Thorn-ton's missile footage alludes to Cold War fractions, Cheang's allusion is to residual US-Japanese conflict, post-Pearl Harbor.

Finishing *Fresh Kill*, Cheang decided to migrate to the Internet and to try and make work there, influenced by Samuel Delany's sci-fi fiction and artist Linda Dement's *Electronic Bodyscapes*. Cheang had begun signing into the BBS [Bulletin Board System], contributing to chat and messaging forums online: "[T]hen comes WWW," Cheang writes, "I made a pilgrimage to Columbia University to see Antoni Muntadas's *The File Room* viewable only by Mosaic web browser. That was 1994. None of us had access to high power computer to run such a browser."[27] Later that year, Cheang traveled to Tokyo on an Asian Cultural Council residency, and gained access to the Tokyo University media lab, headed by Abe san.[28] "I didn't start writing codes till I got to BANFF later to start working on the *Brandon* project."[29] By the time that Hanhardt approached Cheang in 1995 to propose what was to become *Brandon*, she had already begun "experimenting with bound-ary crossing between the actual (state/nation) and virtual (anonymous/avatars), which needed to take up a durational performative format."[30] Here, Cheang's identification of "boundary crossing" into online platforms as a mode or format of durational performance seems pertinent, a project online promising a flexible, durational media and openly modifiable space to compensate for what she saw as the spatial, temporal limits of filmmak-ing, particularly when trying to represent the mixed experiences of a mul-tifaceted transgender subject.

Brandon can be encountered in a variety of directions once inside the website's mainframe. Across its home page is written, "Brandon: a one year narrative project in installments" accompanied by a gif of basic, familiar gender signifiers morphing into one another, baby, to skirted individual, to non-skirted individual. It's the common public signage kind, like on the entry point of a toilet door, but this gif loops to allow *Brandon*'s icon be fluid. Click on the figure and *bigdoll* interface crops up, a patchwork of fifty images, designed as random retrieval as you scroll over it, images of a suited male, of a tattooed torso with breasts, of brown nipples pierced, of dildos, of stylized diagrams of body parts (the prostate, the arm, the knee), of a bulbous crotch clasped beneath underpants, of chains, of a flower's hymen-like petals, of isolated words as if cropped from news headlines: "she," "wanted," "Death Ends Pose as Man." It's an accumulation of words

Figure 3.2
Shu Lea Cheang, *Brandon (Roadtrip Interface)*, 1989–1999, website, http://brandon
.guggenheim.org. Roadtrip interface design, Jordy Jones. Image courtesy of the artist.

and images in perpetual motion. This, my initial window, sets a scene, a
lexicon, of gender signifiers, of transformation, and establishes within this
scene a pleasure-pain spectrum.

The *Roadtrip* interface is conceived as *Brandon*'s trip where he would "surf
across Nebraska's Route 75, the nation border patrol, the linear time zone
and the gender markings to encounter fictional persona play along the
ever-extended, ever-expandable yellow dividers."[31] Configured like a black
road with yellow lines, neon road signs point outwards, or windows pop up
offering pills. It's ecstasy and agony, a cyber road movie, told in episodes
from a variety of perspectives. Brandon meets Herculine Barbin, Venus
Xtravaganza, and Jack Bee Garland, trans-historic transgender subjects. In

the *Mooplay* interface, different commissioned writers' texts are readable but also alterable by the user, interplay that creates a display of random images and links the play to live chat forums, in what Cheang describes as "ever re-combinant streams of narratives."[32] *Mooplay* is a crime scene too, the same chat forum where the cyber-rape took place and the notes left here are violent and disconcerting, harking back to Dibbell's account.

In the *Panopticon* interface, twelve black and white images of cells have been rendered and color-coded in red and blue, a treatment befitting the aesthetics of virtual gaming of that time. Each image connects to a harrowing narrative of historic punishments for transgender bodies, from incarceration and deportation, to sterilization and pharmaceutical testing. The original "panopticon" was Jeremy Bentham's (1787) design for prisons whose inmates were, due to their peripheral cells in the rounded tower, living under the constant threat of surveillance. This is a prison type that prompts Foucault's theory of the disciplinary complex, a physical structure that exerts itself on the psyche, the imagination, like the Orwellian nightmare of Thornton's techno-captive babes. Narratives of transgender subjects flash up through the apertures of these cells, punishing stories of shameful medical practices forced upon bodies in transition.

Brandon was the first Internet-based work to be commissioned by a major US public institution. Existing across a variety of material composites (as website, gallery projection, and live, networked events), it showcases—where form echoes content—the early drive toward a platform for the gathering of diverse material as a mode of identity building. *Brandon's* narrative, subject to numerous incidents of racial and gender discrimination, was nonetheless better captured by this multiuser website's capacity to host multiple, overlapping, non-linear, or non-binary information. In *Brandon*, we see how the accumulated content, consumed and produced by a variety of collaborators (on *Roadtrip* interface with Jordy Jones, Susan Stryker, and Cherise Fong; on *Mooplay* interface with Francesca Da Rimini, Pat Cadigan, and Lawrence Chua; and on *Panopticon* interface with Beth Stryker and Auriea Harvey) bears historical witness to numerous violent incidents. But we also see how this content presents a formal paradigm for any human subject as a receptacle of various narratives, images, and aspects that are fluid rather than static: as always, in formation.

There's an aestheticization of early cyberspace within *Brandon* (like the interiors of Cheang's earlier *Fresh Kill* sets) as a space of dark caverns, vast

terrains, and new frontiers. "It was exciting time homesteading cyber-space," Cheang recalls; "the net then was open mind field [sic] we stumbled upon."[33] The late 1990s Internet was a space to which Cheang was drawn, away from numerous legislative and social discriminations facing queer, transgender, and non-binary subjects. Here, new multiuser online plat-forms offered spaces for identity building and becoming, for choreograph-ing a body's relationship to others altogether differently. Here, all bodies were modifiable, presenting through multiple images and beyond fixed representation.

Beckman's *Hiatus*

Also moving from her work as a filmmaker toward the new potential of cyberspace, and concerned with how a filmmaker might approach the con-struction of identity, Ericka Beckman's *Hiatus* (1999) was a narrative film about a white woman's mixed experience playing an interactive virtual reality (VR) computer game. Protagonist Madi designs her avatar Wanda for a game of land exploration and acquisition, a territory that becomes subject to attack by an avatar-developer called Wang. Wanda's avatar is heavily stylized, dressed in a red corseted outfit, and progresses through the various levels, landscapes, and architectures of Beckman's surreal cyber-landscapes in order to regain her own freedom. Wanda wears a head-mounted dis-play, gloves, and movement-responsive bodysuit, and her live action shots switch between a day-lit apartment and dark-edged cyberspace. Signifi-cantly, the piece is not programmed as a multiuser site, nor an interactive or arcade game, but rather shot on 16 mm film with occasional animated sequences, achieved by consistently shooting in darkness, and overlay-ing and rewinding up to sixteen shots on the same frames of film reel, so as to build up layers of animation in a way that now looks digitally composited.

Beckman had moved to New York after graduating from CalArts in 1975, involving and familiarizing herself with movements in performance and filmmaking in New York. Having met Acconci in California during his teaching sabbatical in 1974, Beckman had played one of the actors in his *Red Tapes*. She was interested in his use of the deep space of the film set as a visual metaphor for the darkness of the psyche or "inner world." From 1976 onwards, Beckman limited her characters and their actions to

Figure 3.3
Ericka Beckman, *Hiatus* (1999), 16 mm film (color, sound), 21 minutes. Image courtesy of the artist.

the illuminated frame amid her set's darkness. In subsequent conversations with Tony Conrad, Beckman says: "I realized how I could manipulate this distance [between the image, the viewer, and the viewer's memory] by taking the easily assimilated images from my childhood and American culture, and perform[ing] them differently."[34]

She was also engaged with avant-garde dance, most notably that of Yvonne Rainer, and Rainer's interest in how games might provide a structuring mechanism for work. In Judson works, as well as through contemporaneous filmmakers, Beckman deciphered how task-oriented performances were able to break down the familiar movements of established tasks, or forms of labor, and at how the woman's body was conditioned as a site of subjectification but also its potential site of action.[35] As Eklund notes: "within each work [of Beckman's], the kinetically expressive movements are based on the 'task-orientated' choreography of Lucinda Childs and Trisha Brown, for Beckman is primarily concerned with drawing an image in space that unlocks an underlying emotional experience of great poignancy."[36] She had also been influenced by Rainer's filmmaking, when she visited CalArts as a tutor in 1974 while preparing for *Kristina Talking Pictures*. Beckman recalls:

[Rainer] allowed a few graduate students to access her process of story/scene editing by way of discussions about screen text and image and performance in a very conceptually rigorous way. I think it helped her to think out loud. She would diagram her scenes with index cards dividing each context into a separate card—spoken lines, gestures, text on screen, layout. I learned from example how to use the performance body to convey meaning without being "real" and how to make the context speak with more power than the performance. It made me look at advertising differently.[37]

Beyond the Judsonites, and Rainer's early films, Beckman's choreographies adopted more familiar characters, figures, or types within popular or folk narratives with whom she could dramatize or reorganize, for example, how a woman might encounter or confront her own image, which is a recurring motif throughout her work.

In *We Imitate; We Break Up* (1978), Beckman filmed her interaction with a marionette called Mario, a rudimentary anthropomorphic puppet with two legs and two arms, fabricated from plywood, painted in gray, and slightly larger in scale than a human. Handled from above by off-screen puppeteers, Mario proceeds with a number of basic movements, and Beckman's character, dressed in school uniform, begins to mimic them to the increasing pace and pitch of a female chorus egging this imitator along. Spotlighted and suspended in darkness, Beckman's task seems relentless and overbearing. The more she imitates Mario's image, the closer she comes to breakdown.[38] Adopting the spatial structures of various games, Beckman's narratives seek to expose subjective urges and social pressures that drive competitive participation, and she consistently refers to her cast members as "players."[39]

In Beckman's work there's a distinct choreography of tension, her subjects working out the anxieties of performing the image. From her early years reading Swiss psychologist Jean Piaget's *Genetic Epistemology* (1968), and staging tests to see how repetitive activities generate or create collective meaning, all aspects of her later productions emphasize a sublime connection between childhood and adulthood image-impressions.[40] Color-coding is often used through costumes and props, like signifiers used in children's games. Basic utilitarian costumes are regularly fabricated in primary colors decorated with elementary shapes, schema like those established by Guy De Cointet, and which she introduced to many of her collaborations with Mike Kelley. Where color and shape combinations quickly signify particular players or moves in children's games, these are often strategically implemented within her work to deconstruct or recode social symbolism.

Beckman's interest in games became more gender-specific over time: "There are many variations of competitive sports for boys that develop for these young athletes, with few new initiatives for girls, aside from gymnastics, cheerleading, skating and other forms of choreographic display. *After You The Better* I wanted to explore stories told through games for girls."[41] She summarizes her subsequent work, *Cinderella* (1986), as "an interactive narrative game for girls ... modeled so that the linear storyline would intersect vertical indices where the story could pivot and change."[42] Like *Hiatus, Cinderella* was shot on 16 mm film and was not participatory for the viewer as a video game might have been, but instead player participation is depicted within various action sequences. *Cinderella*'s plotline blends several historic versions of the fairytale, where the viewer follows the eponymous protagonist through several levels, over numerous attempts to escape servility, a back-and-forth that skews linear narrative progression.[43]

In a late scene, Cinderella encounters a doll made in her own image, composited beside her through a DIY animation effect achieved through a layering up of shots captured through the careful rewinding and time sequencing of the same film-reel. This display of a protagonist encountering her own image achieves a complex *mise-en-abyme*, one woman shot on film confronts her other animated version, captured through this process of overlaying image, positioned on either side of the same frame. It's a depiction of the confrontation of lived self with projected image, and the consequence is that Cinderella is appalled at the extent of her subordination. In this work various references jar, sung in pop-operatic tones, set largely in an industrial unit, and structured and animated as a 1980s computer game. But it's a suitably lurid aesthetic for a fable about the difficulties of liberating oneself from exploitative, feminized labor in the twilight between Fordism's mass production and more atomized labor associated with post-Fordism.

Carrying these interests into her next work, begun in the late 1980s, Beckman immersed herself in the communities and complexities of both VR and the Internet, carrying out various US-based field trips, attending lectures, watching demos, meeting innovators, and accessing VR equipment to get see how negotiable VR was to the human body. In July 1989, Beckman traveled to the SIGGRAPH conference in Boston where she encountered a range of demonstrations and 3D models of VR and the Internet.[44] By thinking through these early hyperlinked systems, Beckman quite

accurately anticipated the problems with the Internet's underlying mode of capitalization, asking at the time: "Who has control over these links? Does the system design links for you? Should we let it evolve, or hire a cataloguing expert? And how do we come to any agreement on what is a symbolic array? Isn't that subjective?"[45]

By attending early games conferences and nascent online chat forums like the WELL (Whole Earth 'Lectronic Link),[46] Beckman ascertained the Internet and VR's potential as "free" space while scrutinizing human exchanges online to assess how identity was being codified, and the significance of anonymity. She says, "It's important to understand where the context comes from and how it enables and constrains desire."[47] In *Hiatus*, Madi initially programs Wanda in seductive guise, but then "spends the greater part of the film warding off the danger that comes with choosing that image."[48] Beckman's decision to shoot both apartment and cyberspace scenes in 16 mm means that this film stock represents and recognizes both the spatial experiences of the player and their avatar as formative, rendering mutually informative the processes of self-construction within the work's denouement.

There is contemporaneity about the visual effects, movements, and perceptual depth achieved by her analogue working process that creates a sense of deep cybernetic space, and a luminescence and dimensionality to her live action sequences that a sophisticated 3D production suite might still struggle to achieve, creating a virtual space we might feel compelled to *get into*. VR and avant-garde film present some obvious differences Beckman admits, like the fact that film "detaches the viewer from the present reality and makes him a spectator," as opposed to the VR environment where "the viewer is in the frame … feeding back data into the immediate, present, real-time environment."[49] In comparing avant-garde film and VR, what was similar for Beckman was their aim to "pull the audience out of normal consciousness."[50] *Hiatus*, as its title suggests, sets out to ask whether there is a gap between virtual and lived existence as it experienced by its users, and whether power structures play out any differently online from how they're mediated in the round.

In 1989, Beckman was granted access to NASA Ames Research Center (ARC), where scientists were developing new forms of VR for a variety of scientific and military purposes. There, under the supervision of scientists involved in the Mars Landing Project, Beckman tried out the specialized

VR software, goggles, and gloves. It was a very male-dominated research environment, where she experienced several unwanted sexual advances from one senior employee. This was: "the catalyst for the narrative plot in this film. The dominance of both the military and scientific community in controlling the development of Virtual Reality became the central conflict in my film."[51] And pressure permeates the work from the moment Wang advances on Wanda, turning the land acquisition game into an urgent task of escape. This event was developed into a plotline roughly contemporaneously with the publication of Dibbell's "rape in cyberspace" article, which crossed the boundary of the virtual with repercussions strongly felt by its two victims. Throughout Beckman's piece, there appears a figure of a Native American man, represented early on as an animated Totem, and later in person (and outside Beckman's color-coded scheme) as a conversant and multi-skilled guide. And throughout the work, there seems an underlying effort to correlate the experiences of female and minority characters as those subject to assault, both material and sexual, perpetrated by this blue frontiersman as a proxy for patriarchal capitalism.

Wang, Beckman's fictional aggressor, is the personification of what Beckman has described as the "hard usage" of VR for combat, control, and capitalist self-interest, interpreting the military industrial complex as it surfaces in the digital age. This is set up by Beckman in opposition to what she often terms its "softer side," open, exploratory, imaginative, and fundamentally community-minded. She had also encountered the "softer side" at NASA, when she met Jaron Lanier, a VR innovator who had provided much technical advice to Beckman over the subsequent decade, and who, most crucially, in his very non-prescriptive attitude about how VR could be explored and implemented, encouraged her, as an artist, to consider and render interactive gaming in diverse, imaginative ways.

The work amalgamates aspects of several arcade and interactive video games Beckman was interested in at this time. The set was partially based on *Habitat*, the first large-scale, interactive, virtual-world game, populated and built by player's avatars, and released by Lucasfilm in 1986. Here players navigated crude 2D environments with their joystick, interacting with other players in apartments called "turfs." These animated environments appeared on the US domestic market a decade before *Second Life* (2003), the first widely played online virtual world, where players were to interact among a network of over one million users. *Hiatus*'s characterization

and appearance was loosely based on Sega's live-action video arcade game *Hologram Time Traveler* (1991), an interactive land-grab game featuring a cowboy, a princess, a warring samurai, and an evil time lord, each coded with a particular primary color.[52] What *Hiatus* reorganizes from *Hologram* is the prominence of the male protagonists as symbols of combat and self-determination, as they appeared in video games produced during changes in the infrastructures of technology capital, within a games industry oscillating between Massachusetts, and Tokyo, and Kyoto, during and after the video game crash of 1983.[53]

Beckman's color wheel coding draws together *Hologram Time Traveler's* primary colored characters, with an approach that resembles Guy De Cointet's color recoding, with a red moll, a green "goddess," and yellow factory workers, all appearing in some degree of corroboration and opposition to the blue cowboy Wang. Beckman's frontiersman was a common figure in video games, in a medium that was already predisposed toward masculine dominance, overdetermined toward warcraft due to its military origins, with early commands including tracking, targeting, and shooting.[54] Wang is dressed in a chroma-key blue suit and fedora. His name alludes to Dr. An Wang of Wang Laboratories, a key innovator of 1980s desktop computing, who employed 30,000 people in his Boston laboratories in 1989, and a figurehead of a US technological gold rush. Beckman's cowboy fantasy player announces, "I'm Blair 33 from Houston, but you can call me Wang." Unlike Madi, we're not shown Blair 33's player, but what we can gather is that Blair 33 is embodying virtual Wang to play out capitalist aspiration while maintaining the familiar ethnic coding of a blue (white) cowboy.[55]

Factory workers dressed and painted in yellow were intended to represent the partial outsourcing of hardware and other types of manufacturing (e.g., consoles, computers, computer chips, phones, and even animated films) to different parts of Asia. Three white men and three Asian men played the roles of technology workers in some geographically unspecified manufacturing unit between North America and East Asia. The third of the Asian men to appear was Japanese performance artist Tet Kinouchi, who opted to perform as a "parody of a Japanese house keeper and gardener as he would have been depicted in [North American] film or television after the Second World War."[56] Beckman judged Kinouchi's parody to be quite fitting, "mirroring the exaggeration of the Wang character."[57]

Residing over rules, strategies, and scores was a games-master, cast unusually for the time, as female. Beckman framed this character as an Asian "green goddess," dressed in a ceremonial gown and headdress cut like that of a geisha, but styled with the green on black lines of an early digital animation grid. Performed by a Thai-Russian actress Nicole Lim Thau, Beckman saw this character as representing "the growing stocks of the pan-Asian markets" of the late 1980s. Combined with the Native American figure, the technology workers and the corseted red (white) woman, there is a suggestion of each of these figures as having been limited, through violence, colonization, and industrial and post-industrial capitalism, and symbolically, through cultural stereotype. Within the plot's narrative, these characters cooperate to overcome the aggressions of the blue cowboy capitalist, a narrative thrust that displaced the power dynamics embedded in *Hologram Time Traveler* and other VR land-acquisition games at that time.

The characters Beckman depicts were "carefully constructed from my observations and research in the 80s and 90s"[58] of these VR arcade games, and *Hiatus* attempts to trouble how gender and racial stereotype operated and could be re-inscribed through the sort of imaginative roleplay of console gaming. It is her first attempt at an intersectional methodology and follows on from a long-term interest in undermining through mobilization and confrontation (articulated in performance and moving image), the fixity and stasis of gendered stereotype.

The "stereotype" has historically described a fixed image, a form that was in the eighteenth and nineteenth centuries considered a technology in itself. Used from the late eighteenth century in letterpress printing, the stereotype was a solid metal plate of metal cast from a *forme*, which would have freed the letters in the original type and created a speedy and effective method of printing. Its nuances have changed. It was described in the mid-nineteenth century as an "image perpetuated without change," and then, in 1922, as a "preconceived and oversimplified notion of characteristics typical of a person or group"—a description that remains, as an image that precedes, objectifies, or "others" particular subjects. Seo-Young Chu writes: "The dangers of stereotyping lie not in its existence but in the potential for its misapplication."[59] Dangerous when used to target and dehumanize specific groups, stereotypes are also harmful in their subtle

pervasiveness. Beckman's approach here was to exaggerate the symbolism inherent in gaming media of the late 1980s and early 1990s; however, a serious question remains about how effective her aesthetic and conceptual strategies were at upturning these various stereotypes, to which Kinouchi's contribution referred, and whether, in some respects, the work perpetuates them.

In *Hiatus*, Beckman moves from her longer term interest in challenging gender stereotype through various conceptual and aesthetic means, toward a representation of how new multiuser platforms were hosting various gender and racial stereotypes and making them accessible and physically inhabitable through the directed motions and costuming—the masks, girdles, and gloves—of early VR technology. And what seems vital in Beckman's chosen medium of 16 mm film is that it allows her to move between these two parallel worlds, the activity of becoming other, to track how various symbols mobilized by VR games were to be enacted by different players and how that physical, perceptual, and intellectual enactment was to inform their own comportment. *Hiatus* was a project that proposed, but also doubts, whether such performing subjects can achieve a hiatus, or break, in the continuity of already highly inscribed images.

Beckman's portrayal of this spectrum of stereotypes inhabiting multiuser platforms is carried out resoundingly from the perspective of the white, female subject. The only figure seen to operate outside cyberspace, controlling her operations from her living room, was Wanda, creating a feminized, white savior narrative, and objectifying and delimiting other characters within the field of cyberspatial activity. This is a key aspect of techno-orientalism, which contaminates much cyberpunk literature and film of this period, and a more lengthy analysis of the shortcomings of this work's intersectional methodology and its inheritance of cyberpunk's tropes remains to be undertaken. What perhaps, or in parts, distinguishes *Hiatus* from other early cyberfeminist approaches is that beyond its rather white privileging narrative arc, there is a clear attempt to study and choreograph movement beneath and beyond the ubiquitous stereotypes programmed in video gaming, and in doing so, as she'd observed of Rainer's filmmaking technique, to "mak[e] the context [of 1980s and 1990s console gaming] speak."

What Beckman found in this new form of mediated entertainment—the populous infrastructures of multiuser VR platforms—were new territories

where stereotypes were not solely culturally imposed and inscribed as they were by mainstream media, film, television, and publishing; in cyberspace, stereotypes were presented to be inhabited and played out, coproduced by players. The work poses oblique questions of what happens when such stereotypes are temporarily yet physically inhabitable, what conflicts and complexities might set or upset a player's imaginary within such perambulations and what social behaviors might be informed beyond cyberspace by such physiological plasticity. While Beckman's intersectional methodology shows as somewhat underdeveloped for its time, the work flags early on how multiuser platforms were set to facilitate (and capitalize upon) the performance of identity, either real or imagined—or real *and* imagined— and enable a congregation and interaction of such identities, a sociability that still represents a sizable part of social media's appeal. What was also thrown into question was whether the complexities and historic limitations forced upon subjects based on identity signifiers including gender and race, imposed by white patriarchal systems, could be severed or bypassed in a participatory cyber world.

Chun considers "high-tech Orientalism" in Gibson's *Neuromancer*'s "influential version of cyberspace, [which] mixes frontier dreams with sexual conquest: it reveals the objectification of others to be key to the construction of any 'cowboy.' This is, perhaps, a brilliant critique of Orientalism in general. Perhaps."[60] And the same "perhaps" swings like a pendulum over *Hiatus*, which seeks to ally its characters, exploited by technology capitalism. In the final scene, the console cowboy is morphed into a goldfish through a Tony Oursler-esque shadow projection, and interned in a bowl, a displacement of the frontiersman, which Beckman still thought achievable as the work was in production. And that production period was significant. *Hiatus* was made without institutional or gallery support from 1989 to 1999, and while the research, plot, and characters were developed, cast, and shot in the early 1990s, much of the animation, editing, and postproduction took place in sporadic periods from 1995 to 1999. This early production coincided with a crucial period in the development of the Internet, VR, and online gaming, anticipating the adaption of open source by global capitalism, leading to the kind of corporation-controlled prosumerism we might recognize and participate in now.

Set on and offline, continuous movement between domains informs Beckman's protagonist's perception of, and capacity to forge, her own

identity. Like Cheang, Hershman Leeson, and Thornton, there's a conception of audience or user participation in cyberspace as presenting, if not a "perfect play space," then at least the opportunity to reconfigure social space anew. They present in complexity the allures and anxieties of online identity games that have since relocated onto platforms like Facebook and Twitter, works that indicate early on, the many facets of prosumerism as we now know it.

4 The Big Bang

The target here, through a speculative genealogy of works, is to establish how artists have, for decades, been strategically and idiosyncratically combining expanded and mutually contingent fields of performance and moving image in order to make sense of, to scrutinize or antagonize, the various appeals and pressures to perform images, as seeded by the mainstream media in print, broadcast, and new technological forms, each from different structural relations to media—that is, to power. These works testify to singular, subjective instincts toward performative images based on—among other forces, quirks and incidents—various artists' non-identical, embodied imbrications of gender, race, ethnicity, sexuality, nationality, class, and ability.

This theory does not claim that these artists anticipate the rise of prosumerism or the popularity of social media in languages that are explicit, rational, or theoretical; nor does it say that now that we see how diffuse its activity, they stand aligned against prosumerism as a form of exploitative labor, committed to alleviating the anxieties, prosthetic memories, and group behaviors it produces. What these works do, encountered partially or as wholly as any reader might achieve beyond this writing, is to render the complexity and politic of this shared instinct to register as image, to transition from one's object self into its image version, to assimilate images from surface to interiority, to present, again, as image, and ultimately to be in control of these transitions with the tools and platforms that prosumers (or proto-prosumers) use. These are the primary, nonrational instincts that motivate prosumerism, the motivations that drive this billion-dollar industry, which is on course to change global capital and its political landscape entirely. The claim here is that Performing Image works anticipate, coincide with, and illuminate the multiple, self-differing motives behind

the world-changing activity of image work, framed strategically under neo-liberalism as image play.

Prosumerism's Origins

Prosumer was a term coined by Alvin Toffler (*The Third Wave*, 1980).[1] It fore-casted the ways in which the average North American citizen would be able to maximize on various advances in DIY technology, health, and science that predated the Internet. Toffler's "prosumption" described the activities of "proactive consumers" improving or co-opting goods and services beyond the marketplace, through sewing, cooking, repairing, adapting, or installing goods. It was motivated by Toffler's distain for the controlling, depersonalized financial sector of the 1970s and an aim to imagine a more cooperative and collaborative "Third Wave" of capitalism.[2]

Toffler's three waves correspond with three ages of industrialization, the first being the pre-industrial, agrarian economies, and the second being industrialization with the centralization of industry and its infrastructures, and the parcelization of services. Acccording to Toffler's scheme, both Sector A (producing goods or services for sale or exchange) *and* B (unpaid, domestic work) existed in the First and Second Waves, but whereas B was initially subsidiary to A, that reversed in the latter stage, with Sector A work grossly undervalued. For Toffler, social discrimination arises from these divisions, so in the Third Wave he proposed they reunite through the strategic uses of technology in the workplace to improve living standards for individual, self-sufficient workers.[3]

With changes in computation and communications technology, Toffler imagines workers living in a newly networked "electronic cottage" and contributing to what he calls a "homework economy":

An information bomb is exploding in our midst, showering us with the shrapnel of images and drastically changing the way each of us perceives and acts upon our private world. In shifting from a Second Wave to a Third Wave info-sphere, we are transforming our own psyches. Each of us creates in his skull a mind-model of reality—a warehouse of images.[4]

Toffler anticipates associated changes in cognitive processes because what technology enables seems to him to be notably visual. Capital, he foresees, will be derived through the exchange of personal information, because "information," he perceives, "has become the world's fastest

growing business."[5] It was an extraordinary prediction at the time, in the late 1970s, while computers were still large immobile objects that required punch cards to operate, before home computing, when work was still was largely confined to, and conceptualized through, workplaces, offices or factories, and domestic, health, education, service, or hospitality spaces. Toffler was able to foresee the way that many of us in a Western context now work, independently and precariously, from temporary offices, or commuting or otherwise in transit, plugged in to surf.

He also anticipated "user-controlled media" emerging as an alternative to mass media, through micro-magazines, special distribution TV, and interactive video games. Companies like Facebook represent the absolute convergence of these forms. In his description of "blip culture," Toffler might be describing the efflux of social media, with: "blips of information, ads, commands, theories, shreds of news, truncated bits of blobs that refuse to fit neatly into our pre-existing mental files. The new imagery resists classification [... coming] in packages that are too oddly shaped, transient, and disconnected."[6]

Toffler was influenced by Marshall McLuhan and Barrington Nevitt's attention to the role of software in the media, granting consumers a new capacity to meet their own needs.[7] His book also coincided with a trend in publishing technology-alert manifestos for new ways of living, established by Stewart Brand's *Whole Earth Catalogue* (1968–1972). But in his determination for advancement, Toffler's vision failed to address the possible fallout of prosumption. Prosumers ought to be paid higher "labor participation rates" with reduced hours per worker; however, "the question is not work versus leisure, but paid work for Sector B versus unpaid, self-directed, and self-monitored work for Sector A"[8]—and this is arguably the key social inequality that, rather than rectify, contemporary prosumption (or now, prosumerism) has ultimately compounded. Because what Toffler's theory failed to propose was how a judicious implementation of prosumption could be overseen or enforced, assuming that this radically new economic reality would self-organize without public intervention, and in fact that question—of who should regulate social media platforms—still looms large today.[9] In neglecting to envisage it as a global phenomenon, Toffler failed to apply to it the possible competition and marketization that defined his Second Wave. Finally, crucially, Toffler failed to envisage how prosumption might exaggerate gender, racial, and class divisions among workers

while simultaneously eroding the provisions of the welfare state. Speculating about leisure time permitted by a homework economy, he avoids the dystopian corollary of an always-at-work "precariat."[10]

Toffler underestimated how thoroughly technology capitalism would put prosumers to work, and rather than reform capitalism's Second Wave and liberate its workers, the third wave that was to materialize magnified the flaws of the second. The adaption of the term by Canadian business writer Don Tapscott and management consultant Anthony D. Williams (in *Wikinomics*) in 2006 provides a succinct roadmap of the activity's degeneration into something distinctly less liberating. As Tapscott's earlier management theory (*The Digital Economy*, 1994) was published, contemporary online prosumerism was in its infancy; but users were proliferating, and the number of platforms increasing.[11] Its devolution between 1994 and 2006 meant that, technically, even though the prosumer can in theory produce and consume in any realm, and under any economic philosophy, within digital economics he or she had become the ultimate neoliberal pawn, put to work for free by new globally reaching technology corporations.

Free Labor

In the mid-1990s, divisions between copyrighted, commercial software and open source software were developing, as were the working methods of their programmers. Open source is a development model that promotes universal access to a product's design and open redistribution of that design, including subsequent improvements to it by anyone. It was developed in response to a culture of copyright and intellectual property laws. Generally, open source code is modified by programmers trying to improve upon or alter the code, and, as regards commercial property, is the antithesis of proprietary software guarded by corporations. A main principle of open source software development is peer production, ideally with the end product, source material, and documentation made available and visible online, at no cost to the public. Linux is one well-known computer operating system assembled under the model of open source software development and distribution, released by Linus Torvalds in 1991, based on the earlier software Unix.[12]

Open source is a distribution model that predates the Internet,[13] but when it was brought online, its development could have gone in either

of two ways. It might have progressed as hypertext designer Ted Nelson sought, with his linking system Xanadu (which he had been developing since 1960), where original sources of code remained visible and were there-fore always attributable. This meant that there would be a two-way, more transparent means of developing online environments, but that it would also "guarantee that the owner of any information would be paid their chosen royalties on any portion of their documents, no matter how small, whenever they are most used."[14] Instead, the Internet's HTML model oper-ating today is one where code is not attributable, where the extent of modi-fication or reproduction of original code is illegible, and where authorship is not identifiable, often to the advantage of the corporation rather than the Internet user. Nelson has stated: "HTML is precisely what we were trying to PREVENT [his capitalization]—ever-breaking links, links going outward only, quotes you can't follow to their origins, no version management, no rights management."[15] Lanier has subsequently explained: "In a [Nelso-nian] network with two-way links, each node knows what other nodes are linked to it. ... Two-way linking would preserve context. It's a small simple change in how online information should be stored that couldn't have vaster implications for culture and the economy."[16] For Nelson and Lanier, this two-way model of programming, where source is traceable, is the only legitimate way that programmers and content-providers can fully disclose their sources and protect their output.

Thomas Streeter refers to the 1990s as a period when, especially as music files were openly shared on platforms like Napster, Linux and the open source movement undermined copyright in its legal and management function: "... freedom and the market were no longer synonymous and, in fact, seemed like they might, in some cases, be opposed."[17] This transi-tion upturns and aggravates century-old debates within the philosophy of property. Nelson's model provided the ideal open source in terms of autho-rial protection, where "each individual contribution to the system would be perfectly preserved and perfectly rewarded: the computer system itself is supposed to prevent the possibility of unattributed theft of ideas because each 'quotation' is preserved by an unalterable link that, not only allows readers to instantly call up intellectual sources, but also ensures direct pay-ment for each use."[18]

Changes in the implementation of open source had enormous impact on the transition from Tofflerian to Tapscottian prosumerism. While in

the late 1990s, programmers felt compelled to modify open source soft-
ware motivated by peer recognition and competitiveness, by 1997 this ten-
dency had come to the attention of commercial software developers like
Apple and IBM. Several key manifestos preempt the shift, one of which was
Michael and Ronda Hauben's manifesto *Netizens* (1992), which "compel-
lingly detailed the numerous ways in which the internet embodied forms
of spirited and deliberately collective action over capitalist self-interest"—
writing about how Usenet and other non-profit and collaborative commu-
nication systems, "taught a generation of technical professionals the value
of online, citizenly collaboration."[19] Another impactful briefing came from
Unix programmer Eric S. Raymond in his analysis of the economics and
subjective motivations of his activities in his essay *The Cathedral and the
Bazaar* (1997).[20] Highlighting how vocational the activity on collaborative
communication systems was, both theses alerted larger corporations to a
latent, voluntary work force. One year after Raymond's essay was published
online, Netscape, Apple, and IBM open-sourced their browsers, and he
began to work for them as a strategy consultant.

And these essays not also signposted corporations toward their new
labor force, they also flagged to them some of the reasons and motivations
this force would have to work for free: so the marketing rhetoric directed
at prosumers changed. Don Tapscott's *Digital Economy* emphasized the
potential profitability for corporations using programmers in this newly
precarious way and pitched these developments to business owners, prof-
iting from this new generation of voluntary programmer. "Prosumer" is
the term Tapscott and Williams ascribe to this individual agent in 2006.[21]
In Tapscott and Williams's reformulation, "proactive consumer" becomes
"producer-consumer." No longer is production defined by customizing or
servicing a product, but instead happens where "the consumer actually co-
innovates and coproduces the products they consume, self-organizing to
create their own wares."[22] Vocabularies of creativity are used to optimum
effect to attract prosumers to sign up to prosumer platforms emphasizing
the importance of "shared" intellectual property and collaborative online
working, while also innovating a new organizational structure and mode
of production as the "economy's primary engine of wealth creation." Put
simply, this was a point (c.2006–8) where corporations understood that
by encouraging prosumers to consider themselves as artists, and these
adaptable mainframes as exhibition platforms, they would exponentially
increase the growth of their users.

Tapscott's version of the prosumer was modeled on a Second Life architect innovating large-scale digital environments in which to play, working and innovating from a basic blueprint.[23] Second Life architecture is therefore both consumed and produced, and as it grows into its own world; real, but built from a collective imaginary, it draws in other users, creating a cellular domain that is self-generating and self-sustaining, a business model less concerned with creating products than "innovating ecosystems."[24] Not coincidentally, Second Life's predecessors, LambdaMOO and Habitat, were both open source, multiuser online environments to which Cheang and Beckman gravitated to research *Brandon* and *Hiatus*, respectively. It is perhaps testament to these early platforms' potential for creativity and "free play" that attracted these artists, among many other users, without previous programming skills or interests, online to play with, and among, others.

Tapscott and Williams saw, in Second Life, that a new mode of "interacting means [consumers] will treat the world as a stage for their innovations … static, immovable, non-editable items will be anathema, ripe for dustbins of twentieth century history."[25] Second Life predates social media sites like Facebook (founded 2004), Twitter (established 2006), and Instagram (founded 2010, acquired by Facebook in 2012[26]), all sites that have also profited enormously by interim developments in technology such as the smartphone (BlackBerry Messenger 2005, iPhone 2007[27]); but Tapscott and Williams's later description of their working mechanism is absolutely applicable to these newer sites of prosumerism.[28] And while these websites make claims to, and arguably succeed at, providing sites for creativity, communication, autonomy, and publicity, in their use of open source programming they have also drawn significant profit from creative, citizenly cooperation.

As things stand, Toffler's socially enabling prosumption was usurped by Tapscott and Williams's version, which, motivated by promises of creativity, sociability, and visibility, sets us all up to work for free. It is "user friendly" only in the loosest possible understanding of the term friend. Toffler's Sectors A and B fuse, creating a highly effective management system that profits from non-attributable free labor, destabilizes mass media, feminizes the workforce, and symbolizes and coexists with neoliberalism as an economic philosophy that lowers living standards, increases financial dependencies and debt, and exacerbates divisions between rich and poor.

Prosumerism at Work

In the digital economy, the forms of attention paid to online materials vary, but attention is universally recognized as commodity: search engines appeal to it, harvest, and sell it in different ways. Google's search words, in a similar vein to Facebook's "Like" button, allows these platforms to aggregate individual user or IP address's data from large social groups, to calculate and target advertisers and users, in turn.[29] They also sell advertising space, information that directs our gaze toward the screen's header or sidebar.[30] But it is important to distinguish browsing revenue from the revenue derived from a prosumer's activity, i.e., from production, where viewing motivates production, which creates a process of consumption-production-consumption, a cycle that builds and fortifies media-hosting platforms online. Although prosumerism encompasses all of these initial stages of consumption, production in turn is key to the continuum.

Considering, as Leckey does in 2008, prosumerism to be a creative act, it is also worth considering it, in its most basic form, as a type of exhibition making, which is broadly speaking the act of accumulating, editing, showing, and making public diverse information, presented to an audience and contributing to a broader cultural conversation. And that facility is one of the aspects that websites like Facebook, Instagram, and Twitter market themselves upon. Sign-in pages describe these services similarly: "Facebook helps you connect and share with people in your life"; Twitter helps you "Connect with your friends—and other fascinating people"; Instagram allows us to "Capture and Share the World's Moments." Once you are through the sign-in page, you arrive at an interface with a clean, and often uncluttered periphery, and a central vertical column with a stream of captions, images, gifs, and links, the newest additions arriving at the top, with a vertical scrolling function to maintain visitors' attention.

Critics are conflicted as to whether the fixed formats and functions of prosumer websites allow for contributors' individuality and creative freedom. Sherry Turkle proposes that Facebook users, rather than projecting creative work outwards, are more self-conscious about glances toward themselves, prioritizing "assembling cultural references to shape how others would see" them, many of whom were ultimately "exhausted by the pressure for performance."[31] Geert Lovink writes: "Social networking sites, anticipating this movement toward security (that is, toward one identity)

coupled with our personal desire for comfort, offer their users a limited, user-friendly range of choice for submitting private and professional data to the world."[32] Its plainness horrifies Zadie Smith. "We were going to live online. It was going to be extraordinary. Yet what kind of living is this? Step back from your Facebook Wall for a moment: Doesn't it, suddenly, look a little ridiculous? *Your* life in *this* format?"[33] Social media's temperate armatures' resemble the colorless, angular interiors of a contemporary art gallery. The newsfeeds that run through this central space support the material like a plinth might a sculpture, a vitrine a drawing, a stage a performance, a wall a painting, a screen a cinematic projection. Information bits vie for our attention, while the furniture that supports them holds them tightly in place.

Prosumer platforms' interfaces seem deliberately pared-down, off-white backgrounds, discreet branding, embedded links, conscious decluttering, to keep the cogs of its commercial and political workings backstage. Brian O'Doherty warned about the illusory dangers of any white cube in 1976: "Unshadowed, white, clean, artificial—the space is devoted to the technology of esthetics. Works are mounted, hung, scattered for study. Their sterile surfaces are untouched by time and its vicissitudes. Art exists in a kind of eternity of display, and though there is lots of 'period,' there is no time. … The space offers the thought that while eyes and minds are welcome, space-occupying bodies are not—or are tolerated only as kinesthetic mannequins for further study."[34] O'Doherty saw the codification and elitism of modernist exhibition spaces as the architectural extension of a generalized condition of the image, in a society where spatial-perception and lived experience was not only mediated but "invented" by photography. The white, airless gallery was a platform for display that disguised time and exaggerated a Cartesian displacement of body and mind, concealing its commercial mechanisms. Is it any wonder then, that social media has evolved to look the same? O'Doherty's description of this interior and its shaping of the viewing encounter might describe the platform and sensibility of the contemporary prosumer experience, where bodies visit regularly (bound in a state of suspended time), regarding organized material set upon pristine display architectures, seeing oneself as a viewer (in an altered state of corporeality), and where one's line of vision is strategically directed, tracked, and ultimately made productive.

But these are spaces for the exposition of personal, emotional, biographical information. While the multiuser platforms Cheang and Beckman co-opted or rendered were peopled by anonymous users, contemporary prosumer websites largely brand real identities that link people in both professional and personal contexts. Lovink writes: "In the competitive networking context of work, we are trained to present ourselves as the best, fastest, and smartest. At the same time, we are aware that this is only an artificial, made-up image of ourselves and that our 'real' self is different, which is what celebrities have been grabbling with for decades."[35] This "real" self, so well packaged, and sent out so frequently, has been usurped by a new anxiety, which is in fact an old anxiety, one that Benjamin noted in 1936, after Pirandello "grips the movie actor," marking him with "inexplicable emptiness," as his body, captured by the cinematic image, loses its corporeality and his aura "evaporates." The movie star's aura is replaced by "the phony spell of the commodity," and this is a commodity spell that has trickled down and been parceled out among us.

By hosting a wide range of personal information, platforms appeal to a range of viewers and accommodate immediate and diverse responses. On Facebook, for example, this is through the "Like" button, with the icon of a white thumb pointing upward. In February 2016, this button was upgraded to include five additional responses, designated the terms, "Love," represented, rather predictably, by a heart, and four more: "Haha," "Wow," "Sad," and "Angry," each symbolized by moderately expressive emoticons. With this upgrade, prosumers can respond to individual posts six ways, so that the host platforms can get a clearer reading of public perception of particular issues or brands. This quickfire game of call and response, of image and affect, divulges more information than the like button alone, and is more swiftly aggregated than comments or content. Affect buttons respond to content that is reliably heterogeneous; but once harvested, sold, and repurposed, it can be reinserted into news streams as advertisements or sponsored content. The infrastructures of social media have been adapted into targeted information looped regulated by the chambers of technology corporations: a totalizing commerce of monitored exhibition and staged encounter. These "loops or cycles" that we're in are perhaps distinct from what Hardt and Negri describe, in 2004, as the "expanding spiral relations," the fluid procedures and unfixed outcomes when, "communication, collaboration, and cooperation are not only based on the common, but in turn

produce the common." The commons they describe predate (and hopefully succeed) the recursive, capital-yielding loops of contemporary prosumerism that Leckey early signals, the processes of which, I propose, his work, among others, penetrates or delays.

Image habits emerge among prosumers, signing in on multiple occasions. Some platforms perform better in the early morning, others in the later stages of the day.[36] Facebook, Instagram, and Pinterest attract peak visitors on weekends, whereas mid-week posts appeal to and attract viewers on Twitter, LinkedIn, and Google. Timings reflect common usage of individual platforms, but as patterns emerge, users become both target and stalker. Friends, networks, and followers are counted, their numbers displayed on every interface as a measure of success, popularity, or productivity. Individuals and corporations alike seek attention, posting material that seems personal and esoteric, while nuancing finessed versions or brands. Social media is never static: its content is perpetually refreshed. There is no delineated or marked time, but rather a perpetual populous present, lit up by images, sent out in search of others.

Geopolitical borders have, thus far, largely been bypassed by social media platforms, the leading examples having almost global reach. Facebook is the most popular global social media platform with the significant exception of China (where Facebook, Instagram, and Twitter are blocked in most areas, and where GQ and WeChat are used instead), parts of Russia (where VKontakte and Odnoklassniki, both owned by the Mail.ru group, dominate), and a significant portion of Africa.[37] In 2016, Facebook CEO Mark Zuckerberg sought to change this, bringing solar-powered drones and new satellites to seventeen countries across south, west, and central Africa, facilitating free access to several websites, including Facebook, through his Free Basics initiative where he has described Internet and social media access as a "basic human right."[38] An earlier version of a similar Facebook scheme (Internet.org) was banned in India in 2015 after much online dissent on the basis that the partial Internet it offered compromised net neutrality and in fact represented a strong strain of digital colonialism. The Save the Internet campaign's Timothy Karr acknowledged Zuckerberg's "genuine zeal to connect the world," while underlining his ambition to "dominate the global internet landscape."[39]

And it's reasonable to assume that, left unchecked, Zuckerberg would continue to expand his business across all continents. But repercussions

to its practices of knowledge extraction, and the content seeded to target it, are underway. Regulations such as the General Data Protection Regulation, brought into the EU and EEA in 2018, ostensibly gives the European authorities jurisdiction to investigate and punish unfair trading of data across international domains, although the challenges of its enforcement are yet to surface. Facebook's suspected impact on the outcome of the 2016 US presidential election, through its association with British political consulting firm Cambridge Analytica (CA), has forced public authorities in the US and the UK (by the Federal Trade Commission, and the British Information Commissioner) to investigate the usage of its unprecedented access to personal and emotional information. Although still under investigation at the time of writing, Facebook would seem to provide ideal data sets for digital campaigning organizations like CA, because, as CA's managing director Mark Turnbull was recorded as saying, "It's no good fighting an election campaign on the facts, because actually it's all about emotion. The big mistake political parties make is that they attempt to win the argument rather than locating the emotional center of the issue, the concern, and then speaking directly to that."[40] By understanding and intercepting the processes and exhibition architectures of prosumerism, the companies harvesting and planting information and knowledge through social media are having unprecedented global impact.

The Big Bang

As Toffler anticipated, blip culture works *through us*, with information bits displayed on platforms to facilitate swift viewing and transfer, producing insatiable appetites for viewing. And it is the contention here that Toffler's image-warehouse mind-model accurately predicts contemporary prosumerism as a cultural phenomenon and economy that is visual, that seeds images and germinates image desires, that recognizes that in the attention economy images present the swiftest, sharpest hook. And as well as having access to billions of users' data, tracing and aggregating the click trails that each image post elicits, social media platforms also license the images that surface within them.

Prosumerism and the stock image industry are two fields of production which have recently converged to produce microstock photography: photographic stock filtered from social media platforms discreetly or covertly as

data, symbolizing another quiet advancement from the already hazardous work conditions encouraging creativity while skimming from the surface of unremunerated, imaginative labor, in sufficient volume to drown stock photography's entire industry.

Stock photography has existed since the mid-nineteenth century invention of the half-tone printing press. In 1920, American entrepreneur H. Armstrong Roberts began stocking surplus images from commercial photographers' outtakes from magazine and editorial shoots.[41] But from the 1990s, Corbis and Getty Images established themselves as market leaders by co-opting new technology's capacity for distribution, compiling seasonal selections of stock images in catalogs, and distributing and selling them on CD-ROM. In its current form, stock companies use digital technology for easy, swift modifying and the Internet for accumulation, distribution, circulation, remuneration, and regulation. Stock images have historically thrived through bulk and speed, representing a generic present or anticipating future events.

Getty Images and Corbis's market dominance has as much to do with policing specific copyright policies of the "content" they provide as it does with accumulation or provision.[42] They continue to market themselves as providing clients indemnity against copyright infringement and providing whatever legal action is necessary to maintain copyright integrity, listing the penalties associated with randomly sourced online images. Stock is continually fingerprinted by online image search engines and tracked if in illegal use.[43] It is through this policing and governance that agencies expand portfolios and yield profit: pitting producers against consumers and positioning themselves as judicious intermediaries.

A "microstock" agency typically denominates lower rates for stock images than the industry leaders, but the term expanded in 2009 to define image stock sourced from prosumer websites. The shift was marked by Getty Images' 2009 acquisition of Flickr's sizable repository of amateur photography.[44] Flickr (launched in 2004) users had traditionally uploaded their image portfolios and shared them among friends online, protected under Creative Commons. When Getty Images acquired Flickr in 2009, users could submit their pictures to the Getty collection by clicking their "request to license" after uploading pictures, which alerted Getty editors to new and growing portfolios. Getty employed individuals to trawl through these images systematically, for which the agency would receive upward of

80% of the revenue of the sale once the photograph has been purchased and consigned. The CC license was also then legally retracted, undermining the principles of the nonprofit organization, "that assists authors and creators who want to voluntarily share their work, by providing free copyright licenses and tools, so that others may take full and legal advantage of the Internet's unprecedented wealth of science, knowledge and culture."[45] Flickr and Getty separated in 2014, with Flickr establishing itself as a microstockist, but since the initial merger most prosumer websites followed suit with requests to license all their users' uploaded images.

When we sign up to social media platforms, we agree to license the images we upload, the terms and conditions of which are regularly revised. In Facebook's registration process, for example, there are approximately eight pages (approximately 14,000 words) of legal documentation detailing the company's terms of service. Oliver Smith remarked, "A photo posted on Twitter remains the intellectual property of the user but Twitter's terms give the company 'a worldwide, non-exclusive, royalty-free license (with the right to sublicense)'. In practice, that gives Twitter almost total control over the image and the ability to do just about anything with it. The company claims the right to use, modify or transmit your photo any way."[46]

Corbis and Getty Images regularly acquire contemporary and historic archives of images to expand their reach and potential profit margins—and, acquiring large public archives from South Africa and Asia, among other territories, signifying a privatized, image colonialism whose profit centers are based in North America. Meanwhile, social media platforms are now on course for gathering the largest image repositories in the world, licensing all their content as they accumulate, able to fingerprint their producers, facially recognize (and through recognition technology gain licensing from) subjects, while reserving the right to use these images in whatever way they see profitable now and in future, selling to whatever private or public agencies they deem fit. And, during a crisis in Western representational politics, this privatization of such a vast database of public information is a truly unsettling reality.

In a situation where people are producing and consuming information on social media for a variety of reasons, and those posts are monitored, licensed, and held in evolving ways, Getty's 2009 acquisition of Flickr represents something of a "Big Bang" in much the same way the term was used to describe the deregulation of global financial instruments in the 1970s.

At that time, the integration of the stock market with financial trading markets resulted in the free operation of banks across borders, the consequences of which we still feel today. Now, social media platforms work like image banks across borders, trading up our licensed images, deregulated and unleashed. Writing about the financial Big Bang, David Harvey has described contemporary capital as a fluid process where money is sent out in search of more money.[47] Similarly, microstock is profitable through the strategic accumulation of diverse portfolios: images communicate, attract attention, and inspire the production of others. Images are sent out in search of others, the products of which are then patrolled, licensed, and monetized through highly effective corporate intermediaries. It represents a seismic deregulation of image labor and a milestone in the relations between the image, viewer, and capital. And if data regulation seems on course through existing and emerging organizations, how do we think about the long-term protection and fair use of prosumerism's creative spoils? And what role, if any, does art play in reflecting the terms and conditions of prosumerism's affective toil?

Microstock's Big Bang in 2009 signals the beginning of an active and aggressive colonization of visual material, the scope of which has no photographic, archival, art historical, or cultural precedent. This is also the period where Leckey, among many other artists far beyond the established lineages and genealogies of net.art, pull focus on prosumerism as a mode of production and consumption with which they are engaged, involved, or absorbed: intuiting or identifying it as subject and activity with enormous scope for play.

5 Performing the Prosumer

In this chapter, I look at specific works that trace the prosumer experience post-2000 by Mark Leckey and Frances Stark. Unlike Beckman and Cheang, during this period Leckey's and Stark's work had already shown in international art institutions, and was represented and sold by commercial galleries across Europe and the US. Thus, they were exploring the performative qualities of online multiuser platforms at a different point in the timeline of prosumerism, developing their own online identities rather than assuming others, and scrutinizing the creative toil of online image work from a different professional vantage point from Beckman and Cheang. They have also both benefitted from a professional mobility quite different to those in previous chapters, and although both have worked and exhibited extensively in New York, both are now based elsewhere. Within their work over the course of this decade, Leckey's and Stark's narratives chart the transition from studio practice (physical studio spaces feature in their works from 2000–2005) to post-studio, or flexible labor (where their work and struggles as "virtuoso," flexible, or adaptive worker-artists features regularly), and they show and perform this transition in spaces online and in the round. In a sense, their works represent less a transgression of the representational space of new media, or a direct critique of prosumerism, than they do inhabit the indeterminacies between image work and image play as a quasi-professional milieu and compulsive personal preoccupation.

Post-2000, their depiction of their creative practice, sites of production, and platforms for exhibition, simultaneously as artists and as prosumers, presents an interesting detour of this mode of production, which is, in itself, so heavily modeled on notional idea of artistic labor, marketing itself as providing the advantages and autonomy of artistic life, and designing itself after strip-lighted, white cube architectures. What Leckey

and Stark are producing, as artists, are works made from the materials and experiences—enriching, impoverished, interesting, and banal—that they have had as prosumers, but what they combine is more cohesive and provocative than the deluge of images many prosumer might face.

By acting as mediators of this material, rather than intermediaries, that is, by taking and making something distinct from what has been gleaned from this process of accumulation, affiliation, and assimilation, they find a different way of acting and of self-valorizing as prosumers, while also creating works that operate reflexively on the multiple viewing conditions within which they are shown. It seems important to underline that works included as examples of Performing Image are not straight facsimiles of the familiar rubrics, graphics, or languages of the prosumer or social media website (although many works of this kind do exist), nor do they critique prosumerism simply by reproducing the material of prosumerism and transposing it into a gallery setting. Jesse Darling is alert to the inherent contradictions at play in such transpositions.[1] Darling has been vocal with an astute critique of artists who transfer material from social media to exhibition form in a very basic fashion, for example by printing screen-grabs, or transcribing online dialogue.[2] Post-Internet art of this sort serves to perpetuate rather than alleviate discrimination within an intellectual or cultural class system, to reinforce a hierarchy between spaces for occupation, for discussion or exhibition, a marking out that distinguishes the expert from the online "dumb user."[3]

This chapter will focus upon works that, from their conceptualization, production and exhibition, transition or coexist between viewing portals and digital editing software online, and galleries and institutions in the round. They do not present overtly oppositional stances toward either art-world hierarchies or prosumer ghettos, however their reflexive criticality within different exhibition architectures, complimented by a mutability of form, is, as I see it, part of their intrinsic critical value. Each gallery and online platform carries its own specific and individual politics and biases—informed by their own geographies, cultural histories, social affiliations, and constitutive economies—but each one also shows work differently because of the very different postures and attentions they require of every individual's body. While the white cube, and particularly the commercial model that supports it, is in many ways a problematic, uninspiring, and staid architecture, it is one that makes space for our own fleshy units to

circulate and attend to works across all media, architectures for viewing that can collude with, or work in opposition to, the attention capturing mechanisms of viewing spaces online.

Mark Leckey's *In the Long Tail*

Mark Leckey's works are openly subjective explorations alert to what it is to be a producer and consumer of images. Many of his works consider how distant or proximate particular images *feel* to his body. Leckey evaluates his own subjective experience through the images that form it, drawn toward the social inclusion that it might permit.[6]

From his earliest works, Leckey has looked at how images provide a modern transcendence and a means of connecting with other people. *Fiorucci Made Me Hardcore* (1999) is a video made from excerpts of analogue video cassette reels of different concerts and gigs compiled from friends' archives, footage or transfers from the Northern soul dancehalls of the late 1960s and early 1970s to discos of the mid 1970s and underground raves in the 1980s.[7] *Fiorucci* references the artist's own experience wearing the Italian sports clothing brand associated with an electronic music scene in northern England in the early 1980s. It was a choice of clothing that also constituted a form of resistance for groups identifying as "casuals."[8] The branded clothing provided a codified means of identification and outward invisibility.

"Brands imprint themselves on your psyche," Leckey has said, "*Fiorucci Made Me Hardcore* basically says that a brand made me transcendent."[9] The artist's captivation with the branded image reappears throughout his later work, often divulged as a source of ecstasy and a means to transcend various social divides.[10] Leckey frames his long-term engagement as: "a way of figuring out what my relationship is to these things. But at the same time they magic up these things that are incredibly beautiful. Or that can be used in a way that is transformative … I don't know what its power is and I can't just be critical of it because it's part of the fabric of the world I live in. I don't know how to step beyond that wall or be detached from it."[11] In Leckey's conceptual paradigms, images pass through the body too, through the colon, imbibed like food. While Leckey was not drawing on his direct knowledge of Beckman's works (which remains largely underhistoricized in relation to the works of her male counterparts), aspects of her practice and interest in the perceptual and developmental impact of

images resonate in Leckey's oeuvre in his open acknowledgment of Mike Kelley, as an "art hero," adopting aspects of his performance persona, interest in popular culture, and his abject references to the body as a site of image invasion.[12]

In *Parade* (2003), the assimilation of images is shown to physically exert itself on the protagonist's body within video, played by Leckey. Set in a dark, round film studio, a large screen plays image sequences rotating on loop. A glamorous man appears at intervals, shot from a camera pivoting at the studio's central point, walking against the direction of the projections between synthesized, asynchronous beats. The projected images behind him include a nightscape of neon-lit tech stores on London's Tottenham Court Road, the display window of a men's luxury clothing store, and the cover image of Brandi's *Full Moon* album from 2002—an album that Hannah Black describes "pioneered a vocal recording style that layered and overlapped her voice," an analogous innovation for a singer who saw herself perform "all my 19 identities on stage."[13] These images are edited into rostrum shots as if being brought *through* Leckey's body. Leckey, as vessel or temporary host, channels the surface qualities of these images: his black costume becomes more opulent in color and texture, his hair slicked back, skin smooth, like it's airbrushed. The transition or passage of image through the body relates back to Rauschenberg's "contact"—it drenches the artist's appearance.

It is a complex dynamic that Catherine Wood notes: "rather than presenting a coherent identity, the film proposes its subject to be lost in a struggle to distinguish between interiority and surface."[14] As Leckey's appearance is buffed in continuous loops (as are Leckey's screening instructions for the work), *Parade* refuses to distinguish an original or true version of the self over its representation. Image appears within image, as the passage of images through the consumer's body is shown to exert physically, making this loop or cycle that we're in visible. Appearance, as outward identity, is shown as a dynamic, perpetually shifting thing, the fluid assimilation and production of what Donna Haraway once described as an "accumulation strategy."[15]

Several years later, Leckey began a different exploration of how images are felt to pass through the body in his *Cinema-In-the-Round* (2006–2008), an ongoing series of lecture performances outlined in the first chapter, which now exists as a video (2008)[16] and is titled after "theater-in-the-

round," an architectural construction where theater audiences surrounded the stage from 360 degrees, which intends to create immersive viewing conditions. Masticatory metaphors are used frequently, suggesting flat images appeal as if they were food, appealing as if they were sustenance "in-the-round."

Leckey began, spotlighted at the rostrum. Dressed in a tuxedo, standing beside a screen, he gives a running, comic commentary on his experience of a carefully ordered and timed sequence of still and moving images projected before the audience. His presentation is divided, like a lecture, into four parts, or chapters. "MEAT & POTATOES" is the first chapter, containing stills of Philip Guston paintings from the late 1960s and 1970s flash up (*Head, Bottle, Light* 1969, *Friend to MF* 1978, *Painter in Bed* 1973, *Shoes* 1980); and, as it progresses, the artist's register begins to shift from knowing expert to responsive poet, an oscillation that continues throughout the presentation: *"They are MEAT and they are POTATOES, They're down to earth and they're flesh and blood, They are DUMB and they are DUMBERER, They're*

Figure 5.1
Mark Leckey, *Cinema-in-the-Round* (2008), DVD, 42' 21. Courtesy of the artist and Cabinet, London.

thick as a brick and a bit puddin' headed, They are MENTAL and they are MAT-TER, And that's because they are images AND they are things ... They are soup that eats like a meal."[17]

His chapter includes wildly diverse images: of works by Philip Guston; by Georg Baselitz; an extract from *The World of Gilbert and George* (1981) that shows the "unstill lives" of vegetables floating in the dark; a video of mirror box therapy for phantom limb pain. Leckey announces: "I've sand-wiched this piece, which is about a lack of something, smack-dab in the middle of these other parts which are all about an excess—of things exceed-ing and exaggerating themselves—in order to draw attention to their pres-ence, their being-in-the-world.... They threaten to spill *out* of themselves, frustrated with their limited beings."

The following chapter, "SACKS OF FUR," combines disparate images of the feline form to illustrate the various transfigurations across the history of representation.[18] The cat symbol conflates (and thus dissolves) various image taxonomies, art historical statuary (the sphinx as an early sculp-ture), television broadcasting history (Felix the cat as the first broadcast image), and emblems of the Pareto curves that represents emergent pat-terns in e-commerce.[19] How are images felt when new technologies seem to change their resolution, or volume? He refers to Sergei Eisenstein, who "talked about the ecstasy of sensing and experiencing the primal omnipo-tence, the element of coming into being and the plasmaticness of existence within the cartoon-animated world from which anything can arise. He says of Disney's animations that they are 'beyond any image, without an image, beyond tangibility—like a pure sensation.' It is that 'without an image' that entrances me—what does that mean?"[20]

In the third chapter, "The WARP and the WEFT,"[21] the artist explores his difficulty in distinguishing the "horizontality" of the image (its flatness) from its "verticality" (its appearance as an upright object), especially when the flat is projected so as to look upright and animated to appear more three-dimensional.[22] It's Leckey's alternative theory of the attention econ-omy, animated by screening an excerpt of James Cameron's film, *Titanic*, as, "The theme of the film is based on Marx's phrase: *all that is solid melts into air.* Cameron uses this idea to describe how the manifest materiality of heavy industry at the beginning of the century dissolves into the impal-pable, intangibility of software production by its end. Where everything has *become an image.*"[23] *Titanic*'s icon becomes a metaphor for the transition

from two-dimensional pictures to the ubiquity of what seems like three-dimensional images, during a period when industrial labor sinks into its affective successor.

In his final chapter, "ROCKS ARE SLOW LIFE," Leckey addresses the perceptual confusion at animated depictions of organic matter, on the curiously living appearance of animated rocks, stones, and metals versus the strangely inert emptiness of vegetable life, evidenced through images of elements from Swiss artists Fischli and Weiss's *Raft* series (1982), objects carved from polyurethane. Here, in this dearth of images, there is no distinction between natural or fake, organic or inorganic; everything perceived at the level of imagery, that is, every object considered as image bears weight. This concluding chapter ends with a garbed excerpt of Hollis Frampton's seminal structural film, *Lemon* (1969, 16 mm), which originally aimed to reveal the emotive technical devices of cinema.[24] But Leckey's pointed counter-interpretation relinquishes Frampton's concern and indulges cinematic effect "in all its voluptuous pulchritude and lemonyness."[25] This critical position of, if not uncertainty, then instability, in relation to the impact or force of images upon a subject, is a much more opaque proposition than Frampton's, but also one that accommodates various subject positions, and acknowledges more heterogeneous motivations and capacities for engaging critically with images than structuralism's foundational critique perhaps allows.[26]

Despite its structure into chapters, this differs from experimental documentary or essay film in that the artist's body is present on stage, as a responsive subject filtering and projecting the images he's presenting beside him. It's a poetic articulation of this filter, this channeling. And with his performed ego, or alter ego, image-assimilator Leckey's piece recalls aspects of Matt Mullican and Guy De Cointet's performances enacting the perceptual activity through which consciousness is formed, combined with elements of the abject personas of Michael Smith and Mike Kelley who exposed the "pathetic" consequences of internalizing idealized media imagery once it passes through the body. It's this passage from surface to interiority that's foregrounded in his lecture performances, his body at the lectern, as if to stress the physicality of this process. His is an interior made visible, his image-mediating monologue and projected pieces relaying to us, like an endoscope into the gut, the images he consumes and the media that yoke him along.

After making this work, Leckey was interviewed in 2008 by Creative Time, when he identified as a prosumer. It was during the period that Facebook and YouTube were widely used; both were created in 2005, the year before Twitter came to common usage, and two years before Instagram was launched (and just prior to what I previously identified as the Big Bang, when social media began licensing prosumers' images as stock). This was the same period (2006–2008) that the term "prosumer" came into common parlance through Tapscott and Williams's *Wikinomics*, or certainly when it became familiar to those interested in how the Internet could facilitate the circulation of information and the distribution of goods, and how it might influence social, or consumer behavior. *Wikinomics* encouraged companies to harness the creative instincts of "bedroom DJs," among other creative types, which is just the type to which Leckey is relating and appealing, and the fact that YouTube is platform for random and arcane prosumer material would seem to constitute much of its appeal. His is an exaggerated performance of the elixir that floats prosumerism, and the work focuses not only on the material he finds there, but the instincts of those who deposit there.

Leckey refers to himself as a prosumer in the process of making a subsequent work called *In the Long Tail,* after Chris Anderson's eponymous economic theory about Internet consumerism and the global distribution of goods.[27] Like *Cinema*, Leckey first delivered this work as a lecture, animated with still and moving images and objects or props.[28] Behind him at the rostrum is a freestanding blackboard where he draws the outline and (long) tail of a cat while introducing timed mechanisms or projected moving image sequences to demonstrate his points. He begins: "The long tail is a theory about the Internet and I spend a long, long time on the Internet, longer and longer actually, and this is what I am constantly thinking about—what my uses are, why I use it and what I get out of it. These are my reflections about its history, its present and its future."[29]

Leckey returns to Felix the Cat, which he has remodeled and placed on stage to recreate the scene of its first live broadcast, and to demonstrate this rudimentary animation process for us. He describes how, through this process, the cat becomes "more rounded, atomized, and dispersed into the ether." The operational efficiency of Leckey's onstage recording apparatus is dubious; the firm focus is on the metamorphosis of the object into a broadcast image and the visceral experience of witnessing that, rather than

Figure 5.2
Mark Leckey, *Mark Leckey in the Long Tail*. Performance still. Performance at the Henry Street Theater, New York, in association with the Museum of Modern Art, New York, October 1–3, 2009. Courtesy of the artist and Cabinet, London, Photograph by Amy C. Elliott.

the technical efficacy or historical accuracy of his props. Leckey lists several historical figures, whose work traced the transcendental capacities of the image, quoting from Károly Tamkó Sirató's (1905–1980) *Dimensionist Manifesto of 1936*: "and after this, a completely new art form will develop, cosmic art, the vaporization of sculpture, the artistic conquest of 4D space which to date has been completely art free." Leckey claims: "these [are the] two ideas that I feel have become the principle engines of the Internet," which include the dematerialization of rigid matter and the "the creation of a space of infinite dimensions with a viewer and creator, or producer and consumer of one and the same, which is summed up best in YouTube motto, 'broadcast yourself.'"

Anderson's *The Long Tail* provides for Leckey a typically anthropomorphic emblem to which the artist can peg his interest in the Internet as "sculpture in the expanded field," the place where niche markets and fetish images can proliferate online.[30] Like his accumulative approach to sampled images, diverse theoretical sources are quoted between intermittent

sequences where Leckey enacts their effects. He mentions the "murmur of the multitude" citing Hardt and Negri (*Multitude* 2004), and describes, in the first person, embodied perspective, his position as an individual in relation to a vast body of other dynamic individuals connected through the communications platform of the Internet. Hardt and Negri's prosaic style of writing was strategic (appealing to broad readership, or multitude); in Leckey's treatment the anthropomorphism of the crowd is exaggerated to much more theatrical ends, voices "murmuring" to him "like a thief in the night," again articulated as someone within that darkness. Hardt and Negri's cacophonous multitude, along with Anderson's *Long Tail* and Tapscott's creative "prosumer," are all populist theories of post-Fordist production that has been accelerated (and potentially redeployed) by communications technologies, modified by Leckey into knowingly slipshod, animated, or caricatured forms. These theories themselves are consumed and (re)produced, by artist as prosumer rather than expert, or certainly a very nuanced form of expert, from a position immersed within the crowd rather than an elevated viewpoint.

With abject lyricism, Lecky reimagines familiar web terminology as lumpen forms or fluid processes. A cursory history of utopian cybernetics[31] precedes a quote from Hans Bellmer's Surrealist theory, "that desires have same anatomy as dreams both composed of deformations, divisions, coalescences, permutations and compensations." Desire, Leckey proposes, can be reconfigured in its various parts in infinite ways, much like surrealist compositions or cybernetic systems, seeing "the body as resembling a sentence which invites you to disassemble it into component parts, so that its true content may be revealed again and again into an endless stream of anagrams."[32] Leckey's analysis addresses how subjective desires are produced by, as well as being productive of, images, and of how platforms like YouTube give life to image-mediated desire.

Desire for a contact with images, as pictured and problematized throughout these works, is something less and more than eroticism, less a quest for sexual satisfaction with another physical body than a modular and readily reconstructed force of yearning that accords with various subjects or objects as they present as picture. It is a force that can be projected in many simultaneous directions at once, and that seeks continuous, multisited (rather than singularly achievable) satisfaction. Desire for perpetual contact resembles a substance addiction, an addiction to substance.

The work's final section explores the Internet's capacity to generate and regulate appetites, increasing the span of the "long tail" and changing the dominance of the mass market so that any commodity is attainable online, creating what Leckey calls a "cosmic grid." Those who travel through it are only getting a limited or restricted sense of its expanse through their own subjective tastes, a contradiction that creates an "autistic grid." Together this creates what Leckey calls a "cosmic-autistic spectrum" influencing our worldview dramatically, as "those who inhabit the tail find themselves caught between these two fields, bound in a nutshell and kings of infinite space." This animated study of desire and delimited space preempts the kinds of enclosed social media environments evident in the US presidential election and UK Brexit referendum of 2016, where fabricated news stories circulated without regulation and reputedly targeted specific voting demographics, a strategically utilized insularity of vision that significantly impacted the course of Western political history.

In Leckey's work, the Internet is anthropomorphized as a complex, dynamic organism with profound and widespread economic impact. Leckey emphasizes his dependency upon it, emphasizing the reciprocity between the Internet's volume and the expanding recesses of human desires for images, perpetually exchanging them in a new, self-sustaining cycle. Leckey puts his own instinct under scrutiny, the tone oscillating between serious and comic, but the work is not straightforward parody. Neither does it present, he claims, an explicit critique of capitalism.[33] While his instinct or drive toward images might result from consumerism, its hold on his inner life is deeply rooted, a depth he sees and addresses to make art. This is not the first example of an artist's oeuvre that discloses a human instinct to get inside the image (that might be said of Oscar Wilde's *The Picture of Dorian Gray*, 1890), or to put it inside you (Warhol's *Campbell's Soup Cans*, 1962, perhaps)—but it is one of the first to articulate the force of that reciprocity, and conjecture how that urge for contact has a specific economic function. While on the surface or margins of his images, we occasionally see aspects of desktop design (YouTube's frame is left intact), what we are chiefly presented with is a dramatic enactment of prosumer impulses. Watching contiguous cycles of image consumption and production, the work, like Rauschenberg's, hyperbolizes these circuits for us to see.

Leckey describes his motives for making art to overcome associated sensations "of distance and intimacy."[34] "Images make me transcendent" he says, in a way that is grammatically incorrect but makes utter sense, and, at the level of perception, resonates with Piper's instinct to "become the music." Images are permeable: there is a plasmatic quality to them. The questioning of nonrational and nonsensical image appeal is rearticulated throughout included works, with magnetism felt as deep pleasure, but also, almost universally, as a promise and a source of great anxiety.

Frances Stark's *My Best Thing*

Frances Stark is an artist based in California, who, like Leckey, combines performance and moving image and who has been active since the 1990s. Like Leckey's works, Stark's works span, and reflect upon, a shift toward user-generated content in a Western context. She has, on occasion, collaborated with Leckey, and in many respects they share a tonal and stylistic register, exaggerating their dependencies upon the instant gratification of images to disarming and often comic effect.

My Best Thing (2011) is a video work about Internet sex, scripted from chat forums, made using free online animation software. *My Best* Thing was made with similar material presented a lecture performance by the

Figure 5.3
Frances Stark. *I've Had It and a Half,* April 17, 2011. Hammer Museum, Los Angeles. Courtesy of the artist and the Hammer Museum, Los Angeles.

artist called *I've Had It and a Half* in Los Angeles in 2011. On a theater stage, dressed formally in a suit and tie, Stark presented, among other correspondences, a dialogue on screen from online sexual encounters. Stark has said of the work's origins: "I got fascinated by feeling so intensely for people I didn't know. I was never into Internet sex, but because it's a form of seduction that took place through typing and interacting visually, I got hooked."[35] *I've Had It* is a work that plays with the experience of pleasure seeking online, and the doubts and ecstasies of these pursuits. Composed of vignettes (the artist reading letters aloud; playing a game of image roulette; projecting animated dialogues; a montage of "dick pics"), the performance is structured to accommodate and aggravate the constant slippage between attention and distraction both for its live audience and online prosumers. From the outset, with an orchestra playing a *divertimento* by Haydn, and a quotation projected on a screen from Polish writer, Witold Gombrowicz, "Do you not agree that the reader is able to assimilate only one part at a time?" Stark shares the problem, the object, of attention with the theater audience.

My Best Thing is a feature length video, which premiered at the Venice Biennale that same year.[36] Stark used Xtranormal to bring many of *I've Had It's* themes together. Xtramornal was an openly accessible online animation software that translated her script into an animated movie using text-to-speech and animation technologies.[37] Xtranormal was established as "a storyboarding tool for writers and film directors" from which Stark programmed the images of her characters, their voicing and different camera scripts, angles, and close-ups. The script is based on separate encounters on Chatroulette, "where you can interact with new people over text-chat, webcam and mic."[38] None of these primary encounters are presented as they would have appeared over a webcam. There's no "money shot" in *My Best Thing's* denouement (despite the suggestive title), just a uniformly rudimentary digital animation. Setting one platform within another (in this case, Chat-Roulette within Xtranormal) draws out a lot of the social, linguistic, and economic quirks of new forms of image work.

This work is structured around online dialogues between a woman and her two consecutive male partners on Chat-Roulette. The figures are animated like white modular Lego figurines, except with round heads, dressed in fig leaves, on a green screen, otherwise devoid of "naturalistic" detail. Voiced by automatons, the episodes are scripted from imagined or

Figure 5.4

Frances Stark, *My Best Thing* (2011), Digital video on flash-drive, 100 minutes. Courtesy of the artist; Marc Foxx, Los Angeles; Gavin Brown's Enterprise, New York; greengrassi, London and Galerie Buchholz, Berlin.

transcribed sexual encounters online, however, intercourse is never depicted nor is there any video exposure of human bodies. This erotic peep show is performed by static animated Lego figurines. Dry, rubbery, and automated: it's unexpectedly immersive viewing.

Splitting image from dialogue is one of many ways that the "authenticity" of the work is undercut within the narrative. In its narrative strategy and ambition, it resembles Rainer's character obscuration, eliminating the female from show (by digitally rendering her as a toy figure), and casting her opposite two male protagonists, in order to create "situations that can accommodate both ambiguity and contradiction without eliminating the possibility of taking political stands."[39] Like Leckey's voracious image-appetites, generated and harnessed by the Internet's vast corporate repositories, Stark's protagonist performs the role of voracious online image-prosumer, in search of new partners, a pleasure-seeking subject rather than a pleasure-giving object. And there's something askew about a sexual encounter voiced yet unseen, something disturbing about the snagging of our by-now programmatic pleasure seeking. There are many allusions to partial or censored viewpoints,[40] and as these events play out "backstage," so our manipulated perspective becomes clearer.

From the beginning, viewers cannot take for granted what's being presented. The protagonist announces to her male counterpart that she's "going through a dancehall phase," as an accompanying video of Beanie Man's "Gimme, Gimmie" is composited into the green background. In this music video, five young women line up to "dagger" a seated Beanie Man, a dance move originating in the West Indies simulating sex between two partners. Stark's Lego woman watches and dances along, barrel-like, her bare backside swiveling awkwardly toward the screen. There is a lot in this image. Read this viewing matrix in relation to gender, and Stark's Lego woman upsets the gendered and gendering gaze of Beanie Man as he observes the dancing women. Read in relation to race, and Stark's (white?) Lego piece exerts her viewing power on black subjects, male and female, who have already historically been sexualized, objectified, or subjected to a particular performative repertoire in the media, and, interconnectedly, undue surveillance in the round. And read in relation to desire, Lego woman's immersion in this music video, her interest in the dance performed within it, shows how gender and race are inscribed and constructed within the acts of viewing. And at this unruly intersection, Stark's she-Lego waggles.

We assume that the female protagonist is based on the artist's own encounters on Chatroulette, but that's never confirmed. Stark has tested the boundary between biography and fiction before—excerpts of autobiography and flashes of self-portraits appear through drawing and collage, sculptures and installations. It's a practice not dissimilar to that of Chris Kraus, whose prose is often self-referential, combative, and confessional.[41] *I Love Dick* is structured around a series of love letters to an elusive addressee with whom the female writer is obsessed and with whom her long-term partner then becomes preoccupied. With some retaliation from the subject of their mutual affection, the three-way, instigated and pursued by Kraus's semi- or pseudo-fictional persona becomes increasingly complicated. Kraus's narrator's instability demands of its reader a similarly striated attention to viewers of Stark's *My Best Thing*, taking the work in, both at face value and from a skeptical remove. There underlies in both love stories a distortion of genre, an obscuration of truth and a triangulation (and strangulation) of heteronormative fiction.

Stark's work insinuates that it is disclosing the process of its own construction, within her carefully assembled script, a literary and cinematic conceit whose precedents also feature within the work's dialogue: Robert

Walser's *The Robber*, Fellini's director in *8 1/2*, David Foster Wallace's *Infinite Jest*, and Thomas Bernard's *The Loser*. Stark treats her activity on Chatroulette and Xtranormal as a kind of collaborative writing process, depicting her online production and consumption habits through outtakes from the communication and animation tools she's been using.

This construction-in-process conceit has appeared before in her work. In *Why should you not be able to assemble yourself and write* (2008), a drawing of the artist in ink and collage, with long dark hair and patterned dress, is rendered from above, reading the works title, legible within the drawing. Here, as Ellegood et al. observe, "Stark may not only be 'assembling [her] self to write' but perhaps even assembling her *self* in the process as well."[42] Writing, for Stark, like Kraus, becomes a political ontology, a scripting of the self in real time. And this migrates online: this Lego self is shown not as predetermined, but constituted and abutted by the information and images that Stark sees daily. That is, the ways in which we decide to opt in or out of prosumerism, the way that we write and image ourselves into being there, also constitutes a new political ontology. Stark's work is not a play of vulnerability, but an exposition of the effort of presenting oneself as an evolving multiplicity. Writing about Stark's work prior to *My Best Thing*, Jenifer Papararo has observed:

… questioning her own production, her relationship to art-making and writing, and her self-identification as an artist and writer has been the instigation for much of her work, as well as a point of struggle, a means for battling her relevance against her inadequacies and counter-intuitively as a means to determine a subject that centers on her as the author, but resonates outside of herself. This single or multifaceted reverberating subject is still uncertain and I think better left undefined, but it increases in density the more Stark shows her vulnerabilities.[43]

The dialogues are narrated, voices synthesized and accented, but they're also subtitled, highlighting the glitches and flaws of a new social vernacular. Mark Godfrey writes about this aspect of Stark's writing in *My Best Thing*, when: "she recognized immediately that her typed chats, while in some ways recalling Socratic dialogues, were a new kind of text, with particular conditions and conventions … full of new acronyms; there were frequent miscommunications between her and her partners, thanks to their varying command of English and many dialogues were typed out with one hand while the other was otherwise occupied."[44] Visual pleasures, more interactive than before, lead to a different kind of physical experience of the image, abbreviations, acronyms, and errors.

As Godfrey observes: "as subjects, we are increasingly expected to display our 'private' tastes and pry on others' intimate confessions. In this context, to reveal her own penchant is not to make any claims about her special status, but just to take her place among other subjects."[45] Stark's "naked presence" might also be a front, an experiment with the contemporary vernacular of (and taste for) the confession as she teases out this quite strategic and socially manipulative form of self-exposure. The work asks how these platforms change a subject's motivation or necessity to self-represent, less a show of self-doubt than an elucidation of the forms of self-exhibitionism prosumerism demands and the self-doubt that motivates (and results from) participation.

Divided into ten episodes, the work is openly geared to the short attention spans of its viewers who, the artist's avatar announces, will encounter the work's premiere at the Venice Biennale. Narrative breaks between each encounter provide intermittent synopses of the work thus far, projected on white PowerPoint slides. This is the image of the effort of attention capture, parceling consumable ten-minute sections within the work's hundred-minute duration. Often activities and accounts are purposefully disjointed. Stark's protagonist "shows" her counterparts sections of the feature as its narrative unfolds, their apathetic responses playing out in real time. "The story will take at least thirty minutes to tell," she proposes, "but I want to do it in short sections. I am really struggling with this idea that nobody can really afford to pay attention."[46] Clearly constructed moments such as this make the work initially appear to be live. Everywhere lurks the threat of attention lag, of gallery viewers and online browsers alike, subjected to viewing fatigue. Both sites of exhibition (online and in the Bienniale) present exorbitant image repositories, the comprehensive viewing of which is often a practical impossibility.[47] The work reflects the similarly voracious and physically impractical appetites of viewers in online prosumer and biennial formats alike, and they do not seem mutually exclusive in these strange, imbalanced image economies.

In this work, as in Leckey's, the construction of subject is explored in parallel with the technologies, or sites, of artistic production. In Leckey's work prior to *Cinema*, the aspects of the artist's London studio often featured, either as a pictorial backdrop like an early book, *7 Windmill St, London W1* (2004), or in animated form, for example in *Made in 'Eaven* (2004), where two internal Georgian alcoves and a fireplace were reflected on the

surface of Jeff Koons's animated bunny, giving it a face. The studio was often included as a metaphor for the artist, suggesting time spent with the material to hand. In 2006, its image was replaced by that of his stature, speaking on the podium, or appearing before a green screen within the work.

This lecture performance coincided with Leckey's vacating his studio due to escalating London rental prices, and his appointment as a professor in a German art school. At this moment, the artist himself becomes the primary site as well as engine of production, a transition that reflects more general economic shift toward precarious or flexible labor, to temporary contracting and hot-desking, and to the kinds of output that can be compressed into a digital file and made to travel. His lecture performance sets out a new physiological relation to the images, germinated and harvested by Internet service providers, but it is also a product of professional changes. This is the voice of a man working precariously, with a vast amount of visual material gleaned from new communications technologies, presenting his findings to various groups of people across a series of planned events, like a traveling salesman or a virtuoso artist, perhaps Virno's virtuoso artist: this is affective labor, staged by its originator.[48] This combination of information and performance, animates and reflects widely felt changes brought about by technology capitalism. But technology-mediated lives aren't necessarily faster and slicker: in fact, both Leckey and Stark's alter egos evidence ineffectiveness of the precarious worker, fingering mundane material, scrutinizing it, loitering and lonely.

There's a lyricism too to both Leckey and Stark's presentation styles (a poetry that, archive material suggests, also imbued Lorraine O'Grady's early lecture performance, *Nevertiti and Devonia Evangeline*). In a passage from *I've Had It,* Stark read aloud a letter received from an unnamed friend about a dream he had had of a "pedagogical opera," a lecture, "delivered in full drag with dancing girls and an orchestra." She wore a suit and bowler hat as she read this aloud. Leckey had been wearing a tuxedo. Virtuosic, Stark's work, like Leckey's, offers more than an academic lecture, an after dinner speech, or salesperson's pitch. Their works target attention by addressing it properly, through media, diversely, as fierce but fragile, agile but unwieldy, tuning in and out at random.

Like Leckey, Stark's studio in California has been mapped into previous works' narrative (for example, in *The Unspeakable Compromise of the Portable Work of Art*, 2002, a conceptual work named after Daniel Buren's 1972 essay

on the importance of the artist's studio to the artist's work); but here her browser also replaces the fixed architecture, and what we're presented with throughout is this animation and automaton voicing that is the produce of that browser time, a space that is both subject and site of production. Stark's avatar is addicted to chat forum activity, to the process of writing and image-making within it. She can't leave, we're told, a dependency that congeals into apathy, which is displayed by several characters. What is "interesting, satisfying and frustrating" about how she spends her free time online are questions introduced throughout the script.[49] Satisfaction and frustration alternate, with the protagonist's undulating reflections on the capacities and limitations of this technology and the kinds of contact it facilitates with other people. There is no question here about whether Stark can make work from this contact but rather how she makes it, and what the difference is now between prosumer work and artistic labor, how they stray into and pool from one's personal life, and how that material might be grabbed, scripted, thickened to work for her.

By using her animated avatar as symbol and shield, Stark herself is mobilized, able to fluctuate between auteur-director and in-shot protagonist. As viewers we are not able to be *as* absorbed in this image as an entirely fictive or documentary narrative, or as absorbed as Stark's protagonists appear to be. There is an inherent separation between us, as suspicious, external viewers, and her protagonists as embroiled prosumers. At distinct points, Stark's avatar steers its viewers from being engrossed in content to wary of construct and it's a method of distraction that has an interestingly adverse effect on whatever screening environment it is shown within.[50] In both the online and institutional settings in which I have seen the work, I've felt both absorbed and self-conscious. Seeing it projected in the dark theater of the ICA London, a circulatory space without seating, I felt acutely aware of other people in the room, of the fleshiness of strangers and the real possibility of cruising for bodies covered by darkness. The immediate physicality of others' bodies, of the heat and moisture of our breath, was lost viewing this work online, or certainly it was far less apparent, but that instinct to find it remained. It was replaced by a sense of shared isolation, of the anxiety of loitering online waiting for a partner to (re)appear.

To be clear, Stark's exhibition space is not explicitly rendered or idealized within her work, but the pressure of public exhibition is made clear. The subject of the completed work's value is raised in the dialogue, the value

of the work we're seeing in formation as dialogue, and how Stark plans to profit from that. It shows no ambition to corrupt this process whereby public attention will convert to financial (by way of cultural) capital—there's no suggestion of withholding the work from an exhibition circuit. There's a clear alignment between the sites and modes of production and exhibition held by both the old institution of art and the new institution of prosumerism, how they host different forms of self-representation, and how this form of exposition is valued across platforms.

Stark's is a complicated rendering of the motivations and effects of prosumerism, and the implicit capitalization of desire, sociability, and intimacy. It resonates with Leopoldina Fortunati's analysis of the machinization of affective labor, and specifically the physical isolation that online chat forums generate. Checking handheld devices incessantly, "people actually are expropriated of large slices of life in order to live out this secondhand reality." These addictive tendencies mean "the lengthening of the time of consumption/production dedicated to this element of immaterial labor, as well as its intensification, but also the dematerialization of the real." Fortunati adds: "By machinizing the more ethereal part of immaterial labor connected to sex, it has even more radically broken the chain of thought, of sexual saying and doing. Today we are assisting in the development of a great industry of erotic imagination detached from practice that recognizes more or less implicitly the 'freedom' to consume it as a commodity."[51] But in Stark's depiction of the spread of this industry, bodies made to thrust and swivel are left with a nagging, anxious sense of undirected yearning. Stark's protagonist is full of spunk but stuck in partial isolation.

In Fortunati's terms, Stark self-valorizes, finding alternative ways to use these new forms of immaterial labor, mechanisms of production, and modes of transmission. In ways very different to what Fortunati conceives—using devices to organize public demonstrations, social movements, and social chains, as well as spaces for public debate—Stark generates value from the process of prosumerism in which she's embedded by making an artwork out of its very material. It's a work that exists online, but that also shows and sells in galleries around the world; and while that vault from one image economy to a distinctly more rarefied other is polar to the kind of long-term collectivized solutions that Forunati envisions for more diffusely equitable engagements with prosumerism, it does present a temporary perforation and visualization of the sometimes exploitable cycles of

quotidian prosumerism. In computing terms, it's a hack: a dramatized and visualized assertion of self as self-determining mediator rather than exploitable intermediary working in the circuits of information production and consumption.

Leckey's altar ego presents himself as somebody keen to inhabit, absorb, or assume the image; he feels this proximity *possible,* whereas Stark's is a reverberating, multifaceted subject, conscious of the restrictions an image might impose upon it, while gratifying her instinct for play. They chronicle and perform heterogeneous human responses to images, and reflect on the exhibition platforms that broker their exchange.

Leckey's and Stark's forays across media predate digital technology's marriage to prosumer websites. That said, their work produced there offers perspective on the changing tools and work spaces prosumer websites provide producers; on the desire-producing machines of social media; on the corporeality of the encounters had there; on the appeals, compromises, vulnerabilities, obscenities, and contradictions of online, image-mediated relations; on attention as a wayward faculty in a constant state of flux; and on attention's drive toward the internet's hub of images for this distinctive physical experience. Prosumerism is not an activity from which they present themselves as removed, but rather a cycle to inhabit, and a new mode of writing themselves into being.

6 The Artist in Particular

Critiques of Prosumerism

Critiques of prosumerism, and the various ways in which capital is mined from the activity of online prosumerism, have been emerging from various sources, since Tapscott and Williams's application of it within digital economics. Criticism radiates from all sides. According to Chamath Palihapitiya, Facebook's former vice-president: "The short-term, dopamine-driven feedback loops that we have created are destroying how society works. No civil discourse, no cooperation, misinformation, mistruth."[1] Speaking at the same event, Facebook's founding president, Sean Parker, reflected upon how the company "exploit[s] a vulnerability in human psychology" by creating a "social-validation feedback loop." There is a fundamental issue within the design of social media platforms, where Evgeny Morozov observes, "values like solidarity are very hard to sustain in [a] technological environment that thrives on personalization and unique, individual experiences."[2] Contrary to their straplines, companies like Facebook are now set up to compartmentalize rather than unite or collectivize their users; it's a business based upon individual tracking, data analytics, and targeted predictive content.

Prosumerism has also been theorized and critiqued within academia over the last ten years. "Digital labor" describes the digital economy's workforce often from a post-Marxist perspective, a subject that anchored a series of conference in 2009 at New York's New School, convened by Trebor Scholz.[3] Digital labor is symptomatic of the significant reorganization of labor in the post-Fordist period, a dominant system of production originating in a Western context, but impacting the world over: undermining systems of welfare and taxation, threatening global borders, nations,

and ecosystems, increasing militarization and violent interventions, and influencing instances of terrorism and genocide. It is symptomatic of an economic principal that has established a global super-wealthy elite and an interconnected and widely diffused state of precarity, poverty, and dispossession, changing living standards and effecting subjects' interior lives, human relationships, and self-perception, altering individual and social behaviors, manifesting in tendencies of hyper-individualism, alongside movements toward social collectivization.

George Ritzer (2010) argues that we should view all current economic activities as a continuum, with prosumption as production (p-a-p) and prosumption as consumption (p-a-c), at either end of the process.[4] Ritzer has long been concerned by Tapscottian prosumerism, contending: "you might also see [your work in Facebook] as a series of tasks that you perform largely for yourself [...] However, many critics now view what you do on the computer as very much like such work since you are often working for others and in the process making them wealthier."[5] And this indeterminacy between work and play that manifests in prosumer work is of key concern to many theorists post-2009.

Scholz asks how exploitable prosumerism is if it "does not feel, look or smell like labor at all"?[6] He asks: "Can we really understand labor as a value producing activity that is based on sharing creative expressions?" Scholz circles the central problematic: if creative work is felt like play, then it's not perceived as work, a situation which allows for the rhetoric of creative opportunity and plays of affect that facilitate prosumer exploitation. But there are several problems in maintaining this work-play binary while challenging any middle ground. Because at one end of the spectrum, one could argue that many people's work feels like play, that like an artist who is supported or remunerated for their work, there is some degree of creative freedom, autonomy, and satisfaction provided by many work conditions; one might even ascribe those satisfactions to the work of a tenured academic or self-sufficient cognitive worker. And at the other end of the spectrum, what happens when creativity or play also double as activism, when prosumer platforms like Twitter are used to build, fortify, and give voice to communities not supported by established representational institutions? Then this play-as-work bind provides something more than a field of lively, individuated play or stable, income-providing work, when it presents a platform

for collectivism and the possibility of rebuilding more equitable social and representational institutions.

Tiziana Terranova establishes the term "free labor," which she determines as "the moment where knowledgeable consumption of culture is translated into excess productive activities that are pleasurably embraced and at the same time often shamelessly exploited."[7] Identifying one's participation as labor within this process is, Terranova contends, a political decision rather than an empirical fact, and she proposes instead the democratization, through shared ownership, of social media.[8] Terranova, Scholz, Ritzer, and many others have established vital critiques of prosumerism concentrating on the industry's exploitation of the free worker to generate surplus value, based on a Marxian distinction between productive and unproductive labor.[9] This updates Dallas Smythe's earlier scientific analysis of audience power as a concrete object "used to accomplish the economic and political tasks which are the reason for the existence of the commercial mass media."[10] In a number of contemporary theses on digital labor, Smythe's theory of the television audience as commodity[11] and Marx's labor theory of value are applied to the current scenario, where online work is productive of capital, but, understood as play by the prosumer, goes unremunerated.[12] There is, essentially, a problem that carries over from television watching to online prosumerism, where pleasure and leisure are easily manipulated, in Smythe's terms, as "propaganda devices, which obscure and confuse the real contradictions between the respects in which people cooperate with and resist the monopoly-capitalist system and its commodities."[13]

Works by Leckey and Stark inhabit and filter from this indeterminacy rather than reiterate or seek redefinition of this distinction between work and play. And while they are certainly carrying this inquiry out from relatively privileged social positions, their work is both alert and alive to the possibilities of this problem, carrying forward this indeterminacy from which, at present, there seems little escape, relinquishing labor norms that belong to a previous economic era and trying to imagine new ones from an unstable and contradictory present.

Terranova has made various proposals to limit the adverse effects of social media through joint ownership, ideas that both preempt and coincide with various more recent practical proposals, on the one hand, to tax profits from data by large existing corporations,[14] and, on the other

hand, to establish, support, and network platform cooperatives, which are cooperatively owned and led businesses using applications to connect customers to cooperative owner-workers, rather than platforms co-opting free or cheap labor run centrally by a corporation funded by venture capital. The idea of platform cooperativism, as articulated by Nathan Schneider and Scholz in 2016,[15] is to evolve fairer online e-ecosystems, democratizing user-built platforms through shared ownership and shared governance, principles that develop from the Commons-based approaches propagated by Yochai Benkler and Michel Bauwens (P2P Foundation),[16] and share some characteristics with what has been proposed as a "Communist Internet."[17] Ultimately, peer-to-peer models of platform cooperativism present the kind of enterprises that Toffler imagined in his Third Wave of capitalism, and which would have been supported by the "two-way" programming that Lanier and Nelson engineered, although now might come of age through innovative uses of blockchain technologies and architectures. With increasing distrust of the misinformation circulated on social media, and increasing knowledge of the ways in which creativity and sociability are being monetized and exploited, one might be optimistic that the financial mechanisms behind prosumerism itself will be reformed, to return it to its utopian origins and restore the possibility of its Third Wave. This proposition risks reiterating Toffler's original blind hope that somebody somewhere would take responsibility for regulating prosumerism, but there is, at present, a coordinated effort between technology founders, politicians, social activists, academics, and entrepreneurs to action this alternative marketplace, and to design its components collaboratively with the diverse constituents it will serve, in what's been termed digital "design justice."[18]

It must be stressed at this juncture that neither Leckey nor Stark make any practical resolutions of this kind. Their works suggest that they are conscious of the contradictions held within the activity, the allures of this accumulative, visual form, how it facilitates and hosts creative people, while also trading and banking on the proceeds of their impulses. Like the works with which I historicize and contextualize them, their use is perhaps in highlighting prosumerism not as simply as a mode of transaction and exchange, but rather as a exploratory, perceptual, or corporeal activity with images, a fulcrum for therapy, for rage, for activism, for diversion, absurdity, or pleasure.

To draw from Rainer's strategy again, they are works that "can accommo-
date both ambiguity and contradiction without eliminating the possibility
of taking political stands." They flag that within prosumerism as an activity
lies a primal impulse toward images as not only a play but also of as a form
of self-making, and that any future version would at least maintain this
facility while creating a more equitable system of governance and better
guarding the constitutive personal material posted there.

And this political stand is not theorized, vocalized, or articulated through
language, that is, through spoken or written language alone. It comes
through these works' combination of image and language, through their
various techniques and renderings, their appeals to the audience and stria-
tions of human attention. And these are works that, should you seek them
out, are functioning and fully operative in a range of spaces and platforms
within a broader economy of attention. The "economy of attention" was
described by Michael Goldhaber in 1997 as "the natural economy of cyber-
space," which is distinct from the information economy in that the scarce
resource for economic analysis was in human attention rather than infor-
mation. "[S]omething else," Goldhaber wrote, "moves through the Net,
flowing in the opposite direction from information, namely attention."[19]
At the center of this economy is industry's competition for "eyeballs,"
for attention, which is arguably what art has historically sought from its
various parishes, principalities, constituencies, and museum-going publics.
Christian Marazzi, in his *New Economy*, articulates within this "attention
economy" that the "limitless growth in the supply of information conflicts
with a limited human demand."[20] In his new economy "language" is what's
on offer, which he distinguishes from the real economy (where goods are
produced and sold) and the financial economy (of speculative investment),
and that language he describes "not only as a vehicle for transmitting data
and information, but also as a *creative force*."[21] And now seems as crucial a
time as any to emphasize the importance of art, in providing some perspec-
tive about the kinds of demands our attention is regularly under, online as
in the round.

Human attention is a difficult substance to weigh, quantify, or analyze. It
roves into other cognitive and neurological areas it informs and is informed
by memory, imagination, consciousness, and self-consciousness; it has
flaws and glitches, degrees of intensity; it can be snapped away by its adver-
sary, distraction. Theorists of the attention economy have looked at this

elusive substance from a variety perspectives: N. Katherine Hayles (2007) has explored how one's online presence produces deep and hyper attention; Bernard Stiegler has elegantly explored technology as a prosthesis for the mind, and questioned how pedagogy might update itself in time with the new plasticity of Internet-users' minds, and he proposes that attention is "not an individual but rather a psychic and social capacity that is historically, and thus technically, conditioned";[22] Catherine Malabou explores the relationship between neuroplasticity and the changing conceptualization of "self";[23] and moving away from Stiegler, Alison Landsberg delivers a thesis on "prosthetic memory" focusing specifically on how film reels and stills are capable not only of reminding but of generating cultural memory across various social, racial, gender, and class divides.[24]

Attention and distraction enter the field of speculative economic and anthropological analysis, filtering its terminology from the neurosciences, but another expanded field of research long concerned with human attention as commodity and propaganda device is the arts, articulated through work and critical theory of cinema, theater, and visual art from very early on in the twentieth century. Interestingly, Jonathan Beller sees the stronghold of twentieth century cinema as the beginnings of the attention economy, rather than, necessarily, the solution to it.

Marrying Marxist and Debordian theory with examples of cinema from the Soviet avant-garde to mainstream contemporary Hollywood, Beller has devised his "attention theory of value." He articulates this theory at great length in his *Cinematic Mode of Production* (2006), beginning with cinematic spectatorship of the late nineteenth century when cinema surreptitiously became the formal paradigm and structural template for social, that is, becoming-global, organization generally.[25] Beller's "cinema" is a metonym for the image *and* the image factory, from the cinema right up "[to] its succeeding, if still simultaneous, formations, particularly television, video, computers, and Internet, de-territorialized factories in which spectators work, that is, in which they perform value productive labor."[26] Historically bookmarking cinema between the Lumière Brothers' experiments in 1895 and Google's monetization of online content from the mid-2000s onwards, he proposes:

[the] method of gathering, weighting, and bundling little pieces of attention more and more thoroughly distil[l]s units of abstract time to a universe of time/attention buyers. This computerized advance over the niche marketing practiced by film and

TV is linked to the practice of what Google calls the monetization of content—where every instance of content on the web can, in principle, be treated simultaneously as a commodity and a medium. This means that every page view, every image if you will, is slated to be sold as a medium of labor power. Google has found its true function in the sifting and parsing of not just data but of human subjective activity. Under the guise of making information available to users, Google has made these users available to capital and thus have made them productive of capital.[27]

In a brief synopsis, Beller writes: "what the accretion of gazes on the surface of the image-commodity shows, precisely, is that the gaze is an economic medium, its lingering is productive of value. The gazes of others create this value: *to look is to labor.*"[28] Beller's exchange-value of the image-commodity lies in its aesthetic appeal with the commodity increasingly tending to the status of an image, where "the media, as a de-territorialized factory, has become a worksite for global production."[29] Reading Dziga Vertov's techniques of acceleration, deceleration, double exposure, and rapid montage in *Man with a Movie Camera* (1929), Beller sees the installation in cinema of the general logic of socio-industrial production.[30] Cinema, film, and frame replace capital, money, and price, respectively, as dynamic organizing forms within a particular tiered politico-financial system. And as capital becomes mediated through images, he maintains, sensory perception changes too. "The generalized movement of commodities through the sensorium and of the sensorium through commodities is cinematic. Thus cinema means mediation between the world system and the very interiority of the spectator."[31] The viewers become a conduit for capital, their attention a commodity, with cinema "colonizing minds and bodies as sites of productivity."[32]

The passage of information and images through the body creates a productive turn, impacting individual psyches and collective social behavior. Now, "media bytes realize their value as they pass through the fleshy medium (the body) via a mechanism less like consciousness and more like the organism undergoing a labor process—call it a haptic pathway. Here, media bytes are thinking money, or better, affective money."[33] Beller's theorizing is compelling, and the situation seems very bleak as images greet and pass through us, we, I, the passive, immersed spectator. But while Beller's theorizing and analyses of individual films are lively, recognizable, and convincing, he makes no distinction between approaches to filmmaking, the Hollywood distribution model of mainstream cinema, with avant-garde and experimental approaches, which have long tested the attention,

memory, and immersion of its viewers. In fact, while cinema might be the formal paradigm through which the attention economy is organized, then its wayward cousins, avant-garde and experimental film, video and moving image, in tandem and often conjunction with performance, have long challenged its audiences, architectures, and economies of viewing. If the job of spectacle is, as Debord claimed, "to cause a world that is no longer directly perceptible to be *seen* via different specialized mediations," then the job of the artistic avant-gardes have been to alert the sentient, thinking viewer about the social conditions directing her lines of vision within this partially perceptible world.

Tom Gunning underlines Fernand Léger's remarks, after having watched, for the first time, Abel Gance's *La Roue* (1923), that radical potential of cinema did not lie in its representational possibilities but rather in its capacity of "making images seen." This observation introduces Gunning's essay "The Cinema of Attraction," and his interest in revisiting the critical significance of pre-narrative cinema in relation to avant-garde or experimental film.[34] It's my contention that making images seen, and making the social operation of images seen, particularly in a changing economy of images, is now the principal, critical task of the artist. Pre-narrative cinema presented to its audience an "exhibitionist confrontation rather than diagetic absorption," which might be a useful descriptor of how the works included reorient attention from how it might otherwise be captured online.

New Institutions

Prior to pre-narrative cinema, the first public museums, established in the nineteenth century, were perhaps the first devices to stalk the viewer's attention and understand it as a means of value production. Tony Bennett's "Exhibitonary Complex" (1988) regarded how historically, the public museum regulated its populace by attracting and entertaining its visitors, inverting the disciplinary architectures Foucault saw in the nineteenth-century penitentiary and infirmary, where inmates were confined to individual cells under the perpetual scrutiny of a central observation tower. Equally interested in how the political subject was disciplined, albeit through captivation, participation, and play, Bennett noted how strategic displays and pathways through public museums like London's British Museum produced subjects of its visitors, seeing themselves as members of

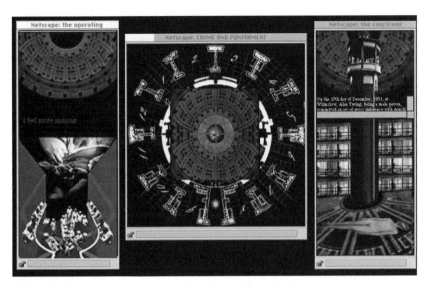

Figure 6.1
Courtesy of the artist; Marc Foxx, Los Angeles; Gavin Brown's Enterprise, New York; greengrassi, London and Galerie Buchholz, Berlin. Panopticon interface design, Auriea Harvey; image courtesy of the artist.

a populous and culturally rich constituency, and thereby harboring ideologies of the state.[35]

Bennett proposed that public collections: "sought to allow the people to know and thence regulate themselves; to become, in seeing themselves from the side of power, both the subjects and objects of knowledge, knowing power and what power knows, and knowing themselves as (ideally) known by power, interiorizing its gaze as a principle of self-surveillance and, hence, self-regulation."[36] The exhibition architecture of the public, civic museum was perhaps effective in the same way that Facebook or Instagram might be, by "winning hearts and minds as well as the disciplining and training of bodies." The clear difference here though is that while Bennett's museum, like Foucault's penitentiary, was the ideological apparatus of the state, companies like Facebook are an apparatus of capital, disciplining and training bodies, while co-opting the proceeds, with discernably private interests.

And prosumer platforms like Facebook, for example, are ambitious, marketing themselves as new form of representational institution, and a new form of mass media. Facebook would aim to succeed the public museum

by marketing itself as a newer, revitalized form of public institution, more socially inclusive and accommodating than previous examples have proven to be, and with far greater accessibility and reach. Facebook does not represent singular subjects, constituencies, or cultural aspects of civic life, but rather, by transferring the task of self-representation to those who are adapting its blueprint, it fashions itself as a new representative institution with greater capacities than those serviced and funded by the state.

Nancy Thumin has looked at how companies like Facebook encourage participation and promise to provide platforms for creativity only to increase their net worth.[37] She identifies a deceptive turn in the concept of self-representation, which "contains an even more explicitly political claim than *representation* and this is because the term itself contains a challenge to the idea that it is the job of one set of people to represent another set of people. This challenge is present in the implicit (and sometimes explicit) claim that in self-representation people are 'doing it for themselves.'"[38] It's a politically disconcerting shift, where the job of representing citizens and cultural aspects of civic life moves from public institution to private corporations while that corporation markets and legitimizes itself as the most accessible public institution to date.

Social media's appeals to users with platforms that are ostensibly widely representative, participatory, and inclusive, come at a time when national museums around the US and Europe are under increasing pressure to update their representational mandates, to reorganize collections, decolonize founding principles, and reorganize monuments, exhibitions, and symbolic displays to represent an integrated diversity in society, while at the same time they are under increasing pressure to maintain and generate mixed income streams. Both areas must continue to be a priority for civic representational institutions, such as art and cultural heritage museums. But the concern here is that, while welcoming new possibilities for exhibition-making, both online and off, we must understand and distinguish between the functions, motivations, and economies of different exhibition architectures and their investment in the cultural policies, politics, and practices of social representation, to value their place within economies of attention, in order to best understand their revision and reconstruction in both the short and long term.

Any museum would be wary of co-opting prosumerism as a new model of visitor engagement, as advised by Andrew Dewdney, David Dibosa, and

Victoria Walsh in 2013,[39] who suggest that the museum's curator submit to its visitors' "distraction and hyper-attention," while plotting "a means for a transactional relationship with [these] audiences."[40] Admittedly written in a significantly earlier and more optimistic phase of social media, it is a theory that underestimates the role of the museum within the attention economy, past, present, and future. That the institution might be under pressure to increase visitor numbers using social media is inevitable, but any contemporary theory or policy would better consider the kinds of "transactional relations" prosumerism signifies, before offering them as a falsely idealized and potentially attention-depleting model of participation.

There's a great risk with the unchecked use of vocabularies underlying prosumerism, terms like "participation" and "democratization," which create a false sense of dissolved institutional or hierarchical power; we risk, as Thumin writes, "seeing this history [as] of one of linear progress from the authority of the expert male voice to the authority of a plurality of ordinary people's voices."[41] As we see figures like Mark Zuckerberg performing seemingly humanitarian speeches to voice global ambitions for building greater "social infrastructures," what we are actually seeing is an extension of this bias.[42] And as the totalizing power of the quasi-institution continues to trade off those building it, the need for alternative representational institutions operating independently of social media's economic model is more vital than ever.

Media Recalibration

And this is also true for the representational platforms of print and broadcast media, which have both had to significantly readjust to changes brought about by digital culture, and whose systematic failures or weaknesses come to light in the age of prosumerism. The rise of social media is having tremendous influence on how conventional broadcast and print media are constituted, a destabilizing of news outlets that reinforces rather than perforates social media's informational feedback loop, to which Palihapitiya and Parker allude. People turn to social media as platforms for visibility and innovation for a variety of purposes, and for far more complicated and nuanced reasons than a quest for fame or an exercise in narcissism.[43] Twitter, for example, has been used as a communications tool by grassroots activist movements to address and counter exploitation, to showcase

inequality, to publicize and garner support for causes and also, in this vein, to communicate with and associate public figures with shared interests. Occupy, Black Lives Matter, Everyday Sexism, and Me Too are movements that have lobbied through and beyond social media through eponymous Twitter handles or tags, reaching and collectivizing constituencies that have historically been purposely disconnected, neglected, or denied. In opposition, the alt-right has taken to social media to curb, goad, and undermine such efforts, and within and between these political antipodes, social media hosts much infighting and public hostilities. From this spectrum, journalists, scholars, and intellectuals appropriate material and pull quotes from social media, which reinforce the structural hierarchies of representative institutions.[44] And, at this level, this document could certainly be judged as one such offender.

Print and broadcast media regularly glean from social media, using prosumers to test political waters, contribute public opinion, grab quotes, and provide witness accounts to public events, as well as a means of informal polling. Readers upload images, contribute stories, opinions, and diverse content, and in this appeal for contributions, news outlets also draw in readers or viewers. Broadsheet newspapers regularly trade on prosumer uploads, an inexpensive way of creating or enhancing "content" in an

Figure 6.2
Emily Roysdon, *I Am Helicopter, Camera, Queen* (2012), performance, video, 34 minutes. Courtesy of the artist.

industry already financially destabilized by digital culture. And broadcast media have also begun to test and source content from prosumer websites. Directors, writers, and actors of recent popular comedies, including *Insecure* (HBO, 2016–present) and *Broad City* (Viacom, 2014–present), originally aired their work online through personalized and openly accessible YouTube channels, also uploading web series, such as *The Misadventures of Awkward Black Girl* (2011–2013) by Issa Rae and *Broad City* by Ilana Glazer and Abbi Jacobson (2014–present). Rae's original series was a conscious effort to challenge Hollywood stereotypes of African American women and to trouble the notion that black figures were non-relatable to television audiences.[45] In both series, narratives focus on professional life, on platonic relations and self-care, rather than hinging on heteronormative relations, enforcing the capacities of women in writing, directing, and acting in comedy drama (as opposed to romantic comedy), and cutting through a recursive and divisive feedback loop in the rhetoric of North American network television production about which bodies television audiences most easily, and profitably, relate to: a major consequence of DIY platforms for media production and consumption.

Social media's recent growth is intertwined with the steady decline of conventional broadcast and print media, and while social media reveals itself to be a space that is often anti-social, isolating, and exploitative, its public prominence and popularity reflect many of the exclusions that mark conventional media, imposing upon those who see or read it. And as broadcast media attempts to redefine itself, those who precariously staff newspapers, magazines, and network television migrate, network, and promote content upon social media. Facebook Live revealed its own broadcast ambitions in 2016, allowing users to broadcast from anywhere they have access. Live and uncensored, the facility generated hundreds of thousands of viewers for some of the most popular posts. However, as uncensored media, in the first eighteen months of this service, it streamed forty-five videos of shootings, rapes, murders, child abuse, torture, or attempted suicide live, with those posting them appealing to the sites capacity to provide multiple witnesses. Prosumer platforms operate and thrive while other representational platforms, judiciaries, and security systems are failing.

Social media forces already existing fissures in conventional media to crack open. It filters broadcast media's viewers and readers, it showcases and preempts mainstream media's ideas, co-opts its staff, and hosts still

and moving images that may not otherwise be shown. Both the heterogeneity and the regularity of content posted on social media attract readers and make it, for many, the first browser window opened online and one that's returned to regularly throughout the day. It influences and regulates the flow of traffic to other news outlets and has proved itself to have an indelible imprint in Western democratic politics and political campaigning. And this traffic generates its own revenue through programs like Google AdSense[46] that accrue value every time they are accessed.

To understand prosumerism as an activity that is solely exploitative is to maintain a particular class, race, and gender politics as the basis for evaluation. The crisis from which prosumerism succeeds is a crisis in interconnected systems and institutions of representation: in democratic politics, in print and broadcast media, and public museums and cultural institutions. Prosumer capitalism trades on the damages and ellipses within these corrupted systems, ostensibly offering new platforms for visibility through and upon which we can self-identify, perform, and interact. So in order to understand how to reform prosumerism, we have to address the complicated, subjective reasons an individual might have for engaging in prosumerism, and for allowing "the commodification of our cognitive capacities."[47]

In Tim Wu's 2016 account of the attention economy, he traces how attention has been captured and capitalized through advertising's stalking of evolving technologies and media since the nineteenth century, from newspapers, to television, to online entertainment, gaming, and social media. In Wu's account, attention merchants have historically plugged into a celebrity culture consumed by fame through the forums where people come together to self-display, sites where they place their images and direct their gaze. Wu's analysis identifies how advertising began to target women in North America as early as 1915, as "most of this new purchasing of household goods was being done by the lady of the house."[48] The first effective advertising campaign that was to do this, by selling a lifestyle rather than a remedy for an already existing need, was launched by the Woodbury Facial Soap Company. In a campaign headed by advertising executive Helen Lansdowne, the picture of Dr. John Woodbury's face was replaced by the image of a man dressed in white tie, holding a woman dressed in an evening gown in his arms, cheek to cheek, with a slogan that read: "A skin you love to touch."[49] Advertising like this, according to

Wu, targeted women presenting in their images of "natural" beauty, a constantly receding ideal.[50] However, in acknowledging how gender is targeted by the attention economy, what Wu doesn't address is race, in that early US cosmetics advertisements published in journals like *Ladies Home Journal*, and later disseminated through other print and broadcast media, were targeted specifically at white women. But while women and men of color were also targeted by cosmetics companies (largely through publications for primarily African American readers, such as the *Chicago Defender* [from 1905], the *Chicago Bee* [1922], and later *Jet* [from 1951] and *Ebony* [from 1945] magazines[51]) there is a vital distinction to be made within Wu's description of this early performative image as a "constantly receding ideal," in that in creating "a standard," it actually created division that affected perceptions and practices everywhere, a standard that still contaminates mainstream Western print and broadcast media.[52]

Contemporary critiques of prosumerism and the attention economy that lean too heavily on condemnation of the exploitation of the "free worker" risk undermining different subjects' positions to power, and universalizing the diverse and dispersed incentives behind prosumerism. Understood against a larger crisis in representation, prosumerism allows users to exercise my, her, their, our, instinct and desire to be seen as image among others, while also butting against, making a dint in, or shedding light upon more problematic systems and institutions, types, and stereotypes historically in circulation.

Identity Capital

There are myriad motivations for gathering in this way, personal, political, sensory, instincts that vary greatly according to personality, individuality, and curiosity, but that are also related to political circumstance and one's relationship or access to power. Condemning labor exploitation in solely post-Marxist or Debordian frameworks is problematic, when the activity is perhaps not felt as being universally exploitative, and when, instead, in some instances, its activity is anarchic, empowering, or politically symbolic.[53]

At best, prosumerism might be felt as at once exploitative and socially enabling. Kylie Jarrett demobilizes the binary of exploitation versus agency in her theorization of social reproduction and immaterial labor in digital

media (2014).[54] She adopts Leopoldina Fortunati's (*Immaterial Labor and its Machinization*, 2007) framework for appraising the exploitation of the "immaterial sphere" of domestic work, in her evaluation of the exploits of digital work, where she observes that the commodification of attention is not simplistic or straightforward, and that: "what is exploitative at one moment of the circuit may not be so at another. This approach thus provides a route around the impasse between exploitation and agency by indicating how an exchange can, at different moments of the same process, generate value for a media provider, retain its status as non-commodified, non-alienated interaction, or be both almost simultaneously."[55] Jarrett's multidirectional analysis of prosumerism resonates with many of the works included in this theory. Which is to say that works included reflect that the daily performance of images as fueled by complex, contradictory, and often interconnected compulsions.

Without acknowledging the specificities of subjective or embodied social experience, there's a risk of overgeneralizing the various reasons that individuals migrate toward social media to work and play. Prosumer critique must acknowledge far more complicated, extreme, nonbinary motivating factors than a quest for pleasure, narcissism, or a will to fame. Its success rests in any or many individuals' sense of visibility, which is reflected in a real and symbolic representation within a political sphere, often predetermined by intersections of identity signifiers. As Aria Dean comments, "being of the mind that to be Black in particular is to be at once surveilled and in the shadows, hypervisible and invisible, [any] either/or theory of representation seems unhelpful."[56] So while prosumerism is potentially economically exploitative to all people, either/or critique of prosumerism might develop a more nuanced relationship with existing biases in Western representational systems, and the process whereby, as Stuart Hall regarded, "what replaces invisibility is a carefully regulated, segregated visibility."[57]

The Artist in Particular

The interest here is considering how a new culture of registering and performing as images, as a form or aspect of social media participation, can be contextualized through a close analysis of art and artists who have long interrogated, in unique ways and through convergent media, the will to register and perform images within a self-organized or somehow alternative

visual, public sphere, as a recourse to the reductive, alienating, isolating, and performative languages of normative imagery in print and broadcast media. While cultural theorists, anthropologists, social scientists, digital economists, film theorists, and queer, feminist, and critical race theorists have, in various important ways, examined how audiences assimilate the various media messages circulating in visual culture, this aim here is to look at how particular works of art provide an alternative mode of critique, anticipating and coinciding with this new mode of production to tease out the various, composite or complex, logical or nonrational, consistent or conflicting motivations that people have to perform images.

In many contemporary theories of the attention economy, the prosumer is the focal point, but in the works included here, the prosumer, or proto-prosumer is often both focal point and agent. The artist identifies with, and in many instances, acts out the experiences, desires, and anxieties of prosumerism, which is positioned differently to the prosumer as exploited worker in much of the aforementioned literature. The artists included span technological generations, but they each find form for the idea of the body as a conduit through which images pass, a conduit that is porous and responsive, adaptive and productive.

Heterogeneous works articulate the singular and particular rather than the generalized and somewhat notional ideas of appropriate artistic responses to this new visual, cultural productivity. This is decidedly different from how the notional artist in general has been couched within opera-ist and workerist theories, in which the artist's work has been emblematic of an autonomous, creative, satisfying mode, with the artist as a model of hyper-flexible labor. She does not only preempt post-Fordist work conditions, but when hyper-flexibility proves dissatisfying, various theories have nominated the artist, by way of social and artistic critique, to rectify the situation of widespread precarity through an unspecified form of criticality.[58]

Paulo Virno models his affective laborer on the performance artist, engaged not in primary, secondary, or tertiary sector activities, but in producing the illusive substance of affect. In a networked post-Fordist society, advertising or marketing executives were to present the same virtuosity as religious ministers.[59] Capitalism's highest achievement was to "mechanize and parcelize even its spiritual production."[60] Hardt and Negri, in 2004, extend Virno's definition of the production of affects, which, unlike

emotions, "refer equally to body and mind ... affects, such as joy and sadness, reveal the present state of life in the entire organism, expressing a certain state of the body, within a certain mode of thinking."[61] What this selection of works do is recognize how affect, or affective imagery, produces desires while never quite satisfying them, a thrust toward, or against, the "constantly receding" imagery that drives prosumerism. And prosumerism is an extreme version of affective labor, where the production of affects is done for free within a networked sphere of consumption-production-consumption. Contextualized in a lineage of workerist theory, prosumerism is the ultimate manifestation of virtuoso, artistic labor, for better and for worse: it is work that is creative, satisfying, empowering, independent, and conversational —it is also a mode of working that is vulnerable, precarious, isolated, and unregulated, and often exploitable.

While workerist theorists, and attention and digital economists, elucidate how the image-viewer can generate capital, this theory asserts art as being in a unique position to reflect the personal within the social and political, that is, the subjective motivations for a person's predisposition to images and inclination to produce and consume them online. Art in particular can reflect specific embodied experiences of affect and map multiple, conflicting, subjective reasons for doing so. The "kind-of prosumerism" that Leckey's work displays is a kind of exhibitionist confrontation of the vortex of prosumerism, which, to borrow Tom Gunning's sentiment of pre-narrative cinema, "displays its visibility, [and is] willing to rupture a self-enclosed fictional world for a chance to solicit the attention of the spectator."[62]

7 Adrift Among Images

In this chapter, I look specifically at works post-2010. There's a sense of anxiety and unease underpinning these works rooted in events on the ground. Just as the 1970s brought about a sense of discomfort and paranoia with the proximity of disturbing media imagery filtering into domestic environments, this decade brings with it a number of startling world events that permeate psyches through images held even closer on smartphone screens. These include frequent natural and environmental disasters around the world, cases of famine and genocide across Africa, millions of subjects suffering radical dispossession from military unrest around the Middle East, events leading to and from the Arab Spring, the traffic and deplorable hostility toward refugees across Europe, alongside and related to the threat dissolving of various postwar organizations formed to maintain peace, amid the rise of alt-right politics in the West, all of which stem from and embellish new and divisive infrastructures of global wealth.

Incalculable images of people proliferate and circulate daily online, while over a quarter of the world's population are dispossessed and stateless, and these situations are not disconnected. High-earning technology capitalism built on prosumerism is entirely symptomatic of corporate-led privatization, promoting globally connected communication systems, which, in order to generate profit, outsources or "offshores" its production to the developing world, implementing economic policies that have sustained and exacerbated conditions of poverty. This forces mass emigration. At the same time, immigration to the West poses the threat of a poverty of resources, underpinned by increasingly undependable flexible labor, resulting in a democratic electorate voting in favor of systematic exclusions, forced exile, and isolation zones. Hito Steyerl observes a global problem, where "a growing number of unmoored and floating images correspond to

a growing number of disenfranchised, invisible, or even disappeared and missing people."[1]

While the traumas and grievances of the Global South are largely outside the direct experience of many of the artists included here, they are, like many of their, our, generation, conscious of how this increasing sense of global unrest is being mediated and likely exacerbated by their own representational bodies, from government to mass media. A disconnect between citizens governed by divisive social politics is little rectified, if not actually exaggerated, by the images unleashed across social media. We must continue to ask ourselves, why, in an age of innumerable images, where technology opens circulation mechanisms up to global users, why we continue to feel unseen? The artists I include in this chapter are part of a generation precariously working, ecologically threatened, grossly misrepresented, and often hampered by changes to citizenly freedoms such as travel and rights to work, nomadic in their search for the means and sites of production: digital migrants, adrift among images. Analysis focuses on works that render the subject as dually operating beneath and beyond the images that would ostensibly capture or contain them: that is, as resistant to the immobility, binaries, and signifiers that fixed images would impose.

The Newly Displaced

Performing Image is a theory that aims to draw together practices that explore, from subjective perspectives, the situation of living under the image. It touches upon what it is to desire a proximity to images while experiencing the frustration of distance. And this theory aims to establish this articulation of the will to perform images, instinctively, indulgently, or antagonistically, as predating digital culture, as deriving from an image performativity inscribed by generations of media turning audience into commodity. This instinct to perform images is intensified under current conditions into habit, addiction, or necessity. In Performing Image, the works "premised on a dialogic, prosumer model" are absolutely not, as Claire Bishop earlier contended of diverse forms of social practice, "allergic to the aesthetic."[2] Attention *vis-à-vis* the visual, the affective, is the source and site of their politic, and the artist's subjective response to images is the paradigm through which works are diversely articulated.

Bishop's point, subsequently revised, reiterated a binary (also maintained by Shanken 2015) between conventional visual art media and new media, Bishop attributing particular aesthetic forms to the latter. This book would update recursive binaries of new and old media,[3] and look at how particular media combinations are selected to reflect how new media technologies facilitate a society of exhibition-makers. Works included in this genealogy express the overt performance of a body, not as an essential unit or truth teller, but as an evolving strategy of accumulation set among other strategies in a new situation of consumption-production-consumption. In David Harvey's materialist analysis of this, production-consumption "continues to evolve and change in ways that reflect both an internal transformative dynamics (often the focus of psychoanalytic work) and the effect of external processes (most often invoked in social constructionist approaches)."[4] These works trace, render, and problematize the impact of a new economy of images as its felt by the subject, following a century-long mutation of capital that has reorganized labor, the factory, and wages, and affected interiority, physicality, and the psyche, along with perceptions of race, ethnicity, gender, sexuality, and nation.

In 2001, considering technology's effect on learning and pedagogy, Marc Prensky proposed the digital immigrant as someone who uses digital technologies occasionally and skeptically, the digital settler as one who had converted to digital technologies and prosumer activities smoothly, and the digital native as an Internet user who was born into this technology and uses it fluently and fluidly, and generally without prior knowledge, practice, or experience of previous modes of production, communication, and exchange.[5] What succeeds digital natives is a new condition of digital nomadism. The term "digital nomad" would update and succeed that of "digital native," when the conditions in which a digital native has operated have devolved into what they may face now, with "now" meaning: the widespread precarity of labor, temporary contracting and temporary living situations, cultural and professional nomadism, and an interconnected global, or cross-cultural, production and consumption. The native is not at home anywhere, which is not to say that they are necessarily fleeing anywhere. This is not a situation of asylum seeking generated by warfare or deriving from areas of conflict; rather this is a generalized nomadism generated by global technology capitalism's—by prosumerism's—status quo.

In this chapter, the artists focus on what substance their image-work generates while also threatening to obscure, erase, and evict them as citizens or subjects. Performing Image works evidence the fact that all exhibition spaces are contested, mobilized, capitalized, within, beyond, and by the body of the prosumer. Here, where affective labor is constant, there is no financially conflict-free space, only a diversity of potentially productive or lucrative exhibition spaces, each seeking to put the viewer to work in different ways.[6]

* * * * *

An extensive survey of the art of prosumerism post-2010, navigating its many different repercussions, personal and political, could lead us to a wide range of contemporary art practices. Many sculptural practices render the physical dissonance experienced when experiencing objects first as image, a material unsettling rendered in the work of Helen Marten, Camille Henrot, and Anthea Hamilton, among many other artists. And in painting and photography too, that quotidian visceral experience of channeling images through the body, digesting them and encouraging them to find singular form, appears in compositions by Lucy Owens, Marnet Larson, Lucie Stahl, Amy Sillman, Mary Ramsden, and Charlene Von Hehl. Owens's works evoke the changes that such work has brought about to sensory-perception, to how we accumulate images, how they settle within us, and how we can easily touch and temper them before sending them into the world. Her oil on canvas works are not simple constructions; their leveling and layering are heavily worked and materially perplexing, an exploration and antidote to the influence of the touch-screen on our perception and a reminder that we are not as adept at reading images in the round as we may feel qualified to, given our time spent online. In installation format, what David Joselit has previously described as "transitive painting," that is, a painting or painter acknowledging herself as an instance, iteration, or node within a wider possible network, might usefully be expanded to consider the work, not through the network, but rather through the paradigm of the artist as prosumer, sending out images in search of others.[7]

Many artists are looking at how prosumerism changes the social architectures of our lives, including Yuri Pattison, Sam Lewitt, and Lucy Raven. Julia Weist and Jonathan Horowitz's works mark the sadness of prosumers living in a technological era of "isolation and data dependency."[8] Prosumerism

retooled and recuperated as a social project of documenting and archiving where those facilities, technology, and media were not already in place is evident in the work of CAMP. Based in Mumbai, CAMP artists Zinnia Ambapardiwala, Shaina Anand, Sanjay Bhangar, and Ashok Sukumaran represent a movement of "experimental auto-ethnography" that finds precedent in the work of Juan Downey as well as the founding remits of photography archives such as Belfast Exposed.[9] Also and elsewhere, works in moving image by Ming Wong, Guan Xiao, or Chen Zhou show what role prosumerism plays in a cross-cultural imaginary, partially informed by Asian culture, social relations, political events, economies, and technologies alongside aspects of North American entertainment industries and consumer goods.

And to that effect, some incredibly valuable new work explores the agency of the prosumer as journalist in new areas of conflict and geographies of uprising, particularly from the Middle East recording and bearing witness to incidents of violence: Rabih Mroué's study of citizen journalists use of camera phones and image sharing technologies, splices together a number of successive shootings at the beginning of the Syrian civil war in *The Pixelated Revolution* (2012); or Lawrence Abu Hamdan's *This whole time there were no land mines* (2017), which combines mobile footage and sound files of recordings made at Golan Heights, when in 2011 this "Shouting Valley" was host to 150 Palestinian protesters from Syria breaking into Israeli territory. Maeve Brennan's *The Drift* (2017) draws focus on how smartphones are being used to both archive artifacts or advertise them within black markets on the Syrian border towns of Lebanon.

But the effort here, beginning from a Western context, has been to research beyond works concerned with reproducing the facets, fingerprints, actions, or architectures of prosumerism, and which really bury into that longer standing instinct toward images—which artists have been tracking and probing for decades—this instinct that flanks and fuels prosumerism in the present. They are works that anticipate and coincide with prosumerism, and that delay, interrupt, or open out the circuitry of images that powers it, which then (potentially) stream through the same portals that valorize it.

To incorporate, prosumerism needs to appeal to (and generate) image desires in some deep subsurface, triggering creative drives and/or a will to feel somewhat differently represented as subjects. This voicing of subject maps where and how the prosumer finds form. Beyond various informative

and functional references to prosumerism surfacing in contemporary art, I would propose Performing Image as an exposition of something more deeply embedded—socially planted and difficult to uproot.

Invisible in Plain View

Performing Image works present image workers adrift. Here proximity and distance to the image is acted out in terms that are sometimes difficult, paradoxical, and unresolved. Belgian-American artist Cécile B. Evans's *Hyperlinks or it didn't happen* (2014) is a high-definition video that explores the threat of invisibility online. This work has been exhibited in a number of locations, including the online art-viewing portal Vdrome.[10] It encompasses sculptural pieces installed around the monitor on which the video is screened, modular components that change according to the installation. They include elements of the prosumer's domestic environment—custom-printed wallpaper, overturned kitchen-cum-office furniture, and a rubber plant—and 3D printed to-scale adult male body parts, painted in black and elevated on custom made supports. While the sculpture implies domestic life increasingly upturned by technology, the video gives voice to how that threat is internalized.

Figure 7.1
Cécile B. Evans, *Hyperlinks Or It Didn't Happen* (2014), video, 22 minutes, supported by Arts Council England. Courtesy of the artist.

PHIL, "a digital copy of a very famous actor"[11] (resembling the never-named Philip Seymour Hoffman) is both the model for Evans's sculptural parts and the video's authoritative narrator, an icon (in life as in reproduction) of empathy and sorrow. PHIL's headshot appears at intervals introducing Evans's cast of disenfranchised females, each fabricated or appearing from different prosumer websites, brought together here in a loosely connected narrative about life online as a kind of ghost-world, full of boundless apparitions.

An "invisible woman" is represented by a synthetic blond bob wig suspended on the image of a remote coastline, an invisibility dually modeled on Ralph Ellison's *Invisible Man* (1952), and on the repeated semi-appearances of Australian musician Sia, who regularly obscures her face in performances and interviews by wearing an oversized platinum blonde wig, or by dressing other bodies in this same wig, as in her music video for *Chandelier* (2014, directed by Sia and Daniel Askill). The wig conceals her face while creating her icon: a clever retaliation against images, or the invasion of their amassing as fame. Evans's invisible woman was, we're told, "a figure in a landscape until someone erased her ... removed her from this scene." On this coastline, she is growing invisible with age. "There's no official term for what she is, but historically there are many like her," PHIL tells us. Invisible woman has a young voice, because "honey, you couldn't afford [an older version]." The stock vocal of an older woman's voice is too expensive, too rare, cause and effect of a global market for the model of the female juvenile.

Another of Evans's women includes Yowane Haku, a "vocaloid" character with the appearance of a young female Japanese animé, animated by Evans with a peer-to-peer song-synthesizing software. She has been made to resemble Hatsune Miku, the animé who supported Lady Gaga on a US tour.[12] Yowane appears to us at intervals, singing and dancing, part juvenile, part seductress, voicing a digitally filtered version of Alphaville's song, *Forever Young* (1984). In another passage, a young English man recounts his experience of being haunted by his dead girlfriend Emily on Facebook, tagging images on his profile of where she should be, sitting beside him. Next, appears the agoraphobic YouTube star Jemma Pixie Heston, who sings and uploads her videos (some of the most viewed in China) from the safety, or confines, of her bedroom, in her parents' home in Worcestershire, England. Other phantoms appear, wraiths and strays from different territories and

dimensions. Evans's female characters are, to quote Beller: "[B]odies, which are reduced to their pure particulars, [that] mark their disappearance from materiality with their reappearance as images. Having conferred nearly all of their subjectivity, all of their living labor on a world that sweeps it away from them, they are, in their absolute impoverishment, not even present as subjects."[13]

And there seems something distinctly gendered about the erasures Evans gathers and presents, in contrast to the presence of PHIL. "His face," AGNES tells us, "was less a collection of features than a glimpse into the possibilities of human emotion." And we're returned to this quality challenged within Rainer's work, and O'Grady's, and Cheang's, of male bodies afforded the privilege of being present in an image without being reduced by it, of the privilege of being able to receive and emote, to be seen as a multi-faceted subject, to carry transition within one's face, rather than a being whose presence, whose range, whose *matter* remains so one-dimensional, an object, unseen.

Judith Butler's interrogation of the body maintains that materiality is constructed socially, historically, and culturally[14] that where certain bodies have been rendered historically valuable, others have been subject to abjection. We need "to problematize the matter of bodies," she writes, "[which] may entail an initial loss of epistemological certainty, but [...] such a loss may well indicate a significant and promising shift in political thinking. This unsettling of 'matter' can be understood as initiating new possibilities, new ways for bodies to matter."[15] How do we think through Butler's matter now, if digital imaging changes our basic understanding of of presence in relation to materiality and physicality, influencing our perceptions of self, and of one another? Rendering presence, as opposed to self-image, becomes increasingly difficult while fashioning online personas, Evans's work would imply, making this distinction while foregrounding invisible women reduced to and by the networked, digital image.

Evans's *Hyperlinks* presents us with multiple conspicuous renderings of women whose images have been vacated, whose bodies matter less. Evans has pictorial strategies, similar to Rainer, Cheang, Leckey, and Stark, of including diverse images, cropped, ripped, compiled, and composited from diverse online and popular sources, often shown in multiple within or imposed upon one another, a *mise-en-abyme* that reflects a self or subjectivity that is "cut-up" and multiple. This work presents a form of Butler's

"unsettling," a loss of epistemological certainty echoed by the material confusion inherent in the digital. It is a strategy of making conspicuous and numerous that already partially erased subject, an overidentification with new forms of self-representation that "finds logical paradoxes within the system rather than imposing an external logic or ethic ... point[ing] to internal paradoxes and repressions."[16] The primary purpose of Evans's apparitions—holographic, dead, or afraid—is to register to camera, to take their place among other drifting images. Evans's works assemble and cut, animate and synthesize diverse image and sounds gleaned from YouTube, Facebook, Google search engines, and other online repositories. Amidst this site and mode of production, an emotive soundtrack plays across the work, and at moments of heightened emotion the balm of affect is concentrated, and made to seem almost tangible (recalling Leckey's inversion of Frampton's structuralism, an exaggerated rather than withdrawn usage of the affective techniques of cinema).

In a similar vein, albeit different media combination, the choreography of Greek artist Alexandra Bachzetsis has for over a decade articulated the pressure imposed upon women to perform images, through performance and dance. Her work exposes how desire can mobilize, how seduction is mediated by (and targeted at) the camera. Bachzetsis's performances embody, writes Laura McLean-Ferris, "the public pressure to perform for an audience."[17]

Bachzetsis has often incorporated live feed video into her dance. This live relay speaks to and about a generation of performers for whom the capacity to upload and share digital images of themselves online in the construction, manipulation, and maintenance of their own self profile is a constant nagging. *Gold* (2004/2016) is a dance conceived over two acts.[18] In the first part, a woman enters a darkened performance space before an audience, dressed in a bikini, stilettos, and heavy gold jewelry, skin slicked with gold body paint. She approaches a digital video camera mounted on a tripod, tapes off a boundary line on the ground that corresponds to the image's frame, and proceeds to perform to camera, soliciting its lens to the sound of her thighs slapping and the high volume hip hop and R&B (a soundtrack of Kelis, Missy Elliot, and Khia). With ring-laden fingers and long acrylic nails, she flicks through pieces of paper between beats, crumpling them into balls and firing them outside the frame's periphery. The dance concludes as she rises to adjust the camera settings and moves

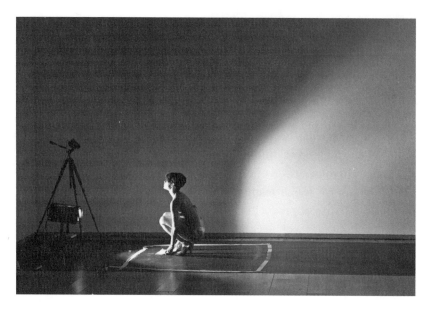

Figure 7.2
Alexandra Bachzetsis, *Gold* (2004). Image by Lucia Puricelli. Courtesy of the artist.
Photograph copyright Lucia Puricelli.

from the center of the stage, walking to a position within the audience.
Stagehands introduce a partition screen and the soundtrack changes to a
classical orchestral piece.

Sitting beside the performer, the same performance is visible in play-
back on the large screen, this time from the vantage point of the camera.
What's written on the paper becomes visible: the lyrics of Missy Elliot's
"Work It," stripped of background music, "girls, girls, girls, get that cash, if
it's 9 to 5 or shaking your ass, ain't no shame, ladies do your thang." The
viewing dynamics entirely shift. Bachzetsis's repositioning has stripped us
of our removed viewing position, safe as voyeurs, and what we thought
we were seeing has utterly changed. It's a two-part strip show, first her,
now us. Bachzetsis's work deconstructs the viewing experience and view-
ing assumptions of this hyper-sexualized, commodified, gendered, and
racialized body.

From A to B via C (2014) is a performance by Bachzetsis involving three
dancers, performed in New York's Swiss Institute. They act out a number of
tableaux, signposted by changes of costume. Layers of clothing are stripped

off, from a pink jersey to a white t-shirt, to a skin-tone one-piece, to a bodysuit printed with a muscular map of the body. As the actors dance, there are allusions to the spectator sports, tennis and baseball (and the money shots that keep spectators keen), to dance and aerobics' displays of physique, to the notation, instruction, and performance of classical ballet. Three is a significant number of dancers here, one mirroring the other, to communicate key positions and postures, their postures a mode of trans-mission, reception, or circulation. They are performing the processes of learning through image and imitation, bodies as images in search of others, assimilating, serving, shooting, and pirouetting. This interiorization of the image though the body is posited as an essential part of learning, of attract-ing attention.

There's a grammatization of the body through technology being enacted throughout this piece, a form of knowledge or memory-making.[19] In a key central tableau, three dancers reconfigure Velazquez's *The Toilet of Venus* (c. 1650). In Bachzetsis's piece performed in New York's Swiss Institute in 2014, a male dancer in a flesh suit assumes the position of Venus, laying on the floor with his back to us (the gender of Bachzetsis's Venus has varied in different stagings of this performance). A young, white, blonde woman dancer, nude, assumes the position of the cherub; but rather than holding a mirror to Venus to self-regard, she angles a monitor to meet his line of vision, a monitor that plays a live feed of the third dancer, standing to stage left, performing the same position as the reclining figure, live to camera. Velazquez's rumination of power's acquisition through the image of beauty and its strategic manipulation is transposed into a twenty-first century context. Bachzetsis's piece relays the new technologies of mirroring, how the body perpetually seeks to learn from others, a process mediated by the camera and the technologies that channel its resulting images. Bachzetsis's Venus knows this process. She's no longer interested in the mirror, instead angling the camera toward herself, her image set to circulate among oth-ers. This image of self-regard, construed some decades ago by Krauss as one generation's gesture of narcissism, surfaces in the networked present as a strategy for self-representation.

What both Evans's and Bachzetsis's works evoke is a loss, displacement, or migration of the political subject from within the body as image, as it circulates and is viewed online. Evans's works play with the topic of invis-ibility. She mixes various images of bodies vacated, an inverse emptiness to

render that strange contradiction of (a resoundingly female) subjectivity as material that does not matter. "A thing is a hole," Carl Andre once said about casting into negative space, "in a thing it is not."[20] Bachzetsis's performances enact the loss of subject within a new regime of viewing, when desire is mediated and corrupted by the lens, when desire's focal point lies in the surface and volume of the image rather than the hot flesh depicted within it, and when that registering to and as image constitutes human contact. Both oeuvres play with how the subject, rendered as image, might become visible, or effectively disappear.

And while Evans does this with imagery that she has found, edited, or cropped online, Bachzetsis sets up a stage on which she positions the body, this same conduit for information, images, stories. The body is a site of image compositing, but it is also a potential release valve that can work out of itself the pressures put upon that body by technology capitalism's harnessing of its desires, transferring pressure to momentum, dynamic to pulse, and thus to her dancer's body, which becomes a site of agitating and unraveling.

Bachzetsis has trained in performance and dance, in academies, research centers, and residencies across Europe and the US, and her work comes to the fore during a time when art institutions across these territories have widely embraced dance within their spaces, in durational or ticketed events, in longer periods as durational exhibitions, co-hosted with dance spaces or as part of conferences and discursive events.[21] This is a keenness that has also generated artists not trained in dance to use choreography within their practices, and while this often throws up problems and pressures, both practical and conceptual, it seems significant that both contemporary dance and contemporary artists' use of dance are being presented in this way. While it might be attributable to pressures to produce events in an experience economy, there seems a particular pertinence to dance's capacity to harness and release the pressures of embodied imagery, and use the body to figure, in various degrees of abstraction, that bridle in an age of surveillance, productivity, and paranoia.

Discomposition

Emily Roysdon is an American artist who enjoys thinking about: "the primacy of movement—how people move socially, politically, formally,

publicly, aesthetically, and experimentally. First focusing on the relationship between image and movement, then moving into an expanded field of choreography, one not bound to dance, but equally relevant to collectivities and organizing."[22] Like Piper and O'Grady, Roysdon has shown works in diverse spaces from streets and public squares, galleries and auditoriums. In 2014, she was commissioned by Tate Live to record a performance in a Tate Modern exhibition space and stream it live online. The performance now exists as a video that can be viewed on Tate's website, and this migration of context, from gallery to browser, is quite typical of the opportunities offered to Roysdon's generation, as institutions value and calculate traffic to their website in an effort to open up exhibitions to online art encounters, and in turn attract greater visitor numbers. It presents a significant shift in the conception of staging performance that Roysdon references within this work.

Commissioners of the piece, Catherine Wood and Kathy Noble, were conscious of this transition and its various implications when inviting her to consider within the work themes of technology, distribution, and legibility. These leitmotifs of diffusion were evident in the work, but they are intersected with processes and performances of identification. Roysdon's *I Am a Helicopter, Camera, Queen* (figure 6.2 in the previous chapter) is an instruction-based choreography incorporating 105 volunteers who identified as queer and/or feminist. On the evening of the performance, dressed simply in black or white, their task was "to perform the room with me, to make room, re-construct an already heavily signified space, and to create a stage within their collectivity."[23] Here, Roysdon pursues human movement as an individual gesture or refrain and also as a collective, political tide.[24]

In *I Am a Helicopter, Camera, Queen*, a fixed rig of cameras follows a crowd moving across a room together. They assemble in different corners and lengths, bisecting the room at different angles and intervals, huddling together to clear a gap behind as a stage for individuals to break away and speak. Each performer voices an abstract declaration of self. Roysdon's prose is often composed of statements that suggest a presence while acknowledging the impossibility of capturing in language (or image) a person's whole. In this way literary elisions become metaphors for commonly neglected subjects—women, people of color, LGBTQIA—with whom she often shares her stage (*Uncounted,*[25] 2014–2017). Thus, Roysdon's performances

constitute an artistic form of occupation as activism. "I am a swallow, camera, realness, wall," says one young person of East Asian origin, breaking free from Roysdon's grouping. Then a young woman of color declares, "I am a territory, technology, confession." An older man, his face is partially obscured, follows, "I am micro, radio." Singular statements of a self or subject defined by time and technology are uttered before one young white woman faces the camera, closer than the others have appeared: "I am both kinds of Queen."

I Am a Helicopter, Camera, Queen questions the role of the image in modes of address, the power of those holding the lens, and how that power shifts when the lens pivots and the audience becomes the point of scrutiny. There's a willing inversion of the viewer-viewed power dynamic, as evident in all works included in this theory thus far, that's being played within the twinned exhibition architectures of Tate's galleries and its website. When making the work, Roysdon was considering: "representations of territory and seeing—regimes of viewing and ways of understanding space. I had a very formal reaction to the room itself and then my thoughts became dominated by the camera, which takes the place of the live audience, and to this I wanted to have a more hysterical reaction. I wanted the room to be full when the live stream opened, for a lot of people to look back on the one person on their own device at home."[26]

Roysdon also created a transition within the work, where the action and actors move from the white exhibition space into the night of the old power station's dark, cavernous, unlit Turbine Hall. Here, singular iterations by the performers reverberate and echo around the enormous space, and what seemed a rearticulation of social space in the first half of the performance, becomes the dark cavern of an individual consciousness. Roysdon describes the two parts as representing the "formal and hysterical," a similar plummet articulated in Acconci's *The Red Tapes*, this work a strategy to both: "build and then discompose the space. We pushed against the walls, then we exceeded them."[27]

What Roysdon describes as "discomposition" aligns with what she has previously termed her "choreographic thinking," a political, spatial strategy of deterritorializing a premarked space into a more open, inclusive one. Roysdon has considered how, as an unconjugated word, "to discompose," describes a movement of thinking before it becomes "an image, fixed and framed out of time."[28] Again this resonates with the efforts of

de-territorializing imbricated public viewing spaces by many of the con-
stituent artists of this theory, from Piper and O'Grady to Cheang and Beck-
man. Roysdon's works contemplate how both gallery and online spaces are
socially productive and generative, how they condition as well as poten-
tially generate new kinds of movement and viewing. In the viewing condi-
tions for *I am a Helicopter, Camera, Queen*, social architectures are brought
together, ambivalent space reassigned as potentially antagonist. Respond-
ing to why specifically she asked for volunteers identifying as feminist and
queer, Roysdon says she is: "interested in queer lives, particularly now, with
economic crises, rising nationalism and Conservativism. [Making work] is
an opportunity to focus and celebrate queer lives and queer bodies and
think about broadcasting those lives as well as identifying as agitators."[29]
Here, thinking choreographically, her troupe loosens up the space, spoiling
singular, reductive images, multiplying and diversifying them. There's a sub-
text within the work that for all its spoils, flaws, and tarnished economies,
the spaces that host art, that host discomposition, are a vital locus within
the heavily monitored, targeted, and monetized cells of social media, and
wider attention economies. Greeting preexisting modes of top-down distri-
bution by creating her own form of peer-to-peer sharing is a strategy that
Roysdon has employed in a number of formats, from DIY publishing and
self-organized public events, to bringing her work into established gallery
conditions.

Leckey's description of "looking at stuff, making it, sending it out and
it's coming back to you," of prosumerism as "a kind of loop or cycle that
you're in," finds form in Roysdon's work, identifying the regimes of view-
ing that social media and image-sharing platforms create and maintain,
and involved in the gesture or choreographies attempting to delay, manip-
ulate, or subvert it. In this cycle, Leckey often sought to insert his own
body, to embed himself in the plasmatic and assimilate or absorb the gloss
and sheen that high-resolution images have to offer. Alternatively, Roysdon
finds herself capable of infiltrating a feedback loop, online, creating a site of
discomposition for diverse subjects.

Another artist conflating performance and moving image as a space for
discomposition, of deterritorializing a premarked space into a more open,
inclusive one is Wu Tsang. *WILDNESS* (2012) was a work in several parts,
a live event, performance series, video installation, and feature-length
film, all based in or about the Silver Platter, a bar in McArthur Park, in Los

Angeles. Founded by Rogelio Ramirez in 1964, it is still run by Ramirez's family, as the longest running gay bar in Los Angeles, as well as a meeting point for Latinx communities for almost fifty years. Tsang's work centers around a night that she began to host with other artists called "Wildness," a weekly evening of experimental performance, documented from 2010. Footage of these performances was eventually edited into a feature-length film, which itself has subsequently been projected within various screening architectures since 2012, with depictions and reconstructions of the bar appearing in other coinciding works, including DAMELO TODO // ODOT OLEMAD (2010/14).

"I actually would not say that the Wildness party-goers were 'artists' or that the bar clientele were 'queer,'" Tsang has said, "but rather that the struggle to find adequate labels/identities/ descriptors for this 'community' is precisely what the film is about."[30] The piece deals with the "basic human problem of belonging and conflict, which are especially at stake in spaces that are rare and vital for oppressed communities."[31] Tsang adopts neither an observational nor ethnographic position as director, but includes herself within the narrative, as both performer and narrator, and complimentary to the fictionalized voice of the bar itself, voiced by Mariana Marroquin. The bar is the subject of the protagonist, host to Latino immigrants and exiles, gay and transgender communities for the last fifty years. "I keep them safe like a bullet proof vest," Silver Platter says.

Tsang, who describes herself as "an activist, artist and queer person" and whose father was an illegal immigrant to the US, identified with many of the Silver Platter regulars (as well as the "limits of my own understanding of others, despite my well-intentioned critical education").[32] She has spoken of the work as "a ways to create my own my own mythology or emotional narrative around something that was both familiar and unknown to me."[33] Conscious of documentary as an exploitative medium, Tsang scripted the work with Roya Rastegar to make the bar a main character, and to characterize it, through various pared-down dramatizations of Ramirez's own experience, as well as the bar's own magnetism for Tsang. This creates a far less sensationalizing documentary of the intersection of race and class politics with drag culture than Jennie Livingston's *Paris is Burning* (1990), and more a cinematic impression, speculative fiction, or mythology of a particular bar as a host to various kinds of performances, "to eliminate any

possibility that this film could be 'about' the women of Silver Platter, or transgender/immigrant experience in general."[34]

WILDNESS's focus is on Silver Platter as a safe space for a variety of people to come together, but also, on occasion, to respond each in their own way, to image performativity, the repeated and productive stylization of the body based on normative or mediated imagery within a highly rigid regulatory frame. According to Rita Gonzales, referring to a number of Tsang's previous works, "Tsang's is a racial drag in which notions of any settled gender affinity are called into question."[35] But *WILDNESS* also presents something additional to this, which Fred Moten describes as: "a sustenance of brown commonality in anecclesiastical reformation. *WILDNESS* serves *Revolt* with grace and style; it reveals the urge to revel that is devotion's drive. To fuse the relation of devotion, revelry, and revolt is to be welcomed into the temple. The alternative chapel is dispersed as soul."[36] Revelry and revolt coexist in Silver Platter where gender affinities are performed and troubled by many of its visitors, among communities that are continuously reconstituted. Tsang's directorial approach compliments this, the bar voicing its own being, redefined nightly by the changing constituencies it welcomes and protects.

Tsang has said of her interest: "drag is like the art of appropriation in a way, how you pick and choose references and put them together. And especially now that the internet has broadened our spectrum of references, it's interesting how we pick and choose. It's not just the one thing that you can find: it's everything you have access to. It can be overwhelming but it can also create amazing art."[37] In Tsang's *WILDNESS*, identity construction coincides with new modes of online consumption, and the construction and regulation of identity—particular within the data mining and surveillance techniques of large social media sites—becomes the background for a more recent two-screen installation called *A day in the life of bliss* (2014), which overlaps and corresponds thematically with a later single screen video installation, *The Looks* (2015).

In both, the central character is Blis, played by American transgender performance artist named boychild, who occupies and performs two identities in a dystopian future society governed by an artificial intelligence system called the LOOKS, which controls humans through a panoptical social media platform called PRSM (or prism). During the day (as captured in *The Looks*), Blis is subject to oppressive, "prearranged procedures such as

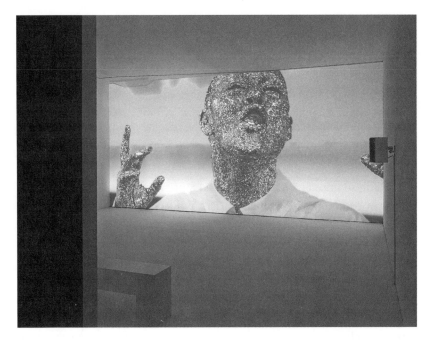

Figure 7.3
Wu Tsang, *The Looks* (2015), two-channel video with sound. Courtesy of the artist and Galerie Isabella Bortolozzi, Berlin. Photograph copyright Achim Kukulies.

makeup and wardrobe that are determined by the fulfillment of the narrowly defined roles stylizing her as a hero."[38] In this society, Blis is within a minority of bodies with two hearts, equipped with a supra-frequency to overturn this regulatory system. Before one of Blis's performances, an avatar MC announces: "The official PRSM channel! The channel that channels you. PRSM: Promising visuality for everyone."[39] This pop star performance is within a particular state of hypervisibility, emphasized by a shot of the audience's camera phones as Blis is on stage. In *A day in the life of bliss,* there is a darker scenography (in contrast with the excessively lit space of *The Looks*), much of which is articulated through nocturnal performances in dark caverns, where Blis and friends go to party, an underground club where devices don't work, where the LOOKS cannot see in. Here, in this intimate space of visibility, Blis dances freely until, in a state of "twinning"—caught between the desire to be looked at and the fear of being seen—something of her frequency reveals to the LOOKS her whereabouts and activity. A special police force breaks into the club and brutalizes Blis and her friends.

Blis is tasered and injured by the police force, a violence that short-circuits her encoding, and ultimately frees her from this digital panopticon. In both the underground scenes, and in the finale of *A day in the life of bliss*, boychild's body moves more freely, with less tension and restraint than in the highly staged and managed pop performances of *The Looks*. The body again is rendered as channeling or carrying the pressures of constant scrutiny and objectification, but it is also choreographed by Tsang, and guided by boychild, as the medium or valve that can release or work out that tension.

A day in the life of bliss is stylized, dramatized, and concluded in a way that recalls aspects of cyberpunk film and literature's obsession with technology's invasion of the body, but it does so from the viewpoint of a character who diffuses gender binary while inverting the racial hierarchies of early works of the genre. Dance again plays a significant part, and several reconfigurations of the piece have included multiscreen projection with elements of live dance. While this work takes Tsang much more clearly into the realm of social media, and the various mechanisms of data mining that stalk our experience and enjoyment of the spectacular, there is a consistent sense through Tsang's works, through alter egos, object mythologies, and drag personas or avatars, as well as through the nuances of movement and dance, of the impossible and almost implausible seduction of performing images and, interconnectedly, of watching them performed—this illogical coexistence of pleasure and paranoia that makes the recursive nature of performativity so difficult to uproot in societies of spectacle, economies of attention, and ideologies of neoliberalism.

Digital culture's impact on social engagement is enacted by a number of video works by American artist Ryan Trecartin. Often shot in unremarkable domestic spaces, striplighted at night, his sets suggest the 24-hour conversational warrens of social media's chat forums. *Any Ever* is a suite of films shot in Florida between 2009 and 2010, wherein an ensemble cast of artists and actors speak loudly, regularly, coinciding confessions, gut-spilling, fearing catastrophe and imminent victimization, coalescing at remedied pitch and speed. Appearance is equally heavily layered with conspicuous glitter and ill-colored over-contouring, almost obscuring the race and gender of his participants, each presenting a newly versioned self. Melissa Gronlund describes this slight but significant transition from subject to performed online self evident in Trecartin's work as "personation."[40] "Though

it traffics in fictional personae," Gronlund writes, "much of the work of personation on YouTube (both historic and general) is motivated by the performance or evocation of the shared of affective relations that characterize the YouTube universe: the loneliness, voyeurism, scopophilia, desire, and binge-watching boredom."[41] Trecartin's actors are anxious aggregates, makers and conduits of Big Data gathered within one disharmonious social matrix, and they express the acute paranoia of a node dependent upon a larger network, through which information will pass but not necessarily stick. This vacuum is often emphasized by text overlay and intertitles, "as if," "any ever," nonsensical conjunctions that fill conversational gaps without necessarily producing meaning. And the same nodal points that Trecartin registers and refines in his ensemble cast of cyphers, he also use as a means of circulation: Trecartin, for example, is represented by Andrea Rosen Gallery in New York, the website of which links to both his Vimeo site and Kenneth Goldsmith's UbuWeb's dedicated artist page. Like many artists showing their works in both gallery contexts and prosumer websites, there's an "any ever" irreverence in showing across the wide spectrum of architectures in the attention economy.

Trecartin has innovated noxious operas of verbosity and anxiety familiar to social media users that resonate with more recent works by American artist Shana Moulton or Scottish artist Rachel Maclean. It has been screened across diverse channels, from YouTube spaces to elaborate installations within traditional gallery spaces and museums, and there's a similar interpretational shift impacted by the exhibition space and how individuals or groups are circulating, or lingering, within it.[42] As tragicomedy, these works propose us all as being conduits or vessels for enormous quantities of images and information, some of which are assimilated and some of which simply pass through: a reduction of this strange new vernacular that social media has brought about and begun to inscribe.

At the Limits of Capture

Dominican-American choreographer and dancer Ligia Lewis (who appears as a dancer, and friend of boychild, in *A day in the life of bliss*) treats the affect of imagery differently, and with an entirely different aesthetic strategy. Lewis has said of her work, that through this piece she wanted to achieve an "impossible desire to be nothing, to become lines in space, to empty

out, as a way to interrogate whether a black body can ever be abstract."[43] Her work responds to the dichotomy of a black body within Western representational hierarchies as being simultaneously hypervisible and invisible, a paradox produced by and maintaining systemic inequalities, which Hall described as being a "carefully regulated, segregated visibility."[44] This dance, *minor matter* (2017), is the second part of a planned trilogy of performances (*BLUE/Sorrow Swag*, 2016; *RED/minor matter*, 2017; and *WHITE*, in progress at the time of this writing), staged across a number of dance and museum venues internationally. Danced with Jonathan Gonzalez and Hector Thami Manekehla, the work progresses in sequences, with the opening postures worked out from various depictions to the body through art history, from Renaissance and Baroque periods to representation of bodies in Modern and Contemporary art, interjected with some familiar iconic postures from sporting greats. Movements of baroque exuberance and flamboyance evolve to the body-pounding of staged wrestling, and then elongate into to a minimal horizon line, dancers rolling in sync feet to shoulder. From these tableaux, in Lewis's words, "three subjects emerge" when the piece takes a radical turn "towards the flesh, and the fleshiness of the space that hosts this experience."[45] The three dancers climb into a stack, working together to snatch at the sky. They move back and forth around the edges of the stage, tracing and testing its external boundary. This periphery becomes a spatial metaphor for the limits of the image's frame, the walls of the black box, and, perhaps, the limitations of representational platforms at large.

The tone of the dance keeps changing: between great exuberance, there is a nervous energy, like they are maneuvering around some oblique and heavy danger. With the dancers wearing plain gym clothes, the piece is not overtly gendered; the three congregate, separate; couple and uncouple; they pound, slap, cajole, and lament. It is danced with pace and vigor. I saw the piece performed in a dark, windowless industrial space illuminated only by a sophisticated rig of red lights, which marked the dancers at intervals. At the outset of the piece, Lewis announced on stage, "I want to turn you inside out and step inside your skin." This is an articulation in dance, of her responses "between love and rage," to the representation of the black body in histories of art, dance, theater, and cinema. And for this white spectator, the work provided a muscular pacing through a spectrum of affect, presenting an overwhelming intensity, within one short hour, of the myriad

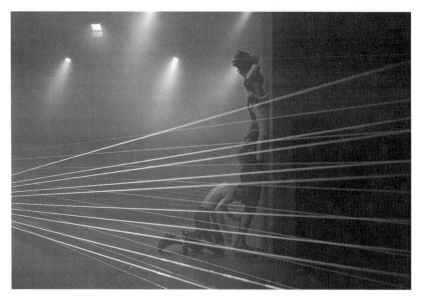

Figure 7.4
minor matter by Ligia Lewis (2017). Performed by Ligia Lewis, Jonathan Gonzalez, and Ariel Efraim Ashbel, as part of BMW Tate Live Exhibition: *Ten Days Six Nights, Tate Modern* (2017). Courtesy of the artist. Photograph copyright Martha Glenn.

possibilities, euphoria, grief, and rage of being both beneath and beyond this image. Lewis says,

Dramaturgically, I am interested in the work shifting regularly, [in] creating an unsettling feeling, with the desire for it to be at the limits of understanding, or of a kind of "capture." I am very inspired by notions of opacity that allow for a blur between our bodies and the space and things that we encounter. This blur is a way to bend, and hopefully extend the borders of representation.[46]

After the work, Hannah Black wrote: "It turns out utopia is going to have to coexist with apocalypse and that both have been with us all along. Lewis's work offers a kind of oblique blueprint for how joy, hope, anger and despair are all always the case, using the paradigmatic fact of blackness."[47] *minor matter* presented with complete sensory intensity, individual subjectivities rendered in full complexity, beyond the confines of the pictorial, the linguistic, or, of historically white institutions, with a quality close to what Eisenstein once tried to articulate as "beyond an image, without an image, beyond tangibility."[48] Lewis's blur, this splay of affect held within it enormous power, a dance of rage and of "range."[49]

Prosthetic Memories

Social media platforms regularly host and monetize particular creative and communicative desires of their prosumers, harvesting big data; but these are also loci for identity construction, for the constitution of individual memories or reparation of collective ones, the significance of which is explored by American artist Martine Syms. Syms has previously identified as a "conceptual entrepreneur," working across a great range of media. After graduation, she set up Dominica Publishing, "an imprint dedicated to exploring blackness as a topic, reference, marker and audience in visual culture."[50] She has long been interested in establishing new methods of challenging top-down distribution with peer-to-peer circulation, and often utilizes prosumerism to help source, edit, or reorganize visual material influential to her in different ways.

Syms's work has often treated memory as an accumulation of images, one that can be disassembled, loosened, supplemented, and publicly examined, before being brought back together to recirculate anew. In an early video, *Memory Palace* (2008), Syms shadows her aunt, a character modeled from old family photographs (and performed by actress Alice Smith), as she moves across a city. Syms follows this woman's movement, a potentially threatening trajectory that echoes her earlier migration from North America's rural south to its more industrial north, movements in public space that were, and arguably remain, dangerous for a black subject.[51] Like Piper, O'Grady, Tsang, among others included in this analysis, Syms considers the vernaculars of human movement as being at once both personal and political, and the performance space or filmic frame as a site where these movements can be mapped or rezoned. Referring to conversations she has had with artist Gordon Hall, Syms proposes:

that politics is something that you do with your body, a vernacular for the way that I move, you move, we all move, and the body as a kind of document of these things happening to me, and the show as documenting the experience of being in my body ... I'm interested in how you keep this black female body present, and maintain value through that circulation, so as this continues to circulate so does the behavior and ideas surrounding these specific bodily experiences.[52]

Syms collects old photographs of black women from family archives, flea markets, and online, women in the process of doing or learning. It's a process, she explains, of acquiring and producing a "prosthetic memory,"[53]

adopting Alison Landsberg's theory of how the cinematic image can constitute in its viewers a functioning memory where, "prosthetic memories are adopted as the result of a person's experience with a mass cultural technology of memory that dramatizes or recreates a history that he or she did not live."[54] Landsberg locates the prosthetic memory's origins in the transition between the pre-narrative "cinema of attractions" and narrative cinema, proposing that the experience of watching certain kinds of films is indistinguishable from lived experience and can create long-lasting memories while reconfiguring identity and social formations.[55] Prosthetic memory, in Lansberg's account, functions for the cinema audience who, empathizing with particular characters, can identify across social divides. Thus prosthetic memory has a purposeful collectivizing function.

Accompanying her accumulated images, Syms excerpts writing from the black radical tradition, from queer theory, film theory, speculative design, and other literary sources. Mind and desktops are coproductive sites of prosthetic memory, where she can trawl, source, and glean information, a circuit rendered for an audience in her performance lectures, *Misdirected Kiss* (2016, named after the eponymous 1904 short feature film distributed by American Mutascope and Biograph). Syms presents to her audience a series of images of figures that have populated, captured, and informed her life, including Queen Latifah as Khadijah James (from the sitcom "Living Single"), Tyra Banks, and Isabel Wilkerson, alongside childhood photographs. These images are accompanied by a personal account and quotes from influential texts, interrupted on one occasion by a walking through of the "power poses" promoted by social psychologist Amy Cuddy during a TED talk that went viral, in part due to the absurdity of proposing that systemic biases be fought with physical postures. When asked by Doreen St. Félix whether her power posing in the work was serious, Syms replied: "It is and it isn't."[56] Beyond the fluctuation in tone between sincerity and parody, the work presents a digital topography of subjecthood layered up in the way of a memory, called upon through multiple words, postures, and images of mixed resolution. Prosumerism's search capacities, in order to consolidate, constitute or reconstitute memories, are valued here.

Syms's first feature, *Incense Sweaters & Ice* (2017), takes as its narrative backdrop a woman's journey from Los Angeles, California, to St. Louis, Missouri, to Clarksdale, Mississippi, retracing the path of the twentieth

Inside the image:

but you're doing it!

that's all that matters

you got this 😊

Aw thanksss 💚💚💚

WB I have to stop comparing myself to other people

you never know what's rly goin on w someone

they're super cheesy but i like these meditations

https://www.tarabrach.com/guided-meditations/

WB Thanks I'll check it

Figure 7.5

Martine Syms, *Incense Sweaters & Ice* (2017), 69 minutes. Copyright Martine Syms, Courtesy of Brigit Donahue, New York, Sadie Coles HQ, London.

century's "Great Migration of African Americans," from rural south to industrial north (also evoked in *Memory Palace*). The work opens with the image of a woman dancing in a nightclub.[57] Syms's protagonist, "Girl" (played by dancer Katherine Simóne Reynolds), seems unaware of those around her, in a contented state of self-enclosure. At intervals, the camera lens acts as proxy for the subtle scrutiny of "WB," the white boy this black woman is dating, appearing through selfies and video selfies on opposite sides of the screen's vertical margins, like the interface of a smartphone. But outside of their intermittent dialogue, the piece is largely composed of shots of Girl engaged in quotidian activities, or what Syms calls, "performing the mundane,"[58] sitting in a car in traffic, smoking cigarettes on a work break, reading a book on a sofa, relaxing with family, or out with friends, releasing Syms's subject from what Malik Gaines has described as a "black performative repertoire," which is imposed and "called upon as insistently as ever by economic exploitation, white supremacy and patriarchy, to maintain striations (and power) within a sphere of visuality."[59]

Politics' impression upon the body, surfacing as a physical vernacular, is also explored by the recurrent appearance within the work of Mrs. Queen Ester Bernetta White, a character played by Jazz singer Fay Victor, based on Maxine Powell, who taught elocution and comportment to black musicians

signed to Motown Records during the 1960s. Mrs. Queen's belief in her own capacity to combat racism and social exclusion through specific elocution, facial expressions, and positive posturing is conveyed with the same oscillating tone as Syms power poses in *Misdirected Kiss*. "Tonally, I disagree with a lot of it," Syms has said. "But I find that voice very humorous. I was interested in playing in that register."[60] Mrs. Queen is recorded in a purple recording studio, set apart from Girl's daytime routines and nights out, and existing more like a specter. Through both characters, Syms scrutinizes performance, and the filming of performance, and the prosthetic memory possible of that filmed performance as a way of redetermining or recoding the performative registers that have been politically and socially inscribed. As St. Félix notes, "Syms looks to performance as both a medium and a subject," captured and reorganized through her performance lectures and moving image work.[61]

* * * * *

Syms's oeuvre resonates with others in this chapter in her implementation of performance and moving image to articulate how embodied subjectivity might be reduced, omitted, or confined through mediated images, and to question how social media might exacerbate or alleviate the biased spheres of visibility that various Western representational bodies have long constructed and maintained.

Throughout this writing, I have been alert to the danger of universalizing the aims of these artists, and the threat of undermining the uniqueness of their experiences through an interconnected analysis of their works. But the heterogeneity of approaches toward image performativity presents a necessarily strong, arguably vital, set of equivalents commensurate with the task of establishing a better critical understanding of the different forces behind a new economy of images within which prosumerism is at work.

8 Proximity and Distance

I propose that works of art set out in the previous chapters address the unique and idiosyncratic motives and mechanisms of image work and image play from diverse, heterogeneous perspectives, each exerting an instinctive push and pull that Leckey expresses as being, "about distance and intimacy—all of this [work] is about trying to become more intimate with something."[1] And, while physical yearning is an innate force of wanting exerted in many possible directions, since "cinema surreptitiously became the formal paradigm and structural template for social, that is, becoming-global, organization generally,"[2] yearning has been a compulsion both mediated and held by images, distending this primitive "urge," felt by Benjamin in 1936, "to get hold of an object at very close range by way of its likeness."[3] Projection and alienation are cause and effect of what, in 1956, Edgar Morin observed as the charm of the image:

The more powerful the subjective need, the more the image upon which it fixes itself tends to be projected, alienated, objectivized, hallucinated, fetishized (as many verbs as can punctuate the process), the more this image, in spite of and because of its apparent objectivity, is rich in this need to the point of acquiring a surreal character.[4]

We perform the images that precede us, and, repeated, these performances congeal over time to produce the appearance of a substance, a system that regulates, disciplines, and divides us among others. Physically, the proximity of the body to the digital image comes ever closer as the devices to view them now sit in our pockets, on our bodies, in our beds, rather than installed in a living room, or seen projected in local cinemas or traveling fairs. They're with us all the time, as is this strange intimacy that promises human contact while it lulls attention away. On trains, in stations, in cafés, at home, our feet are grounded but our minds are elsewhere. Images are

colorful, contact is promising, and promises are constant. The devices that enable this contact, this imminence, also yield continuous access.

In appealing to everyone, social media feeds on prior representational media's disrepair. The "diversification" of media, from private media conglomerates to private social media corporations, ostensibly supports subjects to self-represent upon platforms. This promise of presence, this latent proximity, is a hook pulling us toward platforms to see ourselves among others. It's a container for everyone-everywhere, a space to get *inside,* a center of activity unleashed from the confines of space and time. We go there in order to see inside and be seen from some unknown outside. A body's willed proximity to that center represents the mechanism of image capital, harnessing the subject's perpetual instinct toward the image. This is the power of its performativity. Performing Image works explore this notional sphere of visibility and the recursive information behaviors that keep us driving toward its center. Interested in "the loops or cycles" that we are in, these are a collection of heterogeneous efforts to intercept this performativity of images, to illuminate or trouble the repeated acts of image consumption-production-consumption that constitute and maintain a highly rigid regulatory frame that threatens to continue to precede and produce us.

Many critiques of capital over the last century have regarded how culture interpellates its citizens, theories of momentum as much as absorption, which allude to the proximity and distance between the subject and the ideologies of the state. In this chapter, I look at three dynamics as present, and possibly coexisting, within the examples of Performing Image works, where some articulations create a distance between the subject and its image, as others stage proximity. These works pool together performance and moving image, a convergence that reflects back on social media's "meta-media" and the "information behaviors" produced there. Within their frame, site, or stage, the works spotlight a subject's push and pull toward images, and the circuits of consumption-production-consumption through which body and image mutually take shape.

Body to image, these *pas de deux* have been shown across various exhibition platforms, presenting to those encountering them a pause or delay in the circuit of mediated consumption and production. We as viewers are directed to a strategic point mapped by the artist, not to illicit the same subjective responses to stuff, to images and things and images of things,

not necessarily, but rather to see the formation of a subjectivity, and how that is catalyzed, compressed, and capitalized through image production, consumption, and exchange. Here, during this momentary pause, we may recognize ourselves within the loop, from a temporary point outside.

I put forward three phrasings, used exclusively, or with combinations of the three as alternative critical paradigms through which to think about the works pan-historically, that is, extricated from the generational groupings of this particularly speculative genealogy. Tentatively, I describe a dynamics that perhaps I alone see, and certainly that I see subjectively. The embodied subjectivity presented through actors, avatars, proxies, or dancers, sets of performers, moving, posturing, voicing, employing different narrative strategies against their opposite number, the image, the camera, its lens, sets of images, moving now, the host platform, a stage, a screen, the black box—these new institutions of looking-labor—are the image's economy, capital, like Beller's "cinematic." The artist renders image-play, work, play, the mediated image, capital's apparatus, within the frame.

The artist choreographs this dance on a stage within a frame, a stage, a screen, or a temporary clearing, a space to hold this series of movements. What is danced in these sequences is the coming together of a body to image, object to camera, subject to system, the transition from surface to interiority and it subsequent passage toward image. What that dance reflects is not a body's flat reproduction of itself, at least not only, but more than that, the urge to penetrate, to get and give in. Performing Image shows this cajoling, its lurid detail, an extension, attempted possession, becoming, a hostage situation, a swift exit, exile, a dance of proximity and distance.

Of Distance

One subset of works regarded in previous chapters renders the distancing effect, of a protagonist from the image they are encouraged to inhabit, and in doing so sheds light upon the dominant ideology, which puts productive imaging into action.

Distantiation, or the "alienation effect," was a term originally coined by Bertolt Brecht[5] in his essay on "Alienation Effects in Chinese Acting," published in 1936. He used the term "verfremdungseffekt," or "making strange" (after Viktor Shklovsky defamiliarization theory, 1917), to describe a strategic distancing effect he observed implemented by the Beijing Opera,

where the audience were discouraged from being fully immersed in the narrative or illusory effects of the drama being enacted before them. It describes a form of acting where "the audience was hindered from simply identifying itself with the characters in the play."[6] Actors' actions and utterances were to be processed by the audience as conscious critical observers, rather than passively or subconsciously, creating awareness of the narrative undercurrents, malleable responses, and the artificiality or exaggeration of traditional theater-making techniques or effects, from highly constructed characterization of protagonists, as well as hyper-stylized costumes and makeup. Brecht's "Epic Theatre" style was intended to create rational, self-reflective, rather than passive, audiences, which had its counterparts in painting, literature, and theater.[7]

Distantiation was a strategy shared with philosophers, psychoanalysts, and theorists, referring to the distancing of the observer or reader from an object of scrutiny. Louis Althusser takes up the term in 1966, in response to literature's capacity to distance its subject from the dominant ideology in which he or she is held:

> What art makes us *see,* and therefore gives to us in the form of *"seeing," "perceiving"* and *"feeling"* (which is not the form of *knowing*), is the ideology from which it is born, in which it bathes, from which it detaches itself as art, and which it *alludes* [original italics] ... Balzac and Solzhenitsyn give us a "view" of the ideology to which their work alludes and with which it is constantly fed, a view which presupposes a *retreat,* an *internal distantiation,* from the very ideology from which their novels emerged. They make us "perceive" ... in some sense *from the inside,* by an *internal distance* the very ideology in which they are held.[8]

Althusser observed, particularly in works by Balzac and Tolstoy, content as carefully "detached" from their political ideology during the narrative, a detaching which, when rendered, "makes us 'see' it from the *outside,* makes us 'perceive' it by a distantiation inside that ideology, *presupposes that ideology itself* ... only because he stuck to his political ideology could he produce *in it* this internal 'distance' which gives us a critical 'view' of it."[9] Althusser's essay on literature's relationship to dominant ideologies reflects his own confinement, as a member of the French Communist Party, struggling against its adoption by the Second International and by Stalinist orthodoxies, writing as he did to restore an earlier spirit of Marxism, and some aspects of Leninism.[10]

Acconci, such a choreographer of distance, created a siege on perception of self, through the same currency by which the TV viewer's psyche was Americanized, cutting up and cropping propagandist images, and splicing them between interpretative pictures of an anxiety-riddled mind. And Rainer, in *The Man Who ...*, creates an internal distance between her female subject and the culture in which she feels held, by relieving her from the scrutiny and gendered inscriptions of the central shot, and diminishing the presence of her male counterpart by splitting his image in two, by segmenting his speeches, and by compositing images behind Jack, positing us all as conduits for multiple images while also challenging our attention to them, their productiveness, as the work runs. This method is picked up and repeated, albeit within a more rubbery, digital render in Stark's *My Best Thing*. There is a pervasive sense throughout these works that they are willing a distance between the subject and the image that represents them, and the media behind those images. In rendering familiar technical and aesthetic aspects of the frame, as well as their protagonist's (individual or collective) removal from within it, *from the inside*, they might be said to achieve an internal distance from the very ideology in which they are held.

Cheang's *Brandon* presents a more complex example here. Here, there is a purposeful detachment of the subject from the image or system of representation that fails to represent it in its entirety and its complexity, as presented through the various fictional and found texts that refer to Brandon's body, violated, incarcerated, or harmed by individuals, by society, by the medical profession, judiciary, and penitentiary, as well as by the singularity of gender signifying motifs. Cheang adopts a new method or technique for simultaneous articulation of image and architecture, through *Brandon*'s mainframe. This is a viewing architecture in which the interpretation of one subject by another is always going to be different and the consequences of different impulses, responses, and "clicks." It is a work—like its subject—the depths and multifaceted nature of which it is impossible to ascertain from the limits of one frame. *Brandon*'s mainframe is an appropriation of open source architecture that in the early 1990s was in its utopian infancy, where images and narratives could coexist in their simultaneity, and transmutability, representing those aspects within a body. Insofar as Cheang's works prior to *Brandon* distanced themselves from reductive representational systems, this work explored the historical documentation and

imprints of these damages, while also nesting a reconstructed subject in new spatial and social formations online.

Distantiation is evident through Beckman's work, in key moments when the female protagonist is confronted by the image set up for her to perform. It's a *mise-en-abyme* that appears throughout her works: in *Cinderella*, when she sees herself subordinated in the form of a doll, or in *Hiatus*, when Wanda is subject to assault and then recognizes the powerlessness of her avatar, Madi. Her gendered image or stereotype functions among a matrix of other stereotypes, as conduits subjugated by patriarchal power, distilled through technology capitalism, with this Second Life-type platform feeding off all forms of uncensored participation.

Beckman has made numerous works about women working within patriarchal systems, observing how technology capitalism carries forward biases from previous economic models. In the face of this, she saw Virtual Reality as a space to rehearse a counterattack. It's an update of Althusser's distantiation, where the literary character finds herself removed from the ideology in which she's suspended and seeks to break free. Beckman's distantiation presents one possible response to how ideology is heavily mediated by, and promoted as, the "acculturation of self."[11] Beckman's distancing is that of a white, female subject retreating from an imperfect American ideology as it permeated the media, by way of video games, during the 1980s and early 1990s. Evans's *Hyperlinks* takes this work forward into present day, onto recognizable social media platforms online, where, before our eyes, women are animated only to disappear before us, contained bodies on the way to self-erasure, online bodies that seem to matter less.

Of Proximity

Overidentification is another strategy, another phrasing, to challenge or confront the workings of performativity, potentially utilized by several of the included works, as a method of revealing the urge to contact, touch, or perform images.

Overidentification is an absolute embodiment of the image or images, so as to exist as if seamlessly in its shape. Overidentification is a term that Slavoj Žižek adopted from Lacanian psychoanalysis and applies to the analysis of the contemporary Slovenian avant-garde music group Laibach, in his essay "Why Are Laibach and the Neue Slowenische Kunst Not Fascists?"

(1993). He describes their method as overidentification, to undermine the political system by taking it more seriously that it takes itself. He proposes that Laibach was not simply performing an ironic or parodic imitation of the official communist state ideology, but unsettling the system by overidentifying with it.[12]

Overidentification is a dramatic or theatrical ploy that resembles, but does not reproduce, aspects of parody, satire, irony, or pastiche, which aims to undermine a system of knowledge. Unlike Brecht's "distancing effects," it purposefully obscures any clear lines between two political perspectives or systems of knowledge. According to the research consortium the Political Currency of Art, overidentification: "finds logical paradoxes within the system rather than imposing an external logic or ethic upon it to reveal its flaws. At the same time, within a system that is defined by its supreme tolerance of resistance, privileging of the surface, acceptance of contradiction and absorbency towards critique, it can point to internal paradoxes and repressions, and be an effective means of opposition that goes beyond irony."[13] Unlike the overidentification strategies of Laibach and the NSK, which were "so disconcerting for many political actors in Slovenia in the 1980s," Leckey's on-stage persona overidentifies with a condition within a circuitry of images brought about by changing Western capitalist ideologies, with the Internet cast as a desire machine or deity facilitating alienation and projection.

This drive toward images has long underpinned Leckey's work, and, in the past, he has referenced Sigmund Freud through Sergei Eisenstein's theory of the cinematic "plasmatic." Eisenstein had coined the term plasmatic when watching Disney cartoons in the early 1930s on a first visit to the US,[14] proposing that the contours of Disney's animated forms were plasmatic in the Freudian sense.[15] Eisenstein regarded Disney's animated bodies as morphing and coalescing with their surroundings in time with music, like life's drive returning to its amoeba, creating a profound subconscious reaction in its viewers, and vulnerable emoting, whereby they became susceptible to ideological manipulation.[16] In 2006, the same year he first performed *Cinema*, Leckey used the term "plasmaticness" to describe his overwhelming desire to pass through the surface of the high-definition image into the plasma of its core.[17]

Leckey, in his final scene of *Cinema*, inverts Frampton's distancing from cinematic illusionism, to overidentify with the lemon's "lemonyness."

Leckey's plasmaticness describes his difficulty in distinguishing objects on-screen from those in the round—and this is the very premise of *Cinema*. Leckey replaces the plasmaticness of Eisenstein's cartoons' outlines to the hypnotic effect of the surface of the image on its viewers.[18] His plasmatic is an enjoyable state of suspension that disrupts the spectator's material understanding of things. Both theories of plasmatics describe the screened image as mediating surface suspended between the social conditions of the outside world and the individual's internal perception of it. Essential to the plasmatic is its penetrability of form, where in total proximity, the image is a porous, pregnable thing. *Cinema*'s selection of materials is so idiosyncratic, its connections so tangential, that Leckey's performed overidentification demands less a compatible reaction from the viewer than recognition of Leckey's submission to the image's allure, to the body's will to inhabit and be inhabited by images. What ultimately we're presented with is an externalization of the constant search for contact as mediated by images, a project that bears strong resemblances to and much common ground with, both formally and conceptually, the work of Robert Rauschenberg. Whereas the elder artist intuited a new image economy from the traffic of images he delayed in his Combines, Leckey's work reflects how that image economy feels from YouTube's ground. Leckey's various respective protagonists, actors, and alter egos present as subjects as "caught between surface and interiority."

Leslie Thornton's rendered convergence of the human sensorium into electronic systems, styled in "post-apocalyptic splendor," with Peggy and Fred developing, simultaneously, as us, and imaged others, might read as an alternative form of overidentification, within an imagined technologically determined future. And exploring different modes of projection, or becoming, within a less self-contained social setting, in *Mythic Being*, Adrian Piper dresses up and projects herself as a man on a New York street. This was an experiment in performance, documenting and publishing the results in a daily newspaper, a gesture that, as per overidentification's later definition, "[found] logical paradoxes within the system" of visibility, and presented an "effective means of opposition that [went far] beyond irony." What seems to have been at stake here was visualizing how different signifiers and intersections of gender and race would effect one's public visibility, how one could pass at certain moments unnoticed, or—as Piper found when she began to make public utterances—how quickly one could attract undue scrutiny and surveillance. This street performance gave her the

space to explore masculinity, black masculinity, and, simultaneously and in contradistinction, her own subjectivity, an interrelation she felt second wave feminism was hostile toward and actively closing down. A drag act, certainly, this performance also belongs to a lineage of philosophical and political inquiries into what aspects of identity are socially inscribed and how this effects what is perceptible in public space: how racism, for example, persists through the consumption-production-consumption of images circulated by media privileging white subjects, creating a highly rigid and regulatory sphere of visibility through which all subjects must travel. While one might legitimately read "distantiation" as a conceptual strategy evident the work, Piper's work also approaches the image as porous, pregnable, or inhabitable. It examines and inhabits the idea of a representation of self as something of a coexistent or double, marking us, in Edgar Morin's words, "not so much as a true copy, yet more still than an *alter ego*: an *ego alter*, an other self."[19]

This is not to posit that by "overidentifying" with the image the artist was attempting to accept the system that has produced and maintained her, but surely, the opposite. These dramatic overidentifications present a subject seeking to perforate, inhabit, or render this contact with the image, and, in so doing, also inhabit or make visible the social relations or ideologies that produce, regulate, circulate, or hold it in place. This is the phrasing of proximity.

A Negotiation

In this third hypothetical phrasing a body advances and recedes before the image.

It is a footwork evoked in Michel Pêcheux's theory of "disidentification," articulated in *Language, Semantics and Ideology*,[20] drawing from Althusser's *Ideology and the Ideological State Apparatus* (1970), published several years after his essay on distantiation. Althusser's *Ideology* focused on how subjects are constituted, or "interpellated," by the realm of ideology. Ideology represents the subject's imaginative relationship to the social conditions in which they live, and is always locatable within the *apparatus* of the state. Pêcheux describes three potential modalities, subjective responses to the state apparatus: the "good subject" identifying with it, the "bad subject" rejecting it (thus "counter-determining" or reinscribing it). Disidentification

is Pêcheux's third option, a response to that state apparatus that simultaneously works on and against dominant ideology in order "to transform a cultural logic from within, always laboring to enact permanent structural change while at the same time valuing the importance of local or everyday struggles of resistance."[21] This dynamic relates to the terms set out in Stuart Hall's "Encoding-Decoding" theory of the production and consumption of messages in broadcast media, wherein audiences respond to media messages from three distinct positions—from a hegemonic position, a negotiated position, or an oppositional position—indicating three stages in a spectrum of "distortions" of how immediate an audience member will perceive their own experience to be represented in relation to the cultural bias within that encoded message.[22] Disidentification here resembles an oppositional position.

Judith Butler asks: "What are the possibilities of politicizing disidentification, this experience of misrecognition, this uneasy sense of standing under a sign to which one does and does not belong?"[23] But in both Pêcheux's and Butler's constructions, the subject is *inside* ideology, one who might tactically work on, within, and against cultural form. But José Esteban Muñoz unfixes this subject position for those who identify as often or always *outside* a dominant system of ideology (or representation), a position that may vary or fluctuate according to a subject's shifting or oscillating relations to power, a position necessarily adapted to different social contexts. Muñoz's disidentification is: "not to pick and choose what one takes out of an identification. It is not to willfully evacuate the politically dubious or shameful components within an identificatory locus. Rather, it is the reworking of those energies that do not elide the 'harmful' or contradictory components of any identity. It is an acceptance of the necessary interjection that has occurred in some situations."[24]

Muñoz's theory is one of constant negotiation, articulating a subject who, at different moments, needs to conform or reject dominant ideology in "response to state and global power apparatuses that employ systems of racial, sexual, and national subjugation."[25] Both majority and minority subjects, in Muñoz's account, may be structured "through multiple and sometimes conflicting sites of identification"; however, the minority subject "need[s] to interface with different subcultural fields to activate their own senses of self."[26] Muñoz evidences his theory through three media representations of queer Latino-American men: Pedro Zamora's enactment of

queer and Latino identity practices in the phobic public sphere, via MTVs *Real World* (1993); Sara, a transgender Cuban-American subject from a homeless community gathering around a New York City salt reserve, documented in the feature-length film, *The Salt Mines* (directed by Susana Aiken and Carlos Aparicio, 1990); and the works of Cuban American artist Felix Gonzales-Torrez, whose "disidentificatory strategies of cultural production eschew representation for performance, specifically, disidentificatory performance."[27]

Wu Tsang's works take up Muñoz's "disidentificatory strategy," pulling focus on the disidentifying body, who Gonzales-Torres "invokes" rather than depicts. Tsang's disidentifying body finds form in a durational and documented performance in a safe space, where subjects come together, foregrounding what Muñoz describes as a "performance of decoding mass, high, or any other cultural field from the perspective of a minority subject who is disempowered in such a representational hierarchy."[28] In this vein, Elodie Evers's interpretation of Tsang's *A day in the life of bliss*, as the protagonist lip-syncs on stage, in pop star mode, is that she: "expresses the relationship between detachment and empathy within the performance's act of self-representation. The LED light she carries in her mouth heightens the virtuality of her appearance, creating the impression that her body is curiously uninhabited."[29] This mobility of stage presence seems to describe what Muñoz calls a "process of production, and a mode of performance ... of shuffling back and forth between reception and production."[30] This is the image of an "ego alter," whose alter ego, whose double, whose twin, we are also shown, in a more intimate, underground scene. This shuffling would seem a fitting précis for Ligia Lewis's dramaturgical approach in *minor matter*, not as a dance step, but rather, in the movements of the dancers butting against the delimited space of the black box and proscenium stage, this reductive frame, testing its boundaries with the extensive and intense spectrum of affects the dance yields.

Muñoz's "disidentificatory strategy" might also resonate with Emily Roysdon's "discomposition" strategy, of deterritorializing a premarked space (and simultaneously mobilizing language and "the image") and rezoning it for the duration of that performance into a more open, inclusive one.[31] It chimes with the description of Muñoz's disidentifying subject who can neither escape ideology nor succeed against it, in the face of ideology's universalizing and normalizing narratives, but reconstitutes or rehearses new

political space through the articulation of that subjective narrative, where subjectivity might be rendered through different degrees of figuration or abstraction.[32]

Both proximity and distance are perceptible in O'Grady's work through her own transformational presence. O'Grady brings into view the distance of historical time, through an image of the sculptural rendering of ancient Egyptian Queen Nefertiti projected adjacent to that of her sister. Emerging from their physical likeness, their proximity, come a number of questions of distance, temporal, geographical, and socially constructed. There's a question of the distance between the ethnographic studies of Ancient Egypt that deny those royals had African ancestry (a claim of Eygptology long considered racist), against the visual fact of these women's likeness, projected large before an audience; there's the question of unrecoverable information with the circumstances around their deaths remaining mysterious, Nefertiti's still unknown, and her sister from complications after an illegal abortion in 1962; and there is the distance of mortality, a play of grief and reconciliation, as these images of two women are projected before a third one, moving before them in the front of the stage. But these distances were cut, made proximate, as O'Grady stood before them, delivering her sermon, doubling back on historical time; breathing life into her subjects through memory, poetry and ceremony; admonishing racial (and racist) distinctions that hold these women at a genealogical remove; reconciling a geography of separation. And like *Art Is*, in *Nefertiti/Devonia Evangeline*, O'Grady presents an insistence of proximity to the image, in spite of inscribed distance.

Beyond its decoding of various stratified cultural fields, it stages what Muñoz describes as "a process of production, and a mode of performance ... of shuffling back and forth between reception and production."[33] The works also "point to internal paradoxes and repressions, and [offer] an effective means of opposition that goes beyond irony." It's worth underlining that the phrasings that I present here are meant as modifiable interpretative frameworks, subjectively organized, loose and interchangeable according to how a viewer decodes the works, several of which might be contained within. O'Grady's work, tenacious, imaginative, and poetic, achieves a number of critical operations within them, creating events that, by her own account, are concerned with "diaspora, hybridity and black

female subjectivity"[34] while challenging the representational institutions that surround them.

O'Grady's is a constitutive practice, a public deconstruction and rebuilding of a prosthetic memory through a combination of projected image and scripted, slide-based lecture performances, and there's notable overlap between her works and those of Martine Syms. Both *Misdirected Kiss* and *Incense, Sweaters and Ice* bring into the sphere of visibility images, thoughts, and methods of artists, writers, and thinkers to whom she relates, who have either impacted and shaped her since childhood, or else who, having been kept from the public eye, she can retrieve and reinsert into that openly constructed, prosthetic memory. In this sense, Syms not only performs "a decoding of mass, high, or any other cultural field;" she can also encode it as well.

* * * * *

Works included in this analysis have drawn upon performance and moving image to render, accentuate, or problematize the broadly felt pressures of a subject to perform images. They cleave open the loops or cycles we're in, in an otherwise highly regulated and homogenizing sphere of visibility. Across diverse spaces and for generations artists have innovated a variety of formal and conceptual strategies to show how a subject might revel or revolt, identify or disidentify, from the interpellation of a dominant ideology, where the mediated image is its organizing principle. From at least the 1960s onwards, artists have recuperated the machineries of representation, in different spaces and through different channels of circulation, to render and tamper with how the self has been seen in mainstream mass media, challenging gendered and gendering, racial and racializing, sexualized and sexualizing, normative and normalizing strains of prescriptive, productive, performative imagery. While I hope to have traced how previous generations of artists have explored the co-dependency, co-productivity of images and bodies, this critical interest, and the convergent media that serve it, comes to the fore in the age of social media, at the intersection of identity politics and digital economics.

I pose distantiation, overidentification, and disidentification as interconnected conceptual paradigms through which to view the operations of the distinct works of this genealogy, paradigms which are subjectively applied and therefore altogether disputable, but which seek to help elucidate this

sense of flux that I see within these works, and how they anticipate and reflect upon contemporary current toward prosumerism's image. This critical activity seems pertinent now in the digital economy, as subjective appetites for images motivate and sustain productivity, supporting vast, global media monopolies.

Performing Image comes of age with the spread of social media and the activity of prosumerism, as the instinct to perform images is so vigorously inscribed, or encouraged, by technology capital. It finds compatible media to render and shirk off what Manovich calls, "information behavior." The push and pull toward and from images motivate prosumerism, and drive the traffic toward the platforms that mine the data and creative spoils behind this billion-dollar industry. Performing Image proposes a genealogy of artists who have performed the allures and alienation of images over the past five decades and marks the changing relationship between the viewer, image, and capital during this time. And it is my belief that any analysis of new visual economies powered by affective, prosumer labor, should seek exposure to a range of heterogeneous, subjective prosumer, and proto-prosumer impulses, by way of art, in order to think about contemporary prosumerism's impasse. Image appetites are not simply evidence of narcissism or a will to fame. They evidence a will to see, to be seen, to change how one's seen, to challenge bodies and institutions that continue to refuse to see, to decode and recode these platforms for viewing, from hegemonic, negotiated, and often oppositional positions. Prosumerism trades off these appetites and instincts but has exacerbated rather than rectified a Western representational system in crisis. Now, art plays a vital role in understanding how deeply rooted the appeals of prosumerism are, how strong and productive these loops or cycles that we are in. This source of perspective is crucial to revitalize a mode of production and self-representation equitable to all. Their value to a more nuanced understanding of what is at stake in this new visual economy is incalculable.

Notes

Introduction

1. Ryan Trecartin, *Sibling Topics (section a)* from *Trill-ogy Comp*, a trilogy of videos that Trecartin released in 2009, including *K-CorealNC.K (section a)*, *Sibling Topics (section a)*, and *P.opular S.ky (section ish)*.

2. Benjamin, "The Work of Art in the Age of Mechanical Reproduction," 217.

3. Laing, *The Lonely City*, 226.

4. Morin, *The Cinema, or The Imaginary Man* 24–25.

5. Sedgwick, *Touching Feeling*, 19.

Chapter 1

1. A transcription of *Cinema-in-the-Round* by Mark Leckey, quoted by Kirsty Bell, "Cinema in The Round," 9. This was an event performed and recorded at Tate Modern's Starr Auditorium on September 25, 2007.

2. Leckey's video of *Cinema-in-the-Round* is 42:21 minutes and is dated 2006–2008.

3. This interview with Mark Leckey by Ben Brown for Creative Time, New York took place in the concluding stages of his work *Cinema-in-the-Round* (2006–2008) and in anticipation of his first performance of *In the Long Tail* (2009). Creative Time is a public art commissioning agency who were showing a video version of *Cinema-in-the-Round* as part of *Hey Hey Glossalia*, curated by Mark Beasley in May 2008, https://www.youtube.com/watch?v=Lc5YFOKpsMA.

4. Prosumerism comes into common usage from July 2011 as Havas Worldwide, a global advertising company, report on an expanded field of prosumer activity, identifying five kinds of prosumer (utilitarian, entertainers, advocates, co-creators).

5. Berger reminds us that "the visible" is also a source of perpetual anxiety and loss, because "[the visible] brings the world to us. But at the same time, it reminds us

ceaselessly, that it is a world in which we risk to be lost" (Berger, *And Our Faces, My Heart, Brief as Photos*, 50).

6. Hardt and Negri, *Multitude*, 290.

7. "In perceiving the fetish component of the image, we also perceive the value accrued to it from the looks of others. Thus the media, as a de-territorialised factory, has become a worksite for global production. The value of our look *also* accrues to the image: it sustains the fetish … it is an innovation in productive efficiency" (Beller, *The Cinematic Mode of Production*, 115).

8. Jameson, Postmodernism, xx.

9. de Spinoza, Book III, Proposition 2, Scholium, 280, quoted by Reckitt, "Introduction to Museums and Affect," 1–2.

10. Jones, *Self/Image*, 21.

11. Jones, *Self/Image*, 85.

12. Gleick, *The Information*, 347.

13. Bishop, "Unhappy Days in the Art World?"

14. Austin, *How to Do Things with Words*.

15. Butler, *Gender Trouble*, 45.

16. Sedgwick, *Touching Feeling*, 5.

17. Balsom, *After Uniqueness*, 3.

18. Balsom quoting Jenkins, Ford, and Green's *Spreadable Media* (quoted in Balsom, *After Uniqueness*, 10–11). Italics are Balsom's own.

19. "… the term has also been adopted by DINAMO, the Distribution Network of Artists Moving Image Organizations, an international consortium consisting of twenty-three members, nine of which are based in North America" (Balsom, *After Uniqueness*, 16).

20. Tedesco wrote, "Il semble que les images mouvantes aient été spécialement inventée pour nous permettre de visualiser nos rêves" (Tedesco, "Cinéma Expression," 25).

21. Tedesco, "Cinéma Expression," 25.

22. Balsom, *After Uniqueness*, 17.

23. Greenberg, "Modernist Painting," 6.

24. Higgins, "Intermedia," 2.

25. "I would like to suggest that the use of intermedia is more or less universal throughout the fine arts, since continuity rather than categorization is the hallmark of our new mentality," Higgins, *Intermedia*, 3.

26. Osborne, *The Post-Conceptual Condition*, 80.

27. Westerman, "Between Action and Image."

28. Krauss, "Video: The Aesthetics of Narcissism," 57.

29. "One could say that if the reflexiveness of modernist art is a *dedoublément* or doubling back in order to locate the object (and thus the objective conditions of one's experience), the mirror-reflection of absolute feedback is a process of bracketing out the object" (Krauss, "Video: The Aesthetics of Narcissism," 58). This psychological situation was later reframed by Krauss as an "aggregate condition" and a post-medium condition, in *A Voyage on the North Sea* (1999), 24.

30. Krauss, "Video: The Aesthetics of Narcissism," 54.

31. Krauss, quoting Lacan's *The Language of the Self*, trans. Anthony Wilden, New York, Delta, 1968, in "Video: The Aesthetics of Narcissim," 58, footnote 4.

32. Krauss, "Video: The Aesthetics of Narcissim," 58.

33. "… a psychological condition of the self split and doubled by the mirror-reflection of synchronous feedback" (Krauss, "Video: The Aesthetics of Narcissism," 55).

34. Krauss's later analysis of the "post-medium condition" in an age of television broadcast was a further attempt to make good a critical stance against installation and intermedia, albeit by widening the terms by which we judge the specificity of mediums, even modernist ones, which "must be understood as differential, self-differing, and thus as a layering of conventions never simply collapsed into the physicality of their support." Krauss, 1999, 53.

35. In this area, David Joselit discusses digital images, and "their capacity for replication, remediation, and dissemination at various velocities" (*After Art*, xiv).

36. Vierkant, "The Image Object Post Internet."

37. Mark Amerika, in his "Avant-Pop Manifesto," writes: "Our collective mission is to radically alter the Pop Culture's focus by channeling a more popularized kind of dark, sexy, surreal, and subtly ironic gesturing that grows out of the work of many twentieth century artists like Marcel Duchamp, John Cage, Lenny Bruce, Raymond Federman, William Burroughs, William Gibson, Ronald Sukenick, Kathy Acker, the two Davids (Cronenberg and Lynch), art movements like Fluxus, Situationism, Lettrism and Neo-Hoodooism, and scores of rock bands including the Sex Pistols, Pere Ubu, Bongwater, Tackhead, The Breeders, Pussy Galore, Frank Zappa, Sonic Youth, Ministry, Jane's Addiction, Tuxedo Moon and The Residents."

38. Edward Shanken, "Contemporary Art and New Media," 75–98. Bracketed capitalizations are Shanken's.

39. "Although digital computers were originally designed to do arithmetic computation, the ability to simulate the details of any descriptive model means that the

computer, viewed as a medium itself, can be *all other media* if the embedding and viewing methods are sufficiently well provided" (Kay and Goldberg, 393–394).

40. Lev Manovich, "Post-Media Aesthetics," aimed at updating the more conventional evaluation model of author-text-reader to encompass software used by the author and the reader in order to emphasize the "active role that technology plays in cultural communication" (http://manovich.net/index.php/projects/post-media -aesthetics).

41. Manovich, "Post-Media Aesthetics."

42. Kwon describes the category of contemporary art history as "the space in which the contemporaneity of histories from around the world must be confronted simultaneously as a disjunctive yet continuous intellectual horizon, integral to the understanding of the present (as a whole)." Kwon, "Response to 'Questionnaire on "The Contemporary,"'" 13.

Chapter 2

1. Debord, *The Society of the Spectacle*, 17.

2. Kerlansky, *1968: The Year That Rocked the World*.

3. Sean O'Hagan, "Everyone to the barricades." *The Guardian*, Jan 20, 2008.

4. Sandbrook, *White Heat*.

5. Harvey, "Time–Space Compression and the Postmodern Condition," 284.

6. Harvey, *A Brief History of Neoliberalism*.

7. Crimp's catalog essay (Crimp, *Pictures: Exhibition Catalog*, 7–10) was published in an updated version two years later (1979) in *October*, where he replaced analysis of Philip Smith's work with that of Cindy Sherman, whose work had been shown in Artists Space two years previously. Crimp, "Pictures," 75–88.

8. Goldberg, "Performance: The Golden Years," 45.

9. Molderings, "Life is No Performance," 92–97.

10. Discussed in detail and attributed to Duchamp's use of the term, by Joseph, *Random Order*, 267–268: "More than likely, Rauschenberg has borrowed the term 'contact' from Duchamp, who had stated three years earlier in his famous lecture 'The Creative Act': 'All in all the creative act is not performed by the artist alone; the spectator brings the work *in contact* with the external world by deciphering and interpreting its inner qualifications and thus adds his contribution to the creative act.'" (Joseph quotes from Duchamp, *The Writings of Marcel Duchamp*, 140.)

11. Joseph (quoting Parinaud, "Un 'misfit'"), *Random Order*, 18, 268.

12. P.W. Manchester, *Dance News,* January 1955, 11, quoted in Brown, *Chance and Circumstance,* 114.

13. Krauss asks: "Wouldn't the procedure of analyzing these two fields be enough to remove the picture surface from real space and set it up within the kind of transcendent space which I have been claiming Rauschenberg rejects?" Krauss, "Rauschenberg and the Materialized Image," 52.

14. Krauss, "Rauschenberg and the Materialized Image," 52.

15. Krauss, "Rauschenberg and the Materialized Image," 53.

16. Krauss, "Rauschenberg and the Materialized Image," 54.

17. See Joseph, "A Duplication Containing Duplications," 3–27.

18. The "One Way" sign had recurred in his work since early 1963, when Rauschenberg had reproduced Phillip Harrington's image for Patricia Coffin's article "The New New York," 28.

19. Klüver recalled, "Pontus had written me, after the Amsterdam exhibition: "one thing is very important. All the objects in Black Market have disappeared. Nothing is left. Can you ask Rauschenberg to make new ones. People have taken them without replacing anything themselves. Some 'artists' among the exhibitors removed the objects before the exhibition even opened and did not replace anything." Quoted by Lee, "Gifts from the Street," 219–220.

20. Rauschenberg, notes with Klüver, "Writings, Film: A Collaborative Memory," undated, from the Robert Rauschenberg Foundation's "Writing and Notes" series (1959–2007), as quoted by Lee, "Gifts from the Street," 220.

21. "… rather than pointing toward Rauschenberg's future involvement with technology, *Black Market* seems to point back to, even culminate, the aesthetic that characterized the Combines of the previous six or seven years." Branden W. Joseph, "Rauschenberg's Refusal," 259.

22. Having studied at the University of Iowa, Acconci published a number of short stories, prose pieces, and poems in several magazines, which led to reviewing for *ARTnews* in the late 1960s, and his association with the New York School of Poets.

23. Bourden, "The Eccentric Body of Art," 100.

24. In discussing his work with language, Acconci described the page "as a field for action" and his use of the page "as a model space, a performance area in miniature or abstract form." Acconci, "Notes on Performing a Space," 4.

25. Acconci, "Notebook: On Activity and Performance." On deprivation, stigma, and invasion of privacy: "The subject of a performance can be the control (or lack of control) of personal information," Battock and Nickas, 102. See also Acconci, "10 Point Plan for Video," 8–9.

26. Acconci, "Notebook: On Activity and Performance" Battock and Nickas, 103.

27. Editorial, *Avalanche*, No 6 (Fall 1972). This was a special issue devoted to the works of Acconci, including documentation and the artist's commentary on a number of works including *Trademarks, Rubbing Piece, Waterways, Centers, Shadow Box, Seedbed* and *Memory Box,* with a discussion between Acconci and Avalanche's co-publisher Liza Béar.

28. Nickas, "Introduction," Battock and Nickas, 6.

29. Author's transcription of *The Red Tapes*.

30. Szewczyk, "Unsafe Building," 2009.

31. Goldberg, "Performance: The Golden Years," 48.

32. Banes, "The Birth of the Judson Dance Theater," 167–212.

33. Goldberg, "Performance: The Golden Years," 48.

34. Goldberg, "Performance: The Golden Years," 49. (See also, Childs, "Notes: '64–'74," 33–36.)

35. Steinberg (on Rauschenberg), "Reflections on the State of Criticism," 7–35.

36. Salter, *Entangled*, 241.

37. "Its primary purpose," Catherine Wood contends, "was to hold the audience's attention, to be seen" (Wood, *Yvonne Rainer*, 24).

38. Lambert-Beatty, "Moving Still," 93.

39. Joseph, *Random Order*, 267.

40. Lambert-Beatty, "Moving Still," 94.

41. Lambert-Beatty, "Moving Still" (quoting Rainer, "A Quasi Survey," 65).

42. Rainer, "Statement," taken here from *Work 1961–73*, 71.

43. Rainer's NO Manifesto was first published in the *Tulane Dance Review* 10 (Winter 1965), as part of a postscript to "Some Retrospective Notes on a Dance for 10 People and 12 Mattresses Called *Parts of Some Sextets*." Performed at the Wadsworth Atheneum, Hartford, CT, and Judson Memorial Church, New York City, in March 1965.

44. Mulvey, "Visual Pleasure and Narrative Cinema," 833–844.

45. Rainer, "Some Ruminations around the Cinematic Antidotes to the Oedipal Net(les) while Playing with De Lauraedipus Mulvey, or, He May Be Off Screen, but …," 195.

46. Phelan, *Unmarked*, 73.

47. Phelan, *Unmarked*, 73.

48. Diego Velazquez's painting *Las Meninas* (1656) is the example given by André Gide who reassigned the term *mise-en-abyme* from heraldry to literature in writing about his own ambitions in his own journal in 1893. In Gide, *Journals 1889–1949*, 30.

49. Rainer, "Some Ruminations."

50. Rainer, "More Kicking and Screaming."

51. Phelan, *Unmarked*, 71.

52. Goldberg, "Performance: The Golden Years."

53. Goldberg's television generation included: Laurie Anderson, Julia Heyward, Michael Smith, Martha Wilson, Adrian Piper, Michael McClard, and Robert Longo. Goldberg, "Performance: The Golden Years," 46.

54. Kennedy, *Other Than Art's Sake*.

55. Phelan describes "Photographing herself as the Mythic Being (wearing an afro wig and mustache), Piper's ads are witty, 'masculinist,' fantasies of ambition, competition and compliment." "Survey," 29.

56. Piper, "Out of Order," 43.

57. Lammer and Boudou on Piper's *The Mythic Being*.

58. Uri McMillan, *Embodied Avatars*, 7, 19.

59. Uri McMillan, *Embodied Avatars*, 137.

60. Lammer and Boudou on Piper's *The Mythic Being*.

61. Piper, "Notes on Mythic Being I–III," *Out of Order, Out of Sight*, 122.

62. In 1993 O'Grady's work appeared in *Color*, curated by Adrian Piper, in Printed Matter at DIA Center for the Arts, New York City, in conjunction with the publication of New Observations #97 and in 2001 their work appeared together in the exhibition *Love Supreme*, at La Crieé Centre d'Art Contemporain, Rennes, France.

63. Mauss, "The Poem Will Resemble You," 184–189.

64. O'Grady interviewed by Earnest.

65. Mauss, "The Poem Will Resemble You," 184–189.

66. Prior to her work as an artist, O'Grady was an economics and literature degree graduate, with early jobs in government administration, and later in music journalism for the *The Village Voice* and *Rolling Stone*. But it was in the art world where she admits to feeling most excluded or "cornered." In this unpublished email exchange, O'Grady used the margin comments of her *Artforum* editor on "The Black and White Show," in part to provide background clarification on the situation of race in the

1980s art world and to explore issues she had chosen not to discuss in the portfolio article. http://lorraineogrady.com/art/the-black-and-white-show.

67. Mauss, "The Poem Will Resemble You," 185.

68. O'Grady, http://lorraineogrady.com/art/the-black-and-white-show.

69. This point was discussed by O'Grady in correspondence with the author but was also raised during the artist's talk within a symposium held for the exhibition "Soul of a Nation: Art in an Age of Black Power" at Chrystal Bridges Museum of American Art, on February 3, 2018. https://www.youtube.com/watch?v=1n52z10QzMo

70. O'Grady interviewed by Rosenberg, "How Lorraine O'Grady Transformed Harlem into a Living Artwork in the '80s."

71. O'Grady interviewed by Rosenberg.

72. From O'Grady's account of her visit to Cairo, in O'Grady, "Nefertiti/Devonia Evangeline," 64. Also quoted in Farrington, *Creating Their Own Image*, 221–222.

73. O'Grady in correspondence with the author, February 2018.

74. O'Grady, "Nefertiti/Devonia Evangeline," 64.

75. Mauss, "The Poem Will Resemble You," 188.

76. A subsequent O'Grady artwork, *Miscegenated Family Album* (1980/84), edits down pairings into a photo-installation of cibachrome diptychs.

77. The kinds of analogue appropriation techniques that the Pictures generation artists used (not dissimilar to the DADA artists' collages much earlier in the century) turned into greater, more ambitious, and often abject accumulation strategies, strategies that marked the body and its ingestion of images.

78. Farrington, *Creating Their Own Image*, 222.

79. Molesworth ("Pedestrian Color," 124–125) quotes from Brown's *Chance and Circumstance*, 114.

Chapter 3

1. Elsworth, "The Art Boom."

2. Harbison, "Image Games," 220.

3. Eklund, *Pictures Generation*, 127.

4. Hanhardt, "Mike Kelley's Puppet Show", 221.

5. "How the body is recorded and articulated [in Mike Kelley's performances] describes a crisis of definition and self-representation within contemporary society" (Hanhardt, "Mike Kelley's Puppet Show," 221).

6. In 1989, Beckman and Kelley collaborated on *Blind Country*, where he as male protagonist arrives in "The Country of The Blind" (based on H. G. Wells's eponymous short story, 1904) and tries to take control using his male, sight-derived power.

7. Rugoff, "Mike Kelley and the Power of the Pathetic," 167.

8. Kelley had appeared early on in Beckman's work, from her Piaget trilogy (1978–1981), and her interest in these works in developmental psychology, memory formation, forms and props of play, and childlike behavior informs much of Kelley's later work.

9. Thornton, "We Ground Things, Now."

10. Thornton in correspondence with the author, December 2017.

11. "The prison Holt both describes and enacts, from which there is no escape, could be called the prison of a collapsed present, that is, a present time which is completely severed from a sense of its own past." Krauss, "Video: The Aesthetics of Narcissism," 53.

12. Thornton, "We Ground Things, Now, on a Moving Earth," in the Collective for Living Cinema's journal *Motion Picture* in 1989, quoted in Halter, "Hell is for Children," 521.

13. Thornton. Artist's statement from Artlink website, courtesy of EAI, Artlink Services, Inc., 1997. See also Borger's, "An Interview with Leslie Thornton."

14. Halter, "Hell is for Children," 514–521.

15. Chun, *Control and Freedom*, 37.

16. This was a phrase written by Hershman Leeson that often accompanied the exhibitions of ephemera relating to Roberta Breitmore. Full details of this are published in Tromble, *The Art and Films of Lynn Hershmann Leeson*, 25.

17. The first installation of this work in a solo exhibition, *An Installation of Lorna/ The First Interactive Laser Artdisk,* was in the Fuller Goldeen Gallery, in San Francisco in 1984.

18. Ho, *Shu Lea Cheang on Brandon*, May 10, 2012, Rhizome.org.

19. Shu Lea Cheang, event at Harvard and in New York City also referenced in Gronlund, *Contemporary Art and Digital Culture*, 112.

20. The differences between *Brandon*'s online viewing now to then, which are reported and still exist on various online forums, is that a visit would have been populated by a lot more image "pop-ups" in the 1990s, since there were fewer antiviral controls on browsers. "Visitors to the site, however, may stumble over technological barriers that make some of the content hard to access. Macintosh users will

find that the site crashes their browsers repeatedly. Download times—even on a T1 line—are long, and there's a scarcity of navigational tools on the site, which is intentional, says Drutt, somewhat testily" (Silberman, "Guggenheim Goes Digital").

21. Dibbell, "A Rape in Cyberspace."

22. Dibbell, "A Rape in Cyberspace."

23. Ho, "Shu Lea Cheang on Brandon."

24. Cheang in correspondence with the author, February 2017.

25. Cheang in correspondence with the author, February 2017.

26. The work was subsequently shown within an installation format at the Whitney Museum, which marks Cheang's "accidental" transition into art, having, in her words, "bypassed the gallery, direct to becoming a museum artist by 1990" (Harbison and Cheang in correspondence, February 2017).

27. Harbison and Cheang, February 2017. Antoni Muntadas's *The File Room* had been commissioned and produced by the Randolph Street Gallery in 1994, with subsequent public access in the galleries of the Chicago Cultural Centre, as well as on the web.

28. Cheang in correspondence with the author, February 2017.

29. Cheang in correspondence with the author, February 2017.

30. Yin Ho, "Shu Lea Cheang on Brandon."

31. This quotation is taken from Brandon's *Roadface* interface, under "scripting roadface episodes."

32. This quotation is taken from the Brandon's *Mooplay* interface, copy listed has having been uploaded by writers Pat Cadigan, Lawrence Chua, and Francesca di Rimini, in http://brandon.guggenheim.org/credits/interface/mooplay/index.html.

33. Cheng in correspondance with the author.

34. Bouvier and Stroun, "Ericka Beckman," 22.

35. "[Making Cinderella] was a conscious choice to represent myself in the work and to embrace that gendered perspective … [During the 1980s] Yvonne Rainer, Lizzie Borden, and Trisha Brown were big influences. I was also reading work by Marie-Louise Von Franz, Hélène Cixous, Donna Haraway, Angela Carter, and Jack Zipes." Beckman in correspondence with the author, September 2013.

36. Eklund, *Pictures Generation*, 127.

37. Beckman in correspondence with the author, January 2018.

38. As American film critic J. Hoberman wrote about the work in 1981: "there is something undeniably calisthenic about her vision. Beckman's *mise-en-scène* is characterized by sing-song voice tracks, jerky robot motions, repetitive gestures and the iconic use of sports equipment and cheerleaders. My first impression of her best film, the 1978 *We Imitate: We Break-Up* was of high school gym class taught by George Méliès in a space designed by Giorgio de Chirico." (Hoberman, "Review: Out Of Hand," 76).

39. From the beginning, Beckman structured her films around games, informing her sets, costumes, choreography, camera movements, scripts, scoring, and soundtracks. In the late 1970s, these are children's games, repeated schoolyard activities (*The Piaget Triloy*, 1978–1981), in the early 1980s, these develop into memory games, then moving on to competitive adult games, ball sports, slot machine gambling (*You The Better*, 1983), and later to computer gaming (*Cinderella*, 1988), all of which reflect forms of entertainments espoused by an increasingly competitive capitalist culture.

40. This manifests and is developed throughout her Piaget trilogy.

41. Beckman in correspondence with the author, September 2013.

42. Beckman in correspondence with the author, June 2012.

43. As the MOMA's screening notes on the work read: "Cinderella presents several versions of the popular story and compresses them into game motifs. After a few trials, the female player discovers how to command and order these motifs in a narrative sequence that releases her from the confines of the Cinderella myth itself." Beckman in conversation with Rosen, "Video Viewpoints."

44. Beckman encountered "everything from a towering memory palace, to a growing tree structure [to help users visualize the 'whole Internet'], a rotating filing system, to a 'fibrous net.'" Significantly, the year of this conference was the same one that CERN's "distributed computing" system became the medium with which Tim Berners-Lee was to write the World Wide Web. Segal, "A Short History of Internet Protocols at CERN."

45. From Beckman's notes, compiled at the time and later composed in her lecture. Beckman, "Der Endtfesselte Blick."

46. The Whole Earth 'Lectronic Link (WELL) was one of the first dial-up bulletin board systems (BBS) available to general users, established in 1985 by Stewart Brand. It was influenced by EIES, the Electronic Information Exchange System, which allowed real-time, asynchronous communication among multiple users. It was developed in the mid-1970s and originally funded by the National Science Foundation. Beckman describes herself dropping in and out of the WELL to eavesdrop on various contributors, notably Kevin Kelly, to keep abreast of VR developments.

47. Beckman in correspondence with the author, April 2016.

48. Beckman in correspondence with the author, June 2016.

49. Beckman, "Der Endtfesselte Blick."

50. "… when you disrupt [gravity and verticality] strange and interesting things happen. A lot of the work of the avant-garde filmmaker dealt with the intimate space of the 'viewer' and 'the viewed'… It pulled the audience out of normal consciousness" (Beckman, "Der Endtfesselte Blick").

51. Beckman in correspondence with the author, April 2016.

52. Many 1980s video games influenced *Hiatus*, including: Lucasfilm's *Habitat* (1986), the first large-scale, interactive user-friendly game environment where players interacted with other players in apartments called "turfs"; *Battletech* (1992), a virtual entertainment game allowing eight players simultaneously, set in a futuristic environment (circa 2038); *Michael Jordan, In Flight* (1986), which featured a three-a-side match animated by images of Jordan videotaped on a 3D camera; and *NFL Pro-League Football* (1989), which gave players a number of individual and group strategy options Beckman thought "mind-boggling."

53. The video gaming industry of the 1980s and 1990s was booming having moved to Japan, through companies like Sega (established in Tokyo in 1983) and Nintendo (based in Kyoto, since 1983), following the North American "video game crash" of 1983, a dominance that didn't return to the US until the manufacture of Microsoft's Xbox in the early 2000s.

54. Crogan, *Gameplay Mode.*

55. As was often the case in early VR and online gaming, players regularly switched gender and race, a facility that had both positive and negative consequences. As we're not privy to what transitions Wang allowed Blair33, his mix of identity signifiers might be interpreted a variety of ways: if Blair33 is a white man, then we're seeing image play as a form of capitalist aspiration-cum-racial anxiety, and if (s)he is not, then the performance represents one of more radical transgression of race and gender boundaries.

56. Beckman in correspondence with the author, August 2016.

57. Beckman in correspondence with the author, August 2016.

58. Beckman in correspondence with the author, August 2016.

59. Chu, "I, Stereotype: Detained in the Uncanny Valley," 78.

60. Chun, *Control and Freedom*, 192.

Chapter 4

1. Toffler, *The Third Wave.*

2. Toffler, *The Third Wave*, 277.

3. Toffer correlates Sector A with women's work, and B with men's work. During the Second Wave, "the very word 'economy' was defined to exclude all forms of work or production not intended for the market, and the prosumer (aligned with domestic work) became invisible. This meant, for example, that all the unpaid work was dismissed as 'non-economic'." Toffler diagnoses gender inequality as symptomatic of the divide between Sector A and B, an inequality that will dissolve through prosumption in the Third Wave. (Toffler, *The Third Wave*, 277.)

4. Toffler, *The Third Wave*, 167.

5. Toffler, *The Third Wave*, 167.

6. Toffler, *The Third Wave*, 177.

7. In *Take Today: The Executive as Dropout*, McLuhan and Nevitt observed: "It is in this new dimension of 'software' design that the difference between the old mechanical industry and the new electric circuitry becomes manifest. It is a difference not only of speed and diversity but also of knowledge and of the programming for special, personal needs." Their style and areas of analysis have much in common with Toffler's, along with their sociological concerns about how new technology would impact social behavior and organizational systems.

8. Toffler, *The Third Wave*, 288.

9. Toffler presupposed "the government" would assume responsibility for catalyzing society's conversion to prosumption. The government will "focus scientific and technological research ... provide simple hand tools, community workshops, trained craftsmen or teachers, limited communications facilities and, where possible, power generation equipment—plus favorable propaganda or moral support for those who invest 'sweat equity' in building their homes or improving their bits of land" (Toffler, *The Third Wave*, 356).

10. "The precariat" combines the "proletariat" with "precarious" working conditions, describing a new labor force whose presence and prospects are assessed by academic Guy Standing. The precariat was a term first used in France during the 1980s for temporary or seasonal workers, adapted by Standing to label workers, "flanked by an army of unemployed and a detached group of socially ill misfits," who benefit from little of the social welfare provisions established during the twentieth century. These workers are denizens rather than citizens, with fewer civic rights and existing at the bottom of a society of "tiered membership," financially dominated by a small plutocratic elite. Standing, *The Precariat*.

11. Tapscott, *The Digital Economy*.

12. Linux kernel is now licensed under the GNU General Public License (GPL), version 2. The GPL requires that anyone who distributes a software product based on GPL-licensed source code, must make the originating source code (and any modifications) available to the recipient under the same terms. GNU/Linux License FAQs.

13. There are previous examples of blueprint sharing and modifying in the automobile industry in the early twentieth century. Raymond, *The Cathedral and the Bazaar*.

14. Nelson, "Ted Report," quoted in Streeter, *The Net Effect*, 138.

15. Nelson, "Ted Nelson's Computer Paradigm."

16. Lanier, *Who Owns the Future?*, 227.

17. Streeter, *The Net Effect*, 139.

18. Streeter, *The Net Effect*, 140.

19. Streeter, *The Net Effect*, 154.

20. "It is significant that the arguments of 'The Cathedral and the Bazaar' are not communitarian. In contrast with Stallman or the Haubens, Raymond dismisses appeal to altruism out of hand. The central rhetorical accomplishment of the piece, rather, is to frame voluntary labor in the language of the market; the core trope is to portray Linux-style software development like a bazaar—the archetype of a competitive marketplace—whereas the more centralized and controlled software production as hierarchical and centralized —and thus inefficient—like a cathedral: static, inefficient, medieval. Raymond thus disarticulated the metaphor of the market from conventional capitalist modes of production and reconnected it with a form of voluntary labor, of labor done for its own sake" (Streeter, *The Net Effect*, 158).

21. *Wikinomics* claimed to present "the new art and science of collaboration," proposing new ways for its target reader to exploit the professional potential of online users and browsers in the development of their business to maximize their potential profits. This is a very nuanced and strategic usage of the term "collaboration" that does not mean equal contribution or partnership. In Tapscott and Williams's definition, "prosumerism" profits from the inequality of both parties in monetizing prosumer activity. Instead of relying upon their own material resources and permanent staff members, prosumer-capitalists would be able to employ those online, by using open source technology such as wikis, while extolling the merits of "online collaboration." In the authors' thesis, the four principles of Wikinomics are openness, peering, sharing, and "acting globally." Tapscott and Williams, *Wikinomics*.

22. Tapscott and Williams, *Wikinomics*, 126.

23. *Second Life* is an online virtual world, developed by Linden Lab in San Francisco and launched to the public in June 2003, which currently claims to have approximately one million users. "Infographic: Ten Years of Second Life," published by Linden Lab.

24. Tapscott and Williams, *Wikinomics*, 148.

25. Tapscott and Williams, *Wikinomics*, 127.

26. In 2012, Instagram was bought by Facebook, which now holds over tens of billions of Instagram's images within their data centers. Meze, "How Facebook moved 20 billion Instagram photographs."

27. Wu, *The Attention Merchants*. See "The Fourth Screen and the Mirror of Narcissus," 308–317.

28. Wikipedia was the only example given by Tapscott and Williams of a productive prosumer platform, but what is omitted is that Wikipedia was not originally created to generate profits, but rather as a creative commons endeavor.

29. Arvidsson and Colleoni, "Value in Informational Capitalism and on the Internet"; Wu, *The Attention Merchants*.

30. The term and function "cookies" or "HTTP cookies" combine both of these processes. They are small pieces of data logged by a website and stored by a user's browser, to reappear in view across multiple sites the user visits: data often shared or sold by companies across sites. By retaining information of previous commercial searches, cookies not only appeal to the viewer's gaze, but remind users of previous searches, reinforcing consumer's wants and needs. From "What Is a Cookie?," https://www.aboutcookies.org/Default.aspx?page=5.

31. Turkle, *Alone Together*, 171.

32. Lovink, *Networks without a Cause*, 41.

33. Z. Smith, "Generation Why?"

34. O'Doherty, *Inside the White Cube*, 15.

35. Lovink, *Networks without a Cause*, 42.

36. Peak traffic on Facebook is at 2–3 p.m.; Instagram at 8 a.m. or 5 p.m.; and Twitter, 12 p.m. or 5 p.m., although these figures differ according to weekday, prosumer age, and time zone. Most users use multiple platforms and visit each multiple times daily, now averaging 135 minutes per day (in 2017). Various EU and US social media marketing blogs provided information on daily times, and the Pew Research Center published a well-researched overview, "Social Media Use in 2018," http://www.pewinternet.org/2018/03/01/social-media-use-in-2018.

37. Facebook hosts prosumers in 152 out of 167 countries analyzed according to a survey carried out by media strategist Vincenzo Cosenza, published in January 2018 ("World Map of Social Networks").

38. Bhatia, "The Inside Story of Facebook's Biggest Setback."

39. Shearlaw, "Facebook Lures Africa with Free Internet."

40. This was recorded during an undercover report by the UK's Channel 4 News, broadcast on March 20, 2018.

41. During the 1950s advertising boom, stock agencies adapted their compositions to include open space in the images' upper and side margins, preempting the superimposing of a campaign's copywriting upon the image. Henceforth, stock photographers' compositions were designed for easier, quicker captioning on photographs.

42. Images are grouped in financial categories of exclusivity and sub-grouped in aesthetic categories and costs of images escalate from the moderately priced "Royalty-Free" (RF) to "Rights Managed" (RM). The greater the exclusivity of the image, the higher its price, but a number of clauses to contract often allow the stock agency to renegotiate this, depending on the market of any particular image at any given time. The market will define the cost, not the intrinsic "quality" of that image. "Royalty-Free" (RF) is where rights to an image can be acquired, but that image can be used by any other buyers in an unlimited number of ways, whereas with "Rights Managed" (RM), individual licensing agreements are regularly renegotiated.

43. Copyright is commonly understood as a form of protection provided by the law to the authors of "original works of authorship." By the "Berne Convention for the Protection of Literary and Artistic Works," an international copyright agreement originally signed in Bern, Switzerland in 1886, works are protected in all 160 countries of the Convention, as well as by various other laws, such as the US copyright act.

44. Flickr users had traditionally uploaded their image portfolios and shared them among friends online. After Flickr's acquisition, users could submit their pictures to the Getty collection by clicking their "request to license" after uploading pictures, which alerted Getty editors to new portfolios. If they were selected and consigned to Getty, which employed individuals to trawl through these images systematically, the agency would receive upward of 80% of the revenue of the sale once the photograph had been purchased. This guaranteed a much higher profit margin for the agencies and lower margin for the photographer than was previously negotiated.

45. Accessed from Creative Commons Website, September 12, 2012, http://www .creativecommons.org.

46. O. Smith, "Facebook Terms and Conditions: Why You Don't Own Your Online Life."

47. Harvey, *The Enigma of Capital*, 20.

Chapter 5

1. Darling works across media, in sculpture, installation, video, and gif: "So I got into animated gifs because they are the most Brechtian and didactic of media. It's like, 'look at this! Exactly this and nothing else!'—it's the moment of *gestus*, with the extra *Verfremdungseffekt* afforded by deep compression—anti-HD, anti-photorealism." Darling, Lunch Bytes Conference. Lunch Bytes was a discussion series that

took place from 2014–2015 across seven cities in northwestern Europe focusing on the relationship between digital technologies and art.

2. Darling references Amalia Ulman, whose soliciting to camera appeals to the attention of a white, male, middle-class "Technorati" (Darling, Lunch Bytes Conference).

3. Darling claims: "Every commentator wants to distinguish [him]self from the dumb user who clicks and swarms and emotes all over every platform ... These distinctions may be seen as ways to demarcate class signification in an economy of symbiotic flows in which labor has itself become both commodity and production process ... Contemporary technologies—including surveillance systems, social networks, production techniques, and reproductive processes—have been marshaled and instrumentalized by artists and conglomerates alike." Darling and Tiptree Jr., "Post-Whatever."

4. Darling cites exemplary first-generation "selfie" artists as including, Genevieve Belleveau, Molly Soda, and Mark Aguhar (Darling, Lunch Bytes Conference).

5. Darling has previous quoted Shaadi Devereaux, "Why These Tweets Called My Back."

6. Leckey, with curators Obrist, Wood, McGeown, and Mulholland, *Mark Leckey: See We Assemble*, 34.

7. The work was summarized by Matthew Higgs as it, "charts the rise of British youth dance subcultures, from the talcum-powdered, amphetamine-fuelled dance floors of '70s Northern Soul all-nighters to the Ecstasy-fuelled raves of the late '80s" (Higgs, "Mark Leckey: Openings," 128–129).

8. "You'd be in a crowd," he recalls, "all in this same look that caught people's attention, but [the police] couldn't determine who you were so you would slip through, because they weren't looking for you, they were looking for skinheads." Kretowicz, "Mark Leckey Made Me Hardcore."

9. Leckey et al., *Mark Leckey: See We Assemble*, 35.

10. Many critics interpret the work as a critique of capitalism. Melanie Gilligan writes, "Leckey's commonplace strategies hide an unsettling riddle regarding the status of the commodity today: that it remains the same while the flimsy, unstable world around it can be dropped in and out; that it is relational, its surroundings adjusting to it while it adjusts to them; that although its context is insubstantial, the commodity is solid and becomes an anchor for a panoply of significations and sense impressions." Gilligan, "Mark Leckey," 281–282.

11. Leckey et al., *Mark Leckey: See We Assemble*, 36.

12. Kelley early on developed an abject lexicon for popular imagery, which seemed to physically pass through the artist's body in early works, including *The Poltergeist* (1979), *Monkey Island* (1982–1983), and *Peristaltic Airwaves* (1986), so that where part

of what's questioned in drawings, performances, or diagrams of crude physical absorptions, is how public information might enter the body like it does the mind, individual imaginary, or popular consciousness. In his earlier performance works these activities constituted perverse metaphor for how discursive formations produce class division. Leckey writes: "In terms of art heroes, Mike Kelley is definitely one. He's a big one" (Leckey et al., *Mark Leckey: See We Assemble*, 45).

13. Black, "Full Moon."

14. Wood, "Horror Vacui," 157–163.

15. Haraway wrote: "In thinking about corporealization … it is crystal clear to me that the body is an accumulation strategy in the deepest sense. This is vastly more than a metaphor, and less than an identity, and it has at least a 200 year history … there is some kind of deep corporealization that has gone on through the on-the-ground social practices of the constructions of the body for us in institution after institution—from the body structured by economies of work and heat in the 19th century, the hierarchical organization of the division of labor, the economy that sets up a dichotomy between the energies of the reproductive system and the energies of the nervous system, the kind of oppositional gendered bodies that perhaps organize our major biological and medical notions; and somewhere in the middle of the 20th century, the kind of command-control-communication intelligence bodies, the systems-theoretic bodies that emerged over approximately a twenty-year period between the late 'thirties and mid 'fifties and which have deep material consequences and are deeply materialized instances for bodies enclosed in particular ways" (Harvey and Haraway, "Nature, Politics, and Possibilities," 507–527).

16. Its first incarceration was at the Oberhausen Short Film Festival in 2006, where Leckey was invited to curate a program of moving images by British film curator Ian White that would question the viewing conditions for art in a cinema context, in a series of screenings called "Kinomuseum." White invited five different contributors to work within this program. Leckey's was perhaps the closest thing to an autonomous artwork. Mary Kelley's *Fallout* showed three works in three different auditoria, each examining the traumatic legacies of historical events (the sexual revolution of the 1970s, the AIDS epidemic of the 1980s, and the Iraq War), A. A. Bronson's program emphasized his belief in the indivisibility of art and sex and art and artists. Emily Pethick curated a screening *Hall of Mirrors* around the processes of identification and narcissism, and curator Achim Borchardt-Hume introduced Pierre Bismuth's *Following the Right Hand of Humphrey Bogart and Ingrid Bergman in "Casablanca"* (2007).

17. From the transcript of Leckey's "Cinema-in-the-Round," White, *Kinomuseum: Toward An Artists' Cinema*, 59. (Artist's original italics.)

18. Leckey joins images of: an Egyptian cat statue; a 1920s cartoon image of Felix the Cat; a digital rendering of Garfield for an animated film (2004, director Peter Hewitt); and Krazy Kat (1913–1944).

19. Anderson, *The Long Tail: Why the Future of Business is Selling Less of More.*

20. Leckey quotes Sergei Eisenstein, *Eisenstein on Disney*, 46.

21. Originally titled "THE 3s AND THE Ds" in the Oberhausen version.

22. The idea of horizontality versus verticality relative to Titanic Leckey credits to American art critic Jerry Saltz who originally expressed this opposition in an article on Matthew Barney in *The Village Voice,* whereby Titanic "is a story of a form going from pure horizontality to total verticality" (Leckey, "Cinema-in-the-Round," in White, *Kinomuseum*, 64).

23. Leckey, "Cinema-in-the-Round," in White, *Kinomuseum*, 64.

24. Frampton has said of this piece: "As a voluptuous lemon is devoured by the same light that reveals it, its image passes from the spatial rhetoric of illusion into the spatial grammar of the graphic arts" (Harrison and Wood, *Art in Theory 1900–2000*, 436).

25. Leckey, "Cinema-in-the-Round," in White, *Kinomuseum*, 59–68.

26. Ian White writes of *Cinema*'s ambiguous conclusion, "if this is an assault on the paradigms of art history, it also reveals a paradigm of cinema in which the ultimate object, Leckey's star exhibit, is a spectacular nothing" (White, *Kinomuseum*, 15).

27. Anderson, "The Long Tail," in *Wired.*

28. Attended by the author, the first of a series of its performances in the theater of the ICA, London in January 2009. Like *Cinema-in-the-Round,* the presentation began as a lecture that was then hosted by several international institutions. In October of the same year, Leckey performed it in the Abrons Art Center in New York, programmed by the Museum of Modern Art and later again that year in the auditorium of the Koln Kunstverein (Cologne). The work now exists as a special edition video and was uploaded onto Leckey's YouTube channel in March 2010. The work was subsequently transferred to Vimeo in 2014, https://vimeo.com/73861892.

29. Transcribed by the author from the video documentation of Leckey's performance, courtesy of Cabinet Gallery, London.

30. Leckey muses: "the mass market is that, mass, solid weighty stuff that occupies physical space, when things start to get digitized, space is no linger a concern, space is limitless as its replication and distribution. The record, the book unbound from physical form, free from limitations and can be given away, costs so little to reproduce, people become their own distributor, any need can be met, and need can find an audience, special interest, niche markets have accumulated in the tail, taken in the whole become a mass audience that they're attracting … it goes on and on way beyond the physical eye" (Leckey, *In the Long Tail*).

31. Here, Leckey makes brief reference to writer and campaigner Stewart Brand and programmer Werner Erhard, teachers at the center of research and theory at the Esalen institute at BIG SUR, who were, "sowing seeds of interconnected cyber system, especially in self that pre-empted the now ubiquitous feedback system of Wikipedia" (Leckey, *In the Long Tail*).

32. From this superimposition Leckey launches into another theatrical interlude, where the phrase "the tail itself is an anagram engine" becomes just that: the basic raw material for anagrams. "I am an angel hesitating near, as generating in animal heat, I am an intestinal eagle hang, nightmare in same genitalia, animal heat greasing in neat." (Leckey, *In the Long Tail*).

33. Leckey et al., *Mark Leckey: See We Assemble*, 46.

34. Author in conversation with the artist, January 2013.

35. "Some people like to talk during sex. Others get their kicks by talking about it. And then there are those who would rather just watch" (Yablonsky, "Artifacts: Frances Stark's Best Thing").

36. I saw the work first at Venice in May 2011, in London's ICA November 2011, subsequently at London's Southbank Centre in February 2014, and a number of times on the artist's website. It is also available to view on Vimeo at https://vimeo.com/136163175, uploaded in 2016. Stark's performance lecture leading up to *My Best Thing* was *I've Had it And A Half*, April 11, 2011 at the Hammer Museum, UCLA. Reviewed by Papararo, "Frances Stark," 53.

37. This animation website has since closed down (in August 2013). It is unclear as to whether the work poses copyright issues for Xtranormal and whether any contract of this sort still stands now that the website has dissolved.

38. From the website's description, https://chatroulette.com.

39. Rainer, "Some Ruminations," 195.

40. For example, when female protagonist gives her counterpart a studio tour while we are denied its corresponding images, or the moment when she "shows" him rushes of her film and we realize we have been viewing it all along.

41. In Krauss's later essays, films, and books—*I Love Dick* (1997), *Aliens & Anorexia* (2000), and *Torpor* (2006)—these tropes all emerge through a confessional, diaristic style.

42. Ellegood and Fogle, *All of This and Nothing*, 130.

43. Papararo, "Frances Stark," 53–55.

44. Godfrey, "Frances Stark, Friends with Benefits," 160.

45. Godfrey, "Frances Stark, Friends with Benefits," 164.

46. Author's transcription of the script.

47. "I was thinking about it because I have to do a performance in New York in November [a date that corresponded with the schedule of Stark's 2011 performance at New York's performance biennial, Performa], which will mean a lot of attention, pressure, more than I really want and I was thinking about it because I did it once before." (*My Best Thing*, author's transcripts.)

48. Virno, *A Grammar of the Multitude*, 52.

49. "I want to ask you something strange that relates to your question, I started to do this virtual stuff in the summer. I find it interesting, and satisfying and frustrating, and to be honest, I waste a lot of time with it. I want to start writing about it and it's good but I think I also need to stop doing it. And the other day I said I really need to stop but because I had not known you very long I thought I could not stop … ." (*My Best Thing*, author's transcripts.)

50. For further analysis into the etymology and nuances of the term "distantiation" as I apply it in this context, please see chapter 8.

51. Fortunati, "Immaterial Labor and Its Machinization," 152.

Chapter 6

1. These are recent comments made by previous employees of Facebook, made publicly during an interview at an Axios event, covered in Wong, "Former Facebook Executive: Social Media Is Ripping Society Apart." In recent months, there have been several calls for increased regulation and taxation made by former senior employees of Facebook and other senior technology executives including Salesforce CEO Marc Benioff who has said social media should be regulated like the tobacco industry.

2. Morozov, "When Wall Street and Silicon Valley Come Together."

3. The conference *Digital Labor: The Internet as Playground and Factory* took place in the New School in New York and its corresponding anthology was subsequently published as under the same title, edited by Trebor Scholz.

4. Ritzer and Jurgenson, "Production, Consumption, Prosumption," 13–36.

5. Ritzer, "Are You a Digital Drone?," 666.

6. Scholz, *Digital Labor*, 2.

7. Tiziana Terranova's theory of "Free Labor" identifies "the moment where knowledgeable consumption of culture is translated into excess productive activities that are pleasurably embraced and at the same time often shamelessly exploited." Calling user's participation on online websites labor is, Terranova contends, a political decision and choice. Terranova, "Free Labor," 37.

8. Terranova suggests that for this specific kind of work, "social networking plat-
forms should be de-privatized—that is, that ownership of users' data should be
returned to their rightful owners as the freedom to access and modify the protocols
and diagrams that structure their participation" (Terranova, "Free Labor," 53).

9. Marx adopts the two kinds of "unproductive labour" outlined in Adam Smith's
Wealth of Nations, Vol. II, 305–306. The first is of *"mental servants, unproductive of any
value,"* or labor that "has value, and therefore costs an equivalent, but it produces no
value"—and he provides the clergy, the army, and the navy as some examples. They
are the public servants who produce no value in terms of capitalism. Examples of
the second type are the slaves of Ancient Greece and Rome: "In the manufactures
carried on by slaves, therefore, more labor must generally have been employed to
execute the same quantity of work, than in those carried on by freemen. The work
of the former must, upon that account, generally have been dearer than that of the
latter." Quoted by Karl Marx in "Concluding Observations on Adam Smith," *Capital*,
vol. 4, 1–10.

10. Smythe, "On the Audience Commodity and Its Work." Republished in Durham
and Kellner, 233.

11. Smythe, republished in Durham and Kellner, 246.

12. "In the labor theory of value, a commodity should be objectively measured by
the number of hours of labor taken to produce that item. In principle the labor
theory of value should be able to value of all commodities including that which the
workers sell to capitalists as a wage, or 'labor power.' Labor power should be relative
to labor hours calculated that would provide the worker the means to afford their
basic human needs. However, if all commodities were to be sold at prices that mea-
sured their true labor-hours' value, then how would capitalists enjoy profit?"(Marx,
Capital, vol. 4).

13. Smythe, republished in Durham and Kellner, 247.

14. Madsbjerg, "It's Time to Tax Companies for Using Our Personal Data?"

15. See Schneider and Scholz, *Ours to Hack and to Own: The Rise of Platform Coopera-
tivisim, a New Vision for the Future of Work and a Fairer Internet*, New York: OR Books,
2016.

16. P2P Foundation, 2005; Scholz, *Digital Labor*.

17. Callinicos, "Making History, Agency, Structure and Change in Social Theory."
Christian Fuchs, in his essay, "Class and Exploitation on the Internet," writes: "On
the communist Internet, humans co-create and share knowledge; they are equal
participants in the decision-making processes that concern the platforms and tech-
nologies they use; and the free access to and sharing of knowledge, the remixing of
knowledge, and the co-creation of new knowledge creates and reproduces well-

rounded individuality. A communist Internet requires a communist society" (Fuchs in Scholz, *Digital Labor*, 221–222).

18. "Design Justice" is an organization and social movement that "rethinks design processes, centers people who are normally marginalized by design, and uses collaborative, creative processes to address the deepest challenges our communities face." http://designjusticenetwork.org.

19. Goldhaber, "The Attention Economy and the Net."

20. Marazzi, *Capital and Language*, 64.

21. Marazzi, *Capital and Language*, 27 (original emphasis).

22. Stiegler, *Taking Care of Youth and the Generations*, 18.

23. For an excellent introduction to the scope and field of the attention economy, see Crogan and Kinsley, "Paying Attention: Towards a Critique of the Attention Economy."

24. Landsberg, *Prosthetic Memory*.

25. Beller, *The Cinematic Mode of Production*, 2.

26. Beller, *The Cinematic Mode of Production*, 1.

27. Beller, *The Cinematic Mode of Production*, 234.

28. Beller, *The Cinematic Mode of Production*, 181.

29. Beller continues from this quote, "The value of our look *also* accrues to the image: it sustains the fetish ... it is an innovation in productive efficiency" (*The Cinematic Mode of Production*, 115).

30. "Cinema became capital, reaching as far as the social extends ... it is the film frame (the screen) that allows the images to circulate; film is the money of cinema (and the frame is the unit). The affective dimensions of capital circulation are distilled and experienced in their most purified form in the cinema" (Beller, *The Cinematic Mode of Production*, 39, 58).

31. Beller, *The Cinematic Mode of Production*, 29.

32. Beller, *The Cinematic Mode of Production*, 202.

33. Beller, *The Cinematic Mode of Production*, 214.

34. Gunning, "The Cinema of Attraction," 37.

35. Tony Bennett's "The Exhibitionary Complex" was provoked by American critic Douglas Crimp's essay, "On the Museum's Ruins" (published originally in *October* 13, Summer 1980), which reviewed and revised Foucault's writing on the asylum, the clinic, and the prison as institutionalized articulations of power and knowledge

relations. It reasserts Crimp's concern for how the standard North American museum little represents Western society's diversity, particularly with respect to gender politics. Bennett takes up Crimp's reference and expands on Foucault's theory of how "discursive formations" reinforce societal hierarchies, or "archaeologies of knowledge," by introducing various classifications and integrations of objects and subjects within exhibition displays. Bennett, "The Exhibitionary Complex."

36. Bennett, "The Exhibitionary Complex," 63.

37. Thumin, *Self-Representation and Digital Culture*, 6.

38. Thumin, *Self-Representation and Digital Culture*, 8.

39. "In thinking about art museums of the future it will be necessary to rethink audiences simultaneously as individuals, consumers, collectivities, as well as in the more particular sense of being users and even 'prosumers'" (Dewdney, Dibosa, and Walsh, *Post-Critical Museology*, 205).

40. Dewdney, Dibosa, and Walsh, *Post-Critical Museology*, 203.

41. Thumin, *Self-Representation and Digital Culture*, 19.

42. In a letter written and published on Facebook on Febraury 16, 2017, Zuckerberg stated: "technology has risen as a force that unites us, alongside government and faith. So too must captains of industry rise to accept their opportunity of influence, for the betterment of humanity in one of its most volatile moments."

43. This understanding of social media usage as a narcissistic outlet or undertaking is articulated in Lovink, *Networks Without a Cause*; Papacharissi, *A Networked Self*, 317.

44. "Black Feminism and Post Cyber Feminism," was the title of a discussion, chaired by Akwugo Emejulu at the ICA London in December 2017, which included Siana Bangura, Kiyémis, and Francesca Sobande, who spoke of their experience of online plagiarism and the dangers of sharing on social media.

45. Sherman and Rae, "Making the Black Experience Relatable," 9.

46. Silverman, "How False New Spreads and Why People Believe in It."

47. Crogan and Kinsley, "Paying Attention: Towards a Critique of the Attention Economy," 2.

48. Wu, *The Attention Merchants*, 59.

49. Here, Wu references the Woodbury's Facial Soap advertisementsfirst published in the Ladies Home Journal, March 1915. Wu, *The Attention Merchants*, 60–61.

50. "Through its variously "scientific" techniques like demand engineering, branding, or targeting, the advertising industry had become an increasingly efficient engine for converting attention into revenue. It did so by beginning [to treat] its

customers, particularly women, [as] a constantly receding ideal to strive after" (Wu, *The Attention Merchants*, 64).

51. Media and cosmetics companies were often linked enterprises owned by the same person, *The Chicago Bee* was established and owned by Mr. Anthony Overton in 1922, having established Overton's Hygenic Manufacturing Company in 1898 in Kansas City. *Jet* and *Ebony* were owned by the Johnson Publishing Company, who also owned Fashion Fair Cosmetics and Supreme Beauty Products.

52. "Products for People of Color," in McDonough and Egolf, 409. See also Lynn M. Thomas's essay, "The Modern Girl and Racial Respectability in 1930s South Africa," 97–119, and Alys Eve Weinbaum's essay, "Racial Masquerade: Consumption and Contestation of American Modernity," 120–146, both in *The Modern Girl Around the World: Consumption, Modernity, and Globalization* (Durham, NC and London: Duke University Press, 2008).

53. Ross asserts that "in most corners of the information landscape, working for nothing has become normative and largely because it is not experienced as exploitation" (Scholz, *Digital Labor*, 17).

54. Jarrett, "The Relevance of 'Women's Work,'" 14–29.

55. Jarrett, "The Relevance of 'Women's Work,'" 25.

56. Dean, "Closing the Loop."

57. "I acknowledge that the spaces 'won' for difference are few and far between, that they are very 'carefully policed' and regulated. I believe they are limited. I know, to my cost, that they are grossly under-funded, that there is always a price of incorporation to be paid when the cutting edge of difference and transgression is blunted into spectacularization. I know that what replaces invisibility is a kind of carefully regulated, segregated visibility." Hall, "What is the 'Black' in Black Popular Culture?," quote taken from *Popular Culture: A Reader*, 288.

58. These imminent and cyclic recuperations of artistic critique are pitched in Luc Boltanski and Eve Chiapello's description of how *Mai '68* demonstrations demanded that all workers would be provided the same privileges as intellectual or artistic labor. But, having seeded a form of flexible labor that prioritized productivity over welfare, strategic collaboration over isolated reflection, and hyper-flexibility over autonomy and satisfaction, a situation emerged where the worker's body and intellect were inseparable from their work, where "labour can no longer be treated as a commodity separate from the person of those performing it" (Boltanski and Chiapello, *The New Spirit of Capitalism*, 131).

59. Paolo Virno defines affective labor as: "*an activity which finds its own fulfillment (that is, its own purpose)* without objectifying itself into an end product, without settling into a 'finished product' or into an object which would survive the

performance. Secondly, it is *an activity which requires the presence of others,* which exists only in the presence of an audience" (Virno, *A Grammar of the Multitude,* 52).

60. "The informality of communicative behavior, the competitive interaction typical of a meeting, the abrupt diversion that can enliven a television program, has become now, in the post-Fordist era, a typical trait of the *entire* realm of social production … What is left to question if anything, is what specific role is carried out *today* by the communication industry, since all industrial sectors are inspired by its model" (Virno, *A Grammar of the Multitude,* 59).

61. Hardt and Negri, *Multitude: War and Democracy in the Age of Empire,* 108.

62. Gunning, "The Cinema of Attraction," 37.

63. Jarrett, "The Relevance of 'Women's Work,'" 21.

Chapter 7

1. Steyerl, "The Spam of the Earth," 170.

2. In an interview with Corine Segal on the subject of art and social practice, Claire Bishop proposed: "I don't see social practice as influential enough to crowd out the aesthetic in contemporary art. But social practice's identification with ethics and politics should lead us to ask what's prompting its allergy to the aesthetic. I've already mentioned the art market as a system with which many artists do not identify; this represents a bigger problem, which is a widespread dissatisfaction with free market capitalism and the inequality and disempowerment it produces. I don't think it's a coincidence that social practice arises simultaneously with the digital revolution. Face-to-face relationships are becoming important as we spend more and more time online." Bishop and Segal, "Art for Politics Sake."

3. Bishop revised her articulation of the "divide" (first published in "Digital Divide: Contemporary Art and New Media"), after objections by critic Brian Droitcour and curator Lauren Cornell published in *Artforum* ("Technical Difficulties," LETTERS, p. 36). In subsequent public correspondence (*Artforum* LETTERS, p. 38), Bishop maintained that: "the core question was why so little mainstream art reflects on what it means to think, see, and filter affect through the digital. I'm not talking about individuals and institutions using new media, but about how new media changes us."

4. Harvey, "The Body as an Accumulation Strategy," which was published in 1998, after his 1995 published conversation with Donna Haraway ("Nature, Politics, and Possibilities").

5. Originally defined by Prensky, "Digital Natives, Digital Immigrants."

6. In *The Migrant Image,* T. J. Demos evinces the theory, based on observation of works by Steve McQueen, Hito Steyerl, and the Otolith Group, that such works: "join, sometimes uneasily and paradoxically, political commitment and subjective

desire, forming a complex image world that unleashes unconscious processes and imaginative scenarios. What results is nonetheless a political space, but one apart from politics, oppositional without rationalist determinism, which moves by other means" (Demos, *The Migrant Image*, 91–92). It is a theory that establishes operations of the work to be internal, but equally effecting its outward politics or political operation, a visual intelligence that resonates with works included here.

7. Works by those of Cheyney Thompson, Jutta Koether, and Merlin Carpenter were included in an analysis by David Joselit, "Painting Beside Itself."

8. Laing's description of online immersion relocates the lonely body to a contemporary, virtual city, to see: "how the network might appeal to someone in the throes of chronic loneliness, with its pledge of connection, its beautiful, slippery promises of autonomy and control. You can look for company without the danger of being revealed or exposed ... You can reach out or you can hide; you can lurk and you can reveal yourself, curated and refined" (Laing, *The Lonely City*, 221–226).

9. "Experimental auto-ethnography" is a term used by Latin American film scholar and curator Amalia Córdova in her article "AFTEREFFECTS: Mapping the experimental ethnography of Juan Downey" in response to the exhibition, *The Invisible Architect*.

10. Evans's work *Hyperlinks* been shown in London's Seventeen Gallery, in 2014, and has been shown in various locations since, including on the online art portal Vdrome, http://www.vdrome.org/cecile-b-evans-hyperlinks-or-it-didnt-happen.

11. Chat history excerpt from Evans's *Talk to PHIL*.

12. Evans, Lunch Bytes Conference.

13. Beller, *The Cinematic Mode of Production*, 268.

14. Another Continental feminist theory focused on a philosophical exploration of the status of the body is Elizabeth Grosz's *Volatile Bodies: Toward a Corporeal Feminism*.

15. From Butler's essay, "Bodies that Matter," from her book *Bodies that Matter: On the Discursive Limits of Sex*, 6.

16. Overidentification as defined by The Political Currency of Art (PoCA) Research Group, POCA.

17. McLean-Ferris, "Can You Feel It?"

18. This performance was seen in London's "Art Night," at Two Temple Place, London, curated by Kathy Noble and produced by the ICA on July 2, 2016.

19. Stiegler, *For a Critique of a New Political Economy*.

20. As recalled by Dan Graham, in conversation with Sabine Breitwieser, Museum of Modern Art's Oral History Program, New York, November 1, 2011.

21. Significant institutional exhibitions of dance over the last decade include *MOVE: Choreographing You*, at the Hayward Gallery, London in 2010 (Dusseldorf 2011; Seoul 2012); *Danser sa Vie*, at the Centre Georges Pompidou, Paris (2011); the exhibition *Dance/Draw*, at the ICA Boston (2011); *Dancing Around the Bride*, at the Philadelphia Museum of Art (2013); New York's New Museum hosted a series of events called *Choreography* (2014); London's Tate Modern hosted *If Tate Was Musee De La Dance* (2015, choreographed by Boris Chamovicz); Anne Teresa De Keersmaeker won the Golden Lion at the Venice Biennale (2015); in London, Trajal Harrell's *Hoochie Koochie* appeared at the Barbican Centre (2017).

22. Roysdon, "Notes on performance and institutions, Notes on transitions, to Discompose."

23. Roysdon, interviewed by Wood and Noble, Tate Modern, May 31, 2012, http://www.tate.org.uk/whats-on/tate-modern/performance-and-music/bmw-tate-live-performance-room-emily-roysdon.

24. Previously explored in Roysdon's work *Sense and Sense* (2010).

25. Providing a stage for other performers between intervals in her prose, Roysdon reads aloud, "… for the past while I've been thinking about transitions, the shifting of weight, changing of direction, gender and governments, choreographic and interpersonal, transitions, no matter the context or political moment, a chance to detach from weighted positions, a chance to be moved, what is a transition that's not a solution …" *Uncounted* (performance 4), February 22, 2015, commissioned by PARTICIPANT, INC (NYC), with Gregg Bordowitz, Morgan Bassichis, Sharon Hayes, J. D. Samson, Nick Hallett, and Malin Arnell. http://emilyroysdon.com/index.php?/hidden-text/uncounted-plain-text/.

26. Roysdon, interviewed by Wood and Noble, 2012.

27. Roysdon, interviewed by Wood and Noble, 2012.

28. "To discompose, I have always resisted conjugating it. The infinitive form is part of the proposition, an integral part of the dramaturgy of the idea. That it's in motion. But the action I cling to in the word, is stilled by the scene of its thinking. My struggle to understand it has been in this contradiction—that the movement became an image, fixed and framed out of time. And I could not use it in a sentence," paragraph 8, from Roysdon's text, *Uncounted*, written "inconsistently between 2012–2014," that has since structured nine different "call and response" performances from 2104–2017; http://emilyroysdon.com/index.php?/hidden-text/uncounted-plain-text.

29. Roysdon, interviewed by Wood and Noble, 2012.

30. Wu Tsang interviewed by Berardini, Vdrome, 2012.

31. Wu Tsang interviewed by Andrew Berardini, Vdrome, 2012.

32. Wu Tsang interviewed by Andrew Berardini, Vdrome, 2012.

33. Wu Tsang interviewed by Andrew Berardini, Vdrome, 2012.

34. Wu Tsang interviewed by Andrew Berardini, Vdrome, 2012.

35. Gonzalez, "Speech Acts," 27.

36. Moten, "Some Extrasubtitles for *WILDNESS*," 161; based on a quotation by Oscar Zeta Acosta, *The Revolt of the Cockroach People*.

37. Perlson, "Truth in Gender," 43.

38. Evers, "The Looks," 152.

39. Script transcript, in *Wu Tsang: Not in My Language*, 126.

40. Gronlund, *Contemporary Art and Digital Culture*, 162.

41. Gronlund, *Contemporary Art and Digital Culture*, 162.

42. Between 2011 and 2012, *Any Ever* was screened at The Power Plant, Toronto, Canada, Museum of Contemporary Art Pacific Design Center, Los Angeles, CA, stanbul Modern, Istanbul, Turkey, MoMA PS1, Long Island City, NY, Musée d'Art Moderne de la Ville de Paris, Paris, among many other international museums and institutions.

43. Ligia Lewis interview for dance festival, *American Realness*.

44. Hall, "What Is the 'Black' in Black Popular Culture?," 24–25.

45. Lewis in correspondence with the author, June 2018.

46. Lewis in correspondence with the author, June 2018.

47. Black, "Ligia Lewis."

48. Eisenstein, *Eisenstein on Disney*, 46.

49. In an article for the *New York Times*, Claudia Rankine describes Serena Williams on court: "She shows us her joy, her humor and, yes, her rage. She gives us the whole *range* of what it is to be human, and there are those who can't bear it, who can't tolerate the humanity of an ordinary extraordinary person" (Rankine, "The Meaning of Serena Williams"). The nuances of the term "range" to which Williams brings to court was quoted and discussed in a conference organized by the ICA London and hosted and discussed by Legacy Russell, in the context of her forthcoming book *Glitch Feminism*.

50. In March 2014, Martine Syms gave a talk on "Black Vernacular: Lessons of the Tradition" at the Walker Arts Center, Minneapolis.

51. Jacqueline Najuma Stewart is a film theorist based in Chicago, specializing in African American film culture and the significance of archiving and preserving

amateur film footage, amateur productions, and found photos. About Stewart, Syms says: "In her research she studies the migration of black families from rural south to urban north, in specific patterns over the twentieth century and in parallel with the development of industrial cinema, the migration of black actors onto screens and black filmmakers behind the camera" (Syms's lecture, "Critical Issues in Contemporary Art Practice," which also quotes from Stewart's *Migrating to the Movies*.)

52. Syms, "Black Vernacular."

53. Syms quotes from Landsberg, *Prosthetic Memory* (Syms, "Critical Issues in Contemporary Art Practice").

54. Landsberg, *Prosthetic Memory*, 28.

55. Landsberg's formulation of prosthetic memory is distinct from Stiegler's theory of the "exteriorization of memory," where cinema takes its place among all mnemotechnics "from primitive tools through writing to analogue and digital recording" (Radstone, "Cinema and Memory," 334).

56. St. Félix, "How to Be a Successful Black Woman."

57. This work was premiered at her solo exhibition, *Projects 106: Martine Syms*, at the Museum of Modern Art, New York, and screened recently at the ICA, London on November 2, 2017.

58. St. Félix, "How To Be A Successful Black Woman."

59. Gaines, *Black Performance on the Outskirts of the Left*, 180.

60. St. Félix, "How To Be A Successful Black Woman."

61. St. Félix, "How To Be A Successful Black Woman."

Chapter 8

1. Leckey in conversation with the author, January 2013.

2. Beller, *The Cinematic Mode of Production*, 2.

3. Benjamin, "The Work of Art in the Age of Mechanical Reproduction," 217.

4. Morin, *The Cinema or the Imaginary Man, 1956*, 24–25.

5. Translations of the term *verfremdungseffekt* are widely contested (Jameson, "Doctrine," 40).

6. Willett (ed. and trans.), *Brecht on Theatre*, 91.

7. Jameson, "Doctrine," 43–58.

8. Althusser, "Lenin and Philosophy," 152.

9. Althusser, "Lenin and Philosophy," 154.

10. Fredric Jameson, "Introduction," in *Lenin and Philosophy and other essays*, viii. The complex relationship between Althusser's writing and Stalinism is analyzed in greater depth in Jameson's "On Interpretation: Literature as a Socially Symbolic Act," from, *The Political Unconscious*, 1–88.

11. Tiqqun, *Preliminary Theory of a Young Girl*, 107.

12. This nightly law goes largely unacknowledged but represents the "spirit of community" and implores group identification. "What most deeply 'holds together' a community is not so much identification with the Law that regulates the community's 'normal' everyday circuit, but rather identification with a specific form of transgression of the Law, of the Law's suspension (in psychoanalytic terms, with a specific form of enjoyment)." What also defines this method of overidentification is how it puts its viewer or subject (or in Žižek's formulation, its analyst), under scrutiny, "transferring" not the question of desire, and how or with whom it is materialized, legitimized, quantified, because ultimately "at the end of the psychoanalysis is the shift from desire to drive" (Žižek, "Why Are Laibach and the Neue Slowenische Kunst Not Fascists?," 4).

13. The research group also asks whether "overidentification require[s] totalitarianism, censorship and repression to work?" Overidentification as defined by The Political Currency of Art (PoCA) Research Group, which investigates the condition and consequences of the claims to critique in contemporary art and elsewhere, when such claims can be readily assimilated, as they now are, with the interests of more or less dominant cultural, state, and financial institutions. http://www.thepoliticalcurrencyofart.org.uk/research-strands/irony-and-overidentification.

14. Eisenstein, *Eisenstein on Disney*, 46.

15. Freud's *Beyond the Pleasure Principle* attributed fundamental human drives to the primordial urge to return to the plasma of an originary amoeba cell, from which came the death drive, and to which all human behavior related.

16. In animation Eisenstein believed these were, "the most omni-appealing works [he] had ever met." He wrote about transformations of fish turning into tigers in *Merababies*, or *Willie the Operatic Whale*, as he took to the stage at the Met, in New York (c. 1944): "... a being which has attained a definite appearance, and which behaves like the primal protoplasm, not yet possessing a 'stable' form, but capable of assuming any form and which ... attaches itself to any and all forms of animal existence." Eisenstein, *Eisenstein on Disney*, 46.

17. Leckey, "Life in Film," 38.

18. The term plasmatic is interestingly expanded by Leckey in examples in twentieth-century feature films including F. R. Murnau's *Sunrise* (1927), Ridley Scott's *Blade Runner* (1982), and Jacques Tati's *Play Time* (1967). Leckey, "Life in Film," 38.

19. Morin, *The Cinema, or the Imaginary Man*, 25.

20. Pêcheux, *Semantics and Ideology*.

21. Muñoz, *Disidentifications: Queers of Color and the Performance of Politics*, 11.

22. Stuart Hall, "Encoding/Decoding."

23. In her reading, Butler antagonizes Žižek's interpretation of disidentification as a factionalizing and immobilizing force. Butler, *Bodies that Matter*, 15. (See also Muñoz's, "Famous and Dandy," 144–179.)

24. Muñoz, *Disidentifications*, 12.

25. Muñoz, *Disidentifications*, 161.

26. Here Muñoz takes up the definition of intersectional minorities by Kimberlé Williams Crenshaw, described as the interstices of black and feminist critical issues. Crenshaw, "Beyond Racism and Misogyny," 111–132, as quoted by Muñoz, *Disidentifications*, 6.

27. Muñoz notes Gonzalez-Torres's refusal to invoke but rather "connote" identity, and, "to participate in a particular representational economy. He does not counter negative representations with positive ones, but instead absents himself and his work from this dead-end street" (Muñoz, *Disidentifications*, 165).

28. Muñoz, *Disidentifications*, 25.

29. Evers, "The Looks," 152–153.

30. Muñoz, *Disidentifications*, 25.

31. Roysdon, *Uncounted*, 2012–2014.

32. Muñoz, *Disidentifications*, 161–162.

33. Muñoz, *Disidentifications*, 25.

34. O'Grady in correspondence with the author, February 2018.

Bibliography

Acconci, Vito. "Notebook: On Activity and Performance." In *The Art of Performance: A Critical Anthology*, eds. Gregory Battock and Robert Nickas, 102–104. New York: EP Dutton, 1984; UBU edition, 2010.

Acconci, Vito. "Notes on Performing a Space," *Avalanche* 6 (special issue, Fall 1972): 4–5.

Acconci, Vito. "10 Point Plan for Video." In *Video Art*, eds. Ira Schneider and Beryl Korot, 8–9. New York: Harcourt Brace Jovanovich, 1976.

Althusser, Louis. "Lenin and Philosophy" (1966). In *Lenin and Philosophy and Other Essays*. New York: Monthly Review Press, 2001.

Amerika, Mark. "Avant-Pop Manifesto: Thread Bearing Itself in Ten Quick Posts" (1992–1993). http://www.altx.com/manifestos/avant.pop.manifesto.html.

Anderson, Chris. "The Long Tail." *Wired*, October 2004. https://archive.wired.com/wired/archive/12.10/tail.html.

Anderson, Chris. *The Long Tail: Why the Future of Business Is Selling Less of More*. New York: Hyperion, 2008.

Arvidsson, Adam, and Elanor Colleoni. "Value in Informational Capitalism and on the Internet." *Information Society* 28 (3) (May 2012): 135–150.

Austin, J. L. *How to Do Things with Words*. 2nd ed. London: Oxford University Press, 1972.

Balsom, Erika. *After Uniqueness: A History of Film and Video in Circulation*. New York: Columbia University Press, 2016.

Banes, Sally. "The Birth of the Judson Dance Theatre: A Concert of Dance at Judson Church, July 6, 1962." *Dance Chronicle* 5 (2) (1982): 167–212.

Battock, Gregory, and Robert Nickas, eds. *The Art of Performance: A Critical Anthology*. New York: EP Dutton, 1984; UBU edition, 2010.

Bauwens, Michel. "The Political Economy of Peer Production" (2005). http://www
.ctheory.net/articles.aspx?id=499.

Beckman, Ericka, in conversation with David Rosen. "Video Viewpoints: Art and
Technology in the 1990s," screening notes. New York: Museum of Modern Art, 1993.

Beckman, Ericka. Lecture notes, "Der Endtfesselte Blick," Kunstmuseum Bern, Octo-
ber 25, 1992.

Bell, Kirsty. "Cinema in the Round." *Camera Austria* 101 (May 2008): 9–10.

Beller, Jonathan. *The Cinematic Mode of Production: Attention Economy and the Society
of the Spectacle*. Hanover, NH: Dartmouth College Press, 2006.

Benjamin, Walter. "The Work of Art in the Age of Mechanical Reproduction." In
Illuminations, 211–244. London: Pimlico, 1990.

Bennett, Tony. "The Exhibitionary Complex." In *The Birth of the Museum: History,
Theory, Politics*, 59–88. London: Routledge, 1995.

Berger, John. *And Our Faces, My Heart, Brief as Photos*. London: Writers and Readers,
1984.

Bhatia, Rahul. "The Inside Story of Facebook's Biggest Setback." *The Guardian*
Long Read, May 12, 2016. https://www.theguardian.com/technology/2016/may/12/
facebook-free-basics-india-zuckerberg.

Bishop, Claire, and Corine Segal. "Art for Politics Sake: Claire Bishop on Social Prac-
tice." *Boston Review* (August 24, 2012). http://www.bostonreview.net/books-ideas/
art-politics'-sake-corinne-segal.

Bishop, Claire. "Digital Divide: Contemporary Art and New Media." *Artforum* 51 (1)
(September 2012): 435–441, 534.

Bishop, Claire. LETTERS. *Artforum* 51 (5) (January 2013): 38.

Bishop, Claire. "Unhappy Days in the Art World? De-skilling Theater, Re-skilling
Performance." *Brooklyn Rail,* December 10, 2011. https://brooklynrail.org/2011/12/
art/unhappy-days-in-the-art-worldde-skilling-theater-re-skilling-performance.

Black, Hannah. "Full Moon." *The White Review*, March 2016. http://www.thewhitereview
.org/white_screen/full-moon.

Black, Hannah. "Ligia Lewis." *4 Columns*. http://www.4columns.org/black-hannah/
ligia-lewis.

Boltanski, Luc, and Eve Chiapello. *The New Spirit of Capitalism*, translated by Gregory
Elliott. London: Verso, 2007.

Borger, Irene. "An Interview with Leslie Thornton." Rolando Caputo and Scott
Murray, eds. *Senses of Cinema*, October 2002. http://sensesofcinema.com/2002/leslie
-thornton-experimental/thornton_interview.

Bourden, David. "The Eccentric Body of Art." In *The Art of Performance: A Critical Anthology*, eds. Gregory Battock and Robert Nickas, 98–102. New York: EP Dutton, 1984; UBU edition, 2010.

Bouvier, Lionel, and Fabrice Stroun. "Ericka Beckman." *JPR Journal* 3 (Spring 2012).

Brown, Carolyn. *Chance and Circumstance: Twenty Years with Cage and Cunningham* (New York: Alfred A. Knopf, 2007), 114 (including a review by P. W. Manchester from *Dance News*, January 1955).

Butler, Judith. *Bodies that Matter: On the Discursive Limits of Sex*. New York, London: Routledge, 1993.

Butler, Judith. *Gender Trouble*. New York: Routledge, 1990.

Callinicos, Alex. "Making History, Agency, Structure and Change in Social Theory." *Science and Society* 7 (3) 2007: 369–371.

Chatroulette. https://chatroulette.com.

Childs, Lucinda. "Notes: '64–'74. *The Drama Review* 19 (1), Post-Modern Dance Issue (March 1975): 33–36.

Chu, Seo-Young. "I, Stereotype: Detained in the Uncanny Valley." In *Techno-Orientalism: Imagining Asia in Speculative Fiction, History and Media*, eds. David S. Roth, Betsy Huang, and Greta A. Nui. New Brunswick, NJ: Rutgers University Press, 2015.

Chun, Wendy Hui Kyong. *Control and Freedom: Power and Paranoia in the Age of Cyberoptics*. Cambridge, MA: MIT Press, 2006.

Coffin, Patricia. "The New New York." *Look* magazine, March 26, 1963.

Córdova, Amalia. "AFTEREFFECTS: Mapping the experimental ethnography of Juan Downey." *Brooklyn Light Rail*, June 4, 2012. https://www.brooklynrail.org/2012/06/film/aftereffects-mapping-the-experimental-ethnography-of-juan-downey-in-the-invisible-architect.

Cosenza, Vincenzo. "World Map of Social Networks: January 2018," info-graph mapped according to Alexa and SimilarWeb traffic data. http://vincos.it/world-map-of-social-networks.

Crenshaw, Kimberlé Williams. "Beyond Racism and Misogyny: Black Feminism and 2 Live Crew." In *Words that Wound: Critical Race Theory, Assaultive Speech, and the First Amendment*, ed. Mari J. Matsuda, 111–132. Boulder, CO: Westview Press, 1993.

Crimp, Douglas. *Pictures: Exhibition Catalogue*. New York: Artists Space, 1977.

Crimp, Douglas. "Pictures." *October* 8 (Spring 1979): 75–88.

Crogan, Patrick. *Gameplay Mode: War, Simulation and Technoculture*. Minneapolis: University of Minnesota, 2011.

Crogan, Patrick, and Samuel Kinsley. "Paying Attention: Towards a Critique of the Attention Economy." *Culture Machine* 13, 2012. https://www.culturemachine.net/index.php/cm/issue/view/24.

Darling, Jesse. Lunch Bytes Conference. Haus der Kulturen der Welt, Berlin, March 21, 2015.

Darling, Jesse, and Jimmee Tiptree Jr. "Post-Whatever: On Ethics, Historicity and #usermilitia." In *You Are Here: Art After the Internet*. Manchester: Cornerhouse, 2014. (Rhizome, December 16, 2014, https://rhizome.org/editorial/2014/dec/16/post-whatever-ethics-historicity-usermilitia).

Dean, Aria. "Closing the Loop." *The New Inquiry*, March 1, 2016. https://thenewinquiry.com/closing-the-loop.

Debord, Guy. *The Society of the Spectacle*, trans. D. Nicholson-Smith. New York: Zone Books, [1967] 1994.

Demos, T. J. *The Migrant Image: The Art and Politics of Documentary During Global Crisis*. Durham, NC: Duke University Press, 2013.

Devereaux, Shaadi. "Why These Tweets Called My Back." *The New Inquiry*, 2014. https://thenewinquiry.com/essays/why-these-tweets-are-called-my-back.

Dewdney, Andrew, David Dibosa, and Victoria Walsh. *Post-Critical Museology: Theory and Practice in the Art Museum*. London: Routledge, 2013.

Dibbell, Julian. "A Rape in Cyberspace." *The Village Voice*, December 23, 1993. https://www.villagevoice.com/news/a-rape-in-cyberspace-6401665.

Dickerman, Leah. "Disciplined by Albers: Foundations at Black Mountain." In *Robert Rauschenberg*, edited by Leah Dickerman and Achim Borchardt-Hume, 28–59. London: Tate Publishing and New York: The Museum of Modern Art, 2016.

Droitcour, Brian, and Lauren Cornell. "Technical Difficulties," LETTERS. *Artforum* 51 (5) (Jan 2013): 36.

Eisenstein, Sergei. *Eisenstein on Disney*, ed. Jay Leyda. (Trans. Alan Upchurch). Calcutta: Seagull Books, 1986.

Eklund, Douglas. *Pictures Generation, 1974–1984*. New Haven: Yale University Press, 2009.

Ellegood, Anne, and Douglas Fogle. *All of This and Nothing*. Exhibition catalogue, Hammer Museum. Los Angeles: University of California Press, 2011.

Elsworth, Peter. "The Art Boom: Is This Over, or Is This Just a Correction?" *New York Times*, December 16, 1990. http://www.nytimes.com/1990/12/16/business/the-art-boom-is-it-over-or-is-this-just-a-correction.html.

Emejulu, Akwugo. *Post-Cyber Feminism International*. ICA London, November 15–19, 2017, including Siana Bangura, Kiyémis, and Francesca Sobande.

Evans, Cécile B. *Lunch Bytes Conference*. Haus der Kulturen der Welt, Berlin, March 21, 2015.

Evans, Cécile B. *Talk to PHIL*, performance at *Post Digital Cultures*, 2nd edition, December 5, 2014. Musée Cantonal des Beaux Arts, Lausanne, Switzerland.

Evers, Elodie. "The Looks." In *Wu Tsang: Not in My Language*, 151–154. Cologne: Walter Konig, 2015.

Farrington, Lisa E. *Creating Their Own Image: African American Women Artists*. Oxford: Oxford University Press, 2005.

Fortunati, Leopoldini. "Immaterial Labor and Its Machinization." *Ephemera: Theory and Politics in Organization* 7 (February 1, 2007): 139–157.

Freud, Sigmund. *Beyond The Pleasure Principle and other writings*, trans. John Reddick. London: Penguin Books, 2003.

Frosh, Paul. *The Image Factory: Consumer Culture, Photography and the Visual Content Industry*. New York: Berg, 2003.

Fuchs, Christian. "Class and Exploitation on the Internet." In *Digital Labor: The Internet as Playground and Factory*, ed. Trebor Scholz, 211–224. New York: Routledge, 2013.

Gaines, Malik. *Black Performance on the Outskirts of the Left*. New York: New York University Press, 2017.

Gide, André. *Journals 1889–1949*. trans. J. O'Brien. Harmondsworth, UK: Penguin, 1967.

Gilligan, Melanie. "Mark Leckey." *Artforum* 50 (3) (November 2011): 281–282.

Gleick, James. *The Information: A History, a Theory, a Flood*. New York: Pantheon Books, 2011.

GNU/Linux License FAQs. https://www.gnu.org/gnu/gnu-linux-faq.html.

Godfrey, Mark. "Frances Stark, Friends with Benefits." *Artforum* 51 (5) (January 2013): 158–165.

Goldberg, RoseLee. "Performance: A Hidden History" and "Performance: The Golden Years." In *The Art of Performance: A Critical Anthology*, eds. Gregory Battock and Robert Nickas, 22–26, and 44–55. New York: EP Dutton, 1984; UBU edition, 2010.

Goldhaber, Michael H. 1997. "The Attention Economy and the Net." *First Monday* 2 (4). http://firstmonday.org/article/view/519/440.

Gonzalez, Rita. "Speech Acts." In *Wu Tsang: Not in My Language*, 23–32. Cologne: Walter Konig, 2015.

Greenberg, Clement. "Modernist Painting," Forum Lectures (Washington, DC: Voice of America), 1960. Arts Yearbook 4, 1961 (unrevised). In *Modern Art and Modernism: A Critical Anthology*, ed. Francis Frascina and Charles Harrison. London: Paul Chapman and Open University: 1982, 1988.

Gronlund, Melissa. *Contemporary Art and Digital Culture*. New York: Routledge, 2016.

Grosz, Elizabeth. *Volatile Bodies: Toward a Corporeal Feminism*. Bloomington: Indiana University Press, 1994.

Gunning, Tom. "The Cinema of Attraction: Early Cinema, Its Spectator and the Avant-Garde." *Wide Angle* 8 (3–4), 1986: 63–70. Republished in *Theater and Film: A Comparative Anthology*. New Haven: Yale University Press, 2005.

Hall, Stuart. "Encoding/Decoding." In *Culture, Media, Language; Working Papers in Cultural Studies, 1972–79.*, eds. Stuart Hall, Dorothy Hobson, Andrew lowe, and Paul Willis, 128–138. London: Routledge, 1980.

Hall, Stuart. "What Is the 'Black' in Black Popular Culture?" Orig. published in *Black Popular Culture*, ed. Gina Dent, 24–25. Seattle, WA: Bay Press, 1992. Republished in *Popular Culture: A Reader*, eds. Raiford Guins and Omayra Zaraza Cruz. London: Sage, 2005.

Halter, Ed. "Hell Is for Children: Ed Halter on Leslie Thornton: *Peggy and Fred in Hell*." *Artforum* 51 (1) (September 2012): 514–521.

Hanhardt, John G. "Mike Kelley's Puppet Show: The Postmodern Body on Video." In *Mike Kelley: Catholic Tastes*, ed. Elizabeth Sussman, 221–231. New York: Whitney Museum of American Art, 1993.

Haraway, Donna, and David Harvey. "Nature, Politics, and Possibilities: A Debate and Discussion with David Harvey and Donna Haraway." *Environment and Planning D: Society & Space* 13 (1995): 507–527.

Harbison, Isobel. "Image Games." *Frieze* 150 (October 2012): 220–227.

Hardt, Michael, and Antonio Negri. *Multitude: War and Democracy in the Age of Empire*. New York: Penguin, 2004.

Harrison, Charles, and Paul Wood. *Art in Theory 1900–2000, an Anthology of Changing Ideas*. Malden, MA: Blackwell, 2003.

Harvey, David. *A Brief History of Neoliberalism*. Oxford: Oxford University Press, 2007.

Harvey, David. "The Body as an Accumulation Strategy." *Environment and Planning D: Society and Space* 16 (4) (1998): 401–421.

Harvey, David. *The Enigma of Capital: And the Crisis of Capital*. Oxford: Oxford University Press, 2011.

Harvey, David. "Time-Space Compression and the Postmodern Condition." In *The Condition of Postmodernity*. Oxford: Blackwell, 1990.

Higgins, Dick. "Intermedia." In *Horizons* (Carbondale: Southern Illinois University Press, 1984), 18. [Originally published in *Something Else Newsletter* 1 (1) (New York: 1966), 1–3.]

Higgs, Matthew. "Mark Leckey: Openings." *Artforum* 40 (8) (April 2002): 128–129.

Ho, Yin. "Shu Lea Cheang on Brandon." Rhizome, May 10, 2012. http://rhizome.org/editorial/2012/may/10/shu-lea-cheang-on-brandon.

Hoberman, J. "Review: Out Of Hand." *Artforum* 19 (5) (January 1981): 76.

Jameson, Fredric. "Doctrine." In *Brecht and Method*. London: Verso, 2000.

Jameson, Fredric, *The Political Unconscious,* London: Routledge, 2002.

Jameson, Fredric, *Postmodernism, or, The Cultural Logic of Late Capitalism,* Durham: Duke University Press, 1991.

Jarrett, Kylie. "The Relevance of 'Women's Work': Social Reproduction and Immaterial Labour in Digital Media." *Television & New Media* 15 (I) (2014): 14–29.

Jenkins, Harry, Joshua Green, and Sam Ford. *Spreadable Media: Creating Value and Meaning in a Networked Culture*. New York: New York University Press, 2013.

Jones, Amelia. *Self/ Image: Technology, Representation and the Contemporary Subject*. New York: Routledge, 2006.

Joselit, David. *After Art*. Princeton: Princeton University Press, 2013.

Joselit, David. "Painting Beside Itself." *October* 130 (Fall 2009): 125–134.

Joseph, Branden W. "A Duplication Containing Duplications." *October* 95 (Winter 2001): 3–27.

Joseph, Branden W. *Random Order*. Cambridge, MA: MIT Press, 2003.

Joseph, Branden W. "Rauschenberg's Refusal." In *Robert Rauschenberg: Combines*, 257–283. Organized by Paul Schimmel. Los Angeles: The Museum of Contemporary Art, 2005.

Kay, Alan, and Adele Goldberg. "Personal Dynamic Media." In *The New Media Reader*, ed. Noah Wardrip-Fruin and Nick Montfort, 391–404. Cambridge, MA: MIT Press, 2003.

Kennedy, Peter. *Other Than Art's Sake* (1973–74) http://www.adrianpiper.com/vs/video_tmb.shtml.

Kerlansky, Mark. *1968: The Year That Rocked the World*. New York: Random House, 2005.

Kraus, Chris. *Aliens & Anorexia*. Los Angeles: Semiotexte, 2000.

Kraus, Chris. *I Love Dick*. Los Angeles: Semiotexte, 2006.

Kraus, Chris. "Torpor, Los Angeles." *C: International Contemporary Art* (76), Winter 2002/2003.

Krauss, Rosalind. "The Aesthetics of Narcissism." *October* 1 (Spring 1976): 50–64.

Krauss, Rosalind. "Rauschenberg and the Materialized Image." [first published in *Artforum* 13 (4) (December 1974): 39–56.] Reprinted in *Robert Rauschenberg: October Files 4*, edited by Brandon W. Joseph. Cambridge, MA: MIT Press, 2002.

Krauss, Rosalind. "Reinventing the Medium." *Critical Inquiry* 25 (2) (Winter 1999): 289–305.

Krauss, Rosalind. "Video: The Aesthetics of Narcissism." *October* 1 (Spring 1976): 50–64.

Krauss, Rosalind. *A Voyage on the North Sea: Art in the Age of the Post Media Condition*. New York: Thames and Hudson, 1999.

Kretowicz, Steph. "Mark Leckey Made Me Hardcore." *Fact*, May 3, 2016. http://www.factmag.com/2016/05/03/mark-leckey-interview-fiorucci-hardcore-dream-english-kid.

Kwon, Miwon. "Response to 'Questionnaire on "The Contemporary,"'" *October* 130 (Fall 2009): 13–15.

Laing, Olivia. *The Lonely City: Adventures in the Art of Being Alone*. Edinburgh: Canongate, 2016.

Lambert-Beatty, Carrie. "Moving Still." *October* 89 (Summer 1999): 87–112.

Lammer, Elise, and Karima Boudou. "Conversations: Adrian Piper, *The Mythic Being* at MAMCO, Geneva, 2017." http://moussemagazine.it/adrian-piper-mythic-mamco-geneva.

Landsberg, Alison. *Prosthetic Memory: The Transformation of an American Remembrance in the Age of Mass Culture*. New York: Columbia University Press, 2004.

Lanier, Jaron. *Who Owns the Future?* London: Penguin, Allen Lane, 2013.

Lanier, Jaron. *You Are Not a Gadget*. London: Penguin, Allen Lane, 2013.

Leckey, Mark. *In the Long Tail*. ICA London, January 2009. Abrons Art Center in New York (with Museum of Modern Art); Koln Kunstverein (Cologne); uploaded onto his YouTube, March 2010; Vimeo in 2014. https://vimeo.com/73861892.

Leckey, Mark, interviewed by Ben Brown, *Creative Time* (New York, 2008). https://www.youtube.com/watch?v=Lc5YFOKpsMA.

Leckey, Mark. "Life in Film: Mark Leckey." *Frieze* (115) (May 2008): 38.

Leckey, Mark. *Mark Leckey: See We Assemble*, curators Hans Ulrich Obrist, Catherine Wood, Martin McGeown, and Neil Mulholland. London: Serpentine Gallery and Koenig Books, 2011.

Lee, Pamela. "Gifts from the Street: Early Media Works." In *Robert Rauschenberg*, edited by Leah Dickerman and Achim Borchardt-Hume, 214–231. London: Tate Publishing and New York: The Museum of Modern Art, 2016.

Lewis, Ligia. Interview for dance festival *American Realness*, January 5–10, 2017, Abrons Art Center. https://vimeo.com/199340408.

Linden Lab. "Infographic: Ten Years of Second Life." Linden Lab, June 2013. http://www.lindenlab.com/releases/infographic-10-years-of-second-life.

Lovink, Geert. *Networks Without A Cause*. Cambridge: Polity Press, 2011.

Madsbjerg, Saadia. "It's Time to Tax Companies for Using Our Personal Data?," *New York Times*, November 14, 2017.

Manovich, Lev. "Post-Media Aesthetics," 2001. http://manovich.net/index.php/projects/post-media-aesthetics.

Marazzi, Christian. *Capital and Language: From the New Economy to the War Economy*. Cambridge, MA: MIT Press, 2008; from Semiotext(e), Los Angeles.

Marx, Karl. "Concluding Observations on Adam Smith and His Views on Productive and Unproductive Labour," in chap. 4, "Theories of Productive and Unproductive Labour." *Theories of Surplus Value,* vol. 4 of *Capital*, 1863.

Mauss, Nick. "The Poem Will Resemble You." *Artforum* 47 (9) (May 2009): 184–189.

McDonough, John, and Karen Egolf, eds. *The Advertising Age Encyclopedia of Advertising*, 3 vols. Chicago: Fitzroy Dearborn Publishers, 2002.

McLean-Ferris, Laura. "Can You Feel It?" *Frieze* (May 2015): 90–95.

McLuhan, Marshall. *Take Today: The Executive as Dropout*. New York: Harcourt Brace Jovanovich, 1972.

McMillan, Uri. *Embodied Avatars: Genealogies of Black Feminist Art and Performance*. New York: New York University Press, 2015.

Meze, Cade. "How Facebook Moved 20 billion Instagram Photographs Without You Noticing." *Wired Magazine*, June 24, 2014. https://www.wired.com/2014/06/facebook-instagram.

Molderings, Herbert. "Life Is No Performance." In *The Art of Performance: A Critical Anthology*, eds. Gregory Battock and Robert Nickas, 92–97. New York: EP Dutton, 1984; UBU edition, 2010.

Molesworth, Helen. "Pedestrian Color: The Red Paintings." In *Robert Rauschenberg*, eds. Leah Dickerman and Achim Borchardt-Hume, 118–137. London: Tate Publishing and New York: The Museum of Modern Art, 2016.

Morin, Edgar. *The Cinema, or the Imaginary Man, 1956.* Minneapolis: Minnesota University Press, 2008.

Morozov, Evgeny. "When Wall Street and Silicon Valley Come Together—a Cautionary Tale." *The Guardian*, October 25, 2014, quoted in a lecture by Emily Rosamund, December 2017, Goldsmiths College, London.

Moten, Fred. "Some Extrasubtitles for *WILDNESS*." In *Wu Tsang: Not in My Language*, 160–162. Cologne: Walter Konig, 2015.

Mulvey, Laura. "Visual Pleasure and Narrative Cinema." In *Film Theory and Criticism: Introductory Readings*, edited by Leo Braudy and Marshall Cohen, 833–844. New York: Oxford University Press, 1999.

Muñoz, José Esteban. *Disidentifications: Queers of Color and the Performance of Politics.* Minneapolis: University of Minnesota Press, 1999.

Muñoz, José Esteban. "Famous and Dandy Like B. 'n' Andy: Race, Pop, and Basquiat." In *Pop Out: Queer Warhol*, edited by Jennifer Doyle, Jonathan Flatley, and José Esteban Muñoz, 144–179. Durham, NC: Duke University Press, 1996.

Nelson, Ted. "Ted Nelson's Computer Paradigm, Expressed as One Liners," 1999. http://xanadu.com.au/ted/TN/WRITINGS/TCOMPARADIGM/tedCompOneLiners .html.

Nelson, Ted. "Ted Report," 1997. www.hyperstand.com/Sound/Ted_Report2.html.

Nickas, Robert. 1984. "Introduction." In *The Art of Performance: A Critical Anthology*, eds. Gregory Battock and Robert Nickas, 5–12. New York: EP Dutton, 1984; UBU edition, 2010.

O'Connell, Donal. *Harvesting External Innovation: Managing External Relationships and Intellectual Property.* London: Routledge, 2016.

O'Doherty, Brian. *Inside the White Cube.* Berkeley: University of California Press, 1976.

O'Grady, Lorraine. "The Black and White Show," 2015. http://lorraineogrady.com/ art/the-black-and-white-show.

O'Grady, Lorraine. "Dada Meets Mama: Lorraine O'Grady on WAC." *Artforum* 31 (2) (October 1992): 11–12.

O'Grady, Lorraine. Interviewed by Jarrett Earnest. *Brooklyn Rail*, February 3, 2016. https://brooklynrail.org/2016/02/art/lorraine-ogrady-with-jarrett-earnest.

O'Grady, Lorraine. Interviewed by Karen Rosenberg. "How Lorraine O'Grady Transformed Harlem into a Living Artwork in the '80s—and Why It Couldn't be Done Today." *Art Space*, July 22, 2015.

O'Grady, Lorraine. "Nefertiti/Devonia Evangeline." *College Art Association Art Journal* 56 (4) (Winter 1997): 64–65.

Osborne, Peter. *The Post-Conceptual Condition*. London: Verso, 2016.

Papacharissi, Zizi. *A Networked Self: Identity, Community and Culture on Social Network Sites*. New York: Routledge, 2011.

Papararo, Jenifer. "Frances Stark: I've Had It and A Half." *C: International Contemporary Art* (Fall 2011).

Pêcheux, Michel. *Semantics and Ideology*. New York: St. Martin's Press, 1982.

Perlson, Hili. "Truth in Gender: Wu Tsang and Boyhood on the Question of Queerness." *Sleek Magazine* 43 (Autumn) 2014.

Phelan, Peggy. *Unmarked: The Politics of Performance*. London: Routledge, 1993.

Phelan, Peggy. "Survey." In *Art and Feminism*, 16–49. London: Phaidon, 2001.

Piper, Adrian. *Out of Order, Out of Sight: Selected Writings in Meta-Art 1968–1992*. Cambridge, MA: MIT Press, 1996.

The Political Currency of Art (PoCA) Research Group, POCA; "Overidentification and Irony." Research strand led by Pil and Galia Kollectiv (2009). http://www.thepoliticalcurrencyofart.org.uk.

Prensky, Marc. "Digital Natives, Digital Immigrants." *On the Horizon* 9 (5) (October 2001): 1–6.

Radstone, Susannah. "Cinema and Memory." In *Memory: History, Theory, Debates*, eds. Susannah Radstone and Bill Schwartz, 325–342. New York: Fordham University Press, 2010.

Rainer, Yvonne. *Feelings Are Facts: A Life*. Cambridge, MA: MIT Press, 2006.

Rainer, Yvonne. "More Kicking and Screaming from the Narrative Front/Backwater." *Wide Angle* 7 (1–2) (Spring 1985): 8–12.

Rainer, Yvonne. "A Quasi Survey of Some 'Minimalist' Tendencies in the Quantitatively Minimal Dance Activity Midst the Plethora, or an Analysis of Trio A." In *Minimal Art: A Critical Anthology,* ed. Gregory Battock, 263–273. Berkeley: University of California Press, 1995. (Previously published in *Work 1961–1973*. Halifax: Press of the Nova Scotia College of Art and Design, 1974.)

Rainer, Yvonne. "Some Ruminations Around Cinematic Anecdotes to the Oedipal Net(tles) while Playing with de Lauraedipus Mulvey, or He May Be Off-Screen, but … ." *The Independent* 9 (3) (April 1986), republished in *Psychoanalysis and Cinema*, ed. E. Ann Kaplan, 188–197. New York: Routledge, 1990.

Rainer, Yvonne. "Statement." First published in program for *The Mind is a Muscle*, Anderson Theater, April 11, 14, 15, 1968. Reproduced in *Work 1961–1973* (Halifax: Press of the Nova Scotia College of Art and Design, 1974), 71.

Rainer, Yvonne. *A Woman Who… Essays, Interviews, Scripts*. Baltimore, MD: The Johns Hopkins University Press, 1999.

Rankine, Claudia. "The Meaning of Serena Williams." *New York Times*, August 25, 2015. https://www.nytimes.com/2015/08/30/magazine/the-meaning-of-serena-williams.html.

Raymond, Eric S. *The Cathedral & the Bazaar: Musings on Linux and Open Source by an Accidental Revolutionary*. Cambridge, MA: O'Reilly and Associates, 1999.

Ritzer, George. "Are You a Digital Drone?" In *Introduction to Sociology*, 666–667. Thousand Oaks, CA: Sage, 2013.

Ritzer, George, and Nathan Jurgenson. "Production, Consumption, Prosumption." *Journal of Consumer Culture* 10 (1): 13–36.

Roysdon, Emily, interviewed by Catherine Wood and Kathy Noble. Tate Modern, May 31, 2012. http://www.tate.org.uk/whats-on/tate-modern/performance-and-music/bmw -tate-live-performance-room-emily-roysdon.

Roysdon, Emily. "Notes on Performance and Institutions, Notes on Transitions, to Discompose." Presented at the Annual Performance Symposium at MoMA: "How Are We Performing Today? New Formats, Places, and Practices of Performance-Related Art," November 17, 2012. http://emilyroysdon.com/index.php?/texts/moma -performance-symposium-text.

Roysdon, Emily. *Uncounted,* the text for a performance written between 2012 and 2014, and performed between 2014 and 2017 in a range of spaces, June 1, 2018. http://emilyroysdon.com/index.php?/hidden-text/uncounted-plain-text/.

Rugoff, Ralph. "Mike Kelley and the Power of the Pathetic." In *Mike Kelley: Catholic Tastes*, ed. Elisabeth Sussman. 161–174. New York: Whitney Museum of American Art, 1993.

Sandbrook, Dominic. *White Heat: A History of Britain in the Swinging Sixties*. London: Abacus, 2007.

Salter, Chris. *Entangled: Technology and the Transformation of Performance*. Cambridge, MA: MIT Press, 2010.

Schneider, Nathan and Trebor Scholz. *Ours to Hack and to Own: The Rise of Platform Cooperativisim, a New Vision for the Future of Work and a Fairer Internet*. New York: OR Books, 2016.

Scholz, Trebor. *Digital Labor: The Internet as Playground and Factory*, ed. Trebor Scholz. New York: Routledge, 2013.

Sedgwick, Eve Kosovsky. *Touching Feeling: Effect, Pedagogy and Performativity.* Durham, NC: Duke University Press, 2002.

Segal, Ben. "A Short History of Internet Protocols at CERN," April 1995. http://ben .web.cern.ch/ben/TCPHIST.html.

Shanken, Edward. "Contemporary Art and New Media: Digital Divide or Hybrid Discourse?" *Art Research Journal* 2 (2) (July–December 2015).

Shearlaw, Meave. "Facebook lures Africa with Free Internet but What Is the Hidden Cost?" August 1, 2016. https://www.theguardian.com/world/2016/aug/01/facebook -free-basics-internet-africa-mark-zuckerberg.

Sherman, Shantella, and Issa Rae. "Making the Black Experience Relatable." *Afro,* March 4, 2015. http://www.afro.com/issa-rae-making-the-black-experience-relatable.

Silverman, Craig. "How False New Spreads and Why People Believe in It," December 14, 2016. https://www.npr.org/2016/12/14/505547295/fake-news-expert-on-how -false-stories-spread-and-why-people-believe-them.

Silberman, Steve. "Guggenheim Goes Digital." *Wired*, October 7, 1998. https:// archive.wired.com/culture/lifestyle/news/1998/07/13648.

Smith, Adam. *Wealth of Nations*. Vol. II, 305–306. London: Everyman's Library, 1776/2001.

Smith, Oliver. "Facebook Terms and Conditions: Why You Don't Own Your Online Life." *The Telegraph*, January 4, 2013. https://www.telegraph.co.uk/technology/ social-media/9780565/Facebook-terms-and-conditions-why-you-dont-own -your-online-life.html.

Smith, Zadie. "Boakye's Imaginary Portraits: A Bird of Few Words." *The New Yorker,* June 19, 2017. https://www.newyorker.com/magazine/2017/06/19/lynette-yiadom -boakyes-imaginary-portraits.

Smith, Zadie. "Generation Why?" *New York Review*, November 25, 2010, 57–60, quoted in Lovink (2011), 41, note 7.

Smythe, Dallas W. "On the Audience Commodity and Its Work." In *Dependency Road: Communications, Capitalism, Consciousness, and Canada*, 22–51. Norwood, NJ: Ablex, 1981; republished in *Media and Cultural Studies Reader*, eds. Meenakshi Gigi Durham and Douglas M. Kellner (London: Blackwell, 2006), 230–256.

de Spinoza, Benedict. Book III, Proposition 2, Scholium, 280, quoted by Helena Reckitt, in "Introduction to Museums and Affect." *Journal of Curatorial Studies* 4 (3): 1–2.

Standing, Guy. *The Precariat: The New Dangerous Class*. London: Bloomsbury Academic, 2011.

Steinberg, Leo. "Reflections on the State of Criticism." [first published in *Artforum* 10 (7) (March 1972): 7–35.] Reprinted in *Robert Rauschenberg: October Files 4*, ed. Brandon W. Joseph. Cambridge, MA: MIT Press, 2002

Stiegler, Bernard. *For a Critique of a New Political Economy*. Cambridge: Polity, 2010.

Stiegler, Bernard. *Taking Care of Youth and the Generations*. Stanford, CA: Stanford University Press, 2010.

Streeter, Thomas. *The Net Effect: Romanticism, Capitalism, and the Internet*. New York: New York University Press, 2011.

Stewart, Jacqueline Najuma. *Migrating to the Movies: Cinema and Black Urban Modernity*. Berkeley: University of California Press, 2005.

Steyerl, Hito. "The Spam of the Earth: Withdrawal from Representation." In *The Wretched of the Screen*. Berlin: Sternberg Press, 2012.

St. Félix, Doreen. "How to Be a Successful Black Woman." *New York Times*, July 8, 2017.

Stuart, Hall, "Encoding/decoding" (1973), in Centre for Contemporary Cultural Studies (ed.), Culture, Media, Language: Working Papers in Cultural Studies, 1972–79, Hutchinson, London, 1980, pp. 128–38.

Syms, Martine. "Black Vernacular: Lessons of the Tradition." Walker Arts Center, March 18, 2014. http://martinesyms.com/black-vernacular-lessons-of-the-tradition.

Syms, Martine. "Critical Issues in Contemporary Art Practice." Lecture, University of Washington School of Art and Art History and Design, January 14, 2016. https://vimeo.com/154754826.

Szewczyk, Monika. "Unsafe Building: Coming and Reading into Vito Acconci's 'The Red Tapes.'" Master's thesis, University of British Columbia, 1997. https://open.library.ubc.ca/cIRcle/collections/ubctheses/831/items/1.0091576.

Tapscott, Don. *The Digital Economy*. London: McGraw-Hill, 1997.

Tapscott, Don, and Anthony D. Williams. *Wikinomics: How Mass Collaboration Changes Everything*. London: Atlantic Books, 2008.

Tedesco, Jean. "Cinéma Expression." *Cahiers du Mois* 16–17 (1925): 25. In Edgar Morin, *Le Cinéma ou L'Homme Imaginaire: Essai D'Anthropologie* (France: Les Éditions de Minuit, 1956), 16, note 9.

Terranova, Tiziana. "Free Labor." In *Digital Labor: The Internet as Playground and Factory*, ed. Trebor Scholz, 33–57. New York: Routledge, 2013.

Thornton, Leslie. "We Ground Things, Now, On a Moving Earth." *Motion Picture* 3 (1–2) (1989–1990).

Thumin, Nancy. *Self-Representation and Digital Culture*. Basingstoke, UK: Palgrave Macmillan, 2012.

Tiqqun. *Preliminary Theory of a Young Girl*. Los Angeles: Semiotext(e), 2012.

Toffler, Alvin. *The Third Wave*. London: Pan in association with Collins, 1980.

Tromble, Meredith, ed. *The Art and Films of Lynn Hershmann Leeson: Secret Agents, Private I*, 25. Berkeley: University of California Press, 2005.

Tsang, Wu. Interviewed by Andrew Berardini. Vdrome, 2012. http://www.vdrome .org/wu-tsang-wildness.

Turkle, Sherry. "Growing Up Tethered." In *Alone Together: Why We Expect More of Technology*. New York: Basic Books, 2011.

Vierkant, Artie. "The Image Object Post Internet," 2010. http://jstchillin.org/artie/ pdf/The_Image_Object_Post-Internet_a4.pdf.

Virno, Paolo. *A Grammar of the Multitude*. Los Angeles: Semiotexte, 2003.

Westerman, Jonah. "Between Action and Image: Performance as 'Inframedium,'" January 10, 2015. http://www.tate.org.uk/context-comment/articles/between-action -and-image-performance.

White, Ian. *Kinomuseum: Towards an Artists' Cinema*. Cologne: Konig, 2008.

Willett, John, ed. and trans. *Brecht on Theatre*. New York: Hill and Wang, 1964.

Wood, Catherine. "Horror Vacui: The Subject as Image in Mark Leckey's 'Parade.'" *Parkett* 70 (2004): 157–163.

Wood, Catherine. *Yvonne Rainer: The Mind Is a Muscle*. London: Afterall, 2007.

Wong, Julia Carrie. "Former Facebook Executive: Social Media Is Ripping Society Apart." *The Guardian*, December 27, 2017. https://www.theguardian.com/technology/ 2017/dec/11/facebook-former-executive-ripping-society-apart.

Wu, Tim. *The Attention Merchants*. London: Penguin, 2016.

Yablonsky, Linda. "Artifacts: Frances Stark's Best Thing." *New York Times Magazine*, October 26, 2011. https://tmagazine.blogs.nytimes.com/2011/10/26/artifacts-frances -starks-best-thing.

Žižek, Slavoj. "Why Are Laibach and the Neue Slowenische Kunst Not Fascists?" *M'ars* (Ljubljana) 5 (3–4) (1993), republished in Slavoj Žižek, *The Universal Exception*, 63–66. New York: Continuum, 2006.

Index

Note: Page numbers in italics refer to illustrations; those followed by n. and a number refer to information in a note.

Race (cont.)
 white privileging media, 4, 56–57,
 140–142
 white savior narrative, 86
 white supremacy, 4, 169
Rae, Issa, *The Misadventures of Awkward
 Black Girl* and *Insecure*, 139
Rainer, Yvonne, 6–7, 49–55, 118, 131,
 152
 Duet from *Terrain*, 50–51, *52*
 influence on Beckman, 79–80,
 86
 Kristina Talking Pictures, 79–80
 The Man Who Envied Women, 52–55,
 54, 175
 "NO Manifesto," 51
Ramirez, Rogelio, 160
Ramsden, Mary, 148
Rankine, Claudia, 213n.49
Rape in cyberspace, 72–73, 83
Rastegar, Roya, 160
Rauschenberg, Robert, 6–7, 19, 51, 57,
 108, 115
 Black Market, 42, *43*, 44–45
 Broadcast, *42*, 44
 Combines, 26, 38–45, 51, 53, 178
 "contact," 38, 39, 42, 45, 46, 108,
 188n.10
 Erased De Kooning, *21*, 39
 Judson Dance Theater collaborations,
 50
 Minutiae set and costume designs, 39,
 40, 41
 Untitled (Double Rauschenberg) (with
 Susan Weil), *17*, 39
 Untitled (Man with White Shoes), 41
Raven, Lucy, 148
Raymond, Eric S., 94
Reality television, 7, 25, 67
Real World (MTV show), 181
Recording innovations and media,
 35–37
Reflexivity, 27, 28, 106, 187n.28

"Registering like a photograph," 51,
 55, 64
Regulation of social media standards,
 91, 100, 101, 115, 130
Ritzer, George, 128, 129
La Roue (film), 134
Roysdon, Emily, 156–159, 181–182
 I Am Helicopter, Camera, Queen, *138*,
 157–159
 Uncounted, 157
Russia, social media platforms in, 99

St. Félix, Doreen, 168, 170
Salter, Chris, 49
The Salt Mines (film), 181
Sandbrook, Dominic, 36
Schneider, Nathan, 130
Scholz, Trebor, 15, 127, 128, 129, 130
Sculpture, 41, 111, 148, 150
Second Life, 83, 95, 176
Sedgwick, Eve Kosofsky, 4, 9
Self. *See* Identity and self
Sex
 sexual freedom as white feminist goal
 of the 1970s, O'Grady, 58
 simulation through dance, daggering,
 Stark, 119
 violence in cyberspace, 72–73, 83
 Stark's online sexual encounters,
 116–125
Sexuality
 Cheang's motivations, subjects,
 collaborators, influences, 74–78
 LGBTQIA collaborators of Roysdon's,
 157
 media representations of queer
 Latino-American men, Muñoz,
 180–181
 problems of identifying/depicting
 groups based on sexuality, Tsang,
 160–161
Shanken, Edward, 29–30, 147
Sherman, Cindy, 55, 188n.7

Voluntary labor, 3, 127–130, 133,
141–142
microstock photography and social
media, 100–103
and open-source model, 93–94

Wang, Dr. An, 84
Weil, Susan, *Untitled (Double
Rauschenberg)* (with Rauschenberg),
17, 39
Weist, Julia, 148
Wells, H. G., "The Country of the
Blind," 192n.6
WELL (Whole Earth 'Lectronic Link)
online forum, 82
Westerman, Jonah, 27
WGBH (television station), 74
White, Ian, 202n.16, 203n.26
White cube exhibition spaces, 97,
106–107
Wikinomics, 14, 92, 112, 198n.21
Williams, Anthony D., 7, 12, 14, 92, 94,
95, 112
Wilson, Martha, 55–56
Wood, Catherine, 108, 157
Work. *See* Free Labor; Labor; Voluntary
Labor
Wu, Tim, 140–141

Xanadu, hypertext project, 93
Xtranormal animation software, 117,
120

Yonemoto, Bruce and Norman. *See*
Kelley, Mike
YouTube, 112, 113, 114, 139, 164

Zamora, Pedro, 180–181
Žižek, Slavoj, 176–177
Zuckerberg, Mark, 99, 137